UNIVERSITY OF NORTH CAROLINA BASKETBALL

Some of the greatest minds in the history of basketball were assembled in North Carolina's team huddle during a time-out of a January 1961 game in Chapel Hill's Woollen Gymnasium. Head coach Frank McGuire (kneeling front), the architect of Carolina's 1957 NCAA champions and a member of the College Basketball Hall of Fame, was in his final season with the Tar Heels, as he would soon be leaving to coach the NBA's Philadelphia Warriors. Assistant coach Dean Smith, located to the immediate left of McGuire in the photograph, became head coach at the University of North Carolina (UNC) later that year and went on to win 879 games, more than any other coach in the history of major college basketball. Players on the team include Donnie Walsh, who went on to become CEO of the NBA's Indiana Pacers; Doug Moe, a former NBA coach of the year; and Larry Brown, the only head coach in the history of basketball to win both an NCAA championship and an NBA championship. (*Yackety Yack.*)

UNIVERSITY OF NORTH CAROLINA BASKETBALL

Adam Powell

with a foreword by Phil Ford

Published by Arcadia Publishing
Charleston SC, Chicago IL, Portsmouth NH, San Francisco CA

Printed in Great Britain

Library of Congress Catalog Card Number: 2005925643

For all general information contact Arcadia Publishing at:
Telephone 843-853-2070
Fax 843-853-0044
E-mail sales@arcadiapublishing.com
For customer service and orders:
Toll-Free 1-888-313-2665.

Visit us on the internet at http://www.arcadiapublishing.com

The 1993 NCAA champion Tar Heels hoist their trophy high. After losing consecutive games in late January and early February, North Carolina won 17 of their final 18 games to earn the school's second NCAA title in 12 years under Dean Smith and the third in team history. (*Yackety Yack.*)

CONTENTS

Acknowledgments 6

Foreword 7

1. Laying the Foundation: 1910–1911 to 1931–1932 9

2. The "New" Southern Conference Years:
 1932–1933 to 1951–1952 25

3. The "Underground Railroad": 1952–1953 to 1960–1961 45

4. Dean Smith Finds His Way: 1961–1962 to 1980–1981 61

5. Winning the Big One: 1981–1982 to 1996–1997 87

6. Changes and Homecomings: 1997–1998 to 2004–2005 115

ACKNOWLEDGMENTS

Having grown up in North Carolina, following the exploits of my alma mater's basketball program for more than 20 years, I am honored that Arcadia Publishing asked me to write a book on the subject. Along those lines, my first acknowledgment goes out to my close friend Selby "Chip" Stokes. Chip was the first to suggest the idea of this project, and it probably wouldn't have reached fruition if not for his original vision and his efforts to connect me to the right people, such as acquisitions editor Adam Latham. Chip is my touring buddy and one of my best friends, and I thank him for all he's done. Ain't life grand?

As always, I offer my love to my family. To Mom, Dad, and both my grandmothers, thanks for your support, and I hope for many happy times in the future.

Other special thanks go out to the *Yackety Yack*, the official yearbook of the University of North Carolina at Chapel Hill. The photographic images from various editions of the *Yackety Yack* are included throughout this work, including the front cover, and a personal note goes to editor Christina Bormann. Appreciation also goes to photographer Jeffrey Camarati, whose work adorns the back cover and the final page. A very special thanks goes out to my good friend Aaron Garrish for his assistance with acquiring hardware to scan images for this project. Aaron has helped me too many times in the past to fully give him credit here, but I always respect his opinions and contributions. I also want to give a shout out to my roommate, Rick Pawliczek, for his many trips to and from the UNC campus for research and for his patience in living with me.

I also give thanks to Phil Ford of the Detroit Pistons, who graciously agreed to write the foreword for this book. One of the great players in school history, Phil's contributions to UNC, both as player and coach, are worthy of great admiration. To Woody Durham, thanks as always for providing me with your knowledge and recollections from more than 30 years on the sidelines watching and talking about the Tar Heels. Thanks also to Steve Kirschner and Matt Bowers in the UNC Athletic Department for allowing me access to Coach Roy Williams and the Tar Heel players during the 2004–2005 season. Other thanks go to the staff at the Wilson Library on the UNC campus and University Photo Services in Chapel Hill. I also wish to express appreciation to author Ken Rappoport, a superb documenter of sports history. His books on UNC basketball have allowed this history to live on for many generations to come, and I congratulate him for his outstanding contribution to this genre of journalism. I also want to express appreciation to the owners and staff of Tar Heel Report (www.tarheelreport.com) for giving me the opportunity to write about the Tar Heels.

To Coach Dean Smith, you were one of my heroes growing up, and watching your teams were a joy of my childhood. Thanks for everything you have done for the sport of basketball and for everything you have done for the University of North Carolina.

Finally, I wish to thank every player who has ever donned the powder blue–and–white jersey representing the University of North Carolina, of whose exploits made this book possible. Your contributions helped create a legacy of basketball excellence that is growing by each passing winter. Many of you played before I was born, but I have grown up hearing and reading the stories, and have been fortunate enough to experience it from a fan's perspective since the early 1980s. Fans of the Tar Heels are fans for life, and I thank you for giving me something to be truly passionate about, which in turn makes my life, and the lives of all Carolina fans, all the more meaningful.

FOREWORD

In the state of North Carolina, basketball is more than a game. It is a way of life for many people from a very young age. I grew up playing ball, and by the time I was a senior at Rocky Mount High School, there were several universities that showed interest in me becoming a student-athlete at their institution. Coach Smith stressed academics as well as athletics, which made a lasting impression on my public school teacher parents and me. My final two choices were UNC and N.C. State. It was a difficult decision, considering State was coming off a national championship. But my parents and I fell in love with Coach Smith. Attending Carolina was one of the best decisions I have ever made.

It was an honor to be part of some fine teams at UNC, and to play with so many great teammates, who I am still friends with to this day. We were blessed to have many wonderful moments, including the 1975 ACC tournament and having four players, a head coach, and an assistant coach on the 1976 United States Olympic team, which won the gold medal in Montreal.

Coach Smith's respect for his players and assistant coaches runs much deeper than basketball, and for that we will be forever grateful. It is no surprise that so many former players and assistants talk frequently with Coach Smith on the phone and make their way back to Chapel Hill in the summer to visit. He makes it a point to stay in touch with us, and we, in turn, look to him for wisdom and advice for our own lives. Coach Smith is, along with my parents and wife, one of the most influential people in my life.

Over the years, Coach Bill Guthridge could have taken any of the number of head coaching jobs he was offered, but he chose to stay at North Carolina. He deserves a lot of credit for that. We wouldn't have been nearly as successful if he had gone and coached elsewhere. Then, when he did become head coach, our teams went to two Final Fours, and he received the National Coach of the Year Award. He was devoted to the players, and he was a great head coach to work with as an assistant. I have a tremendous amount of respect and love for Coach Guthridge.

With Coach Roy Williams back in Chapel Hill, North Carolina basketball is continuing its tradition of excellence. Coach Williams is one of Coach Smith's great prodigies, a true student of the game who knows how to win. He, like Coach Smith, has a knack for recognizing outstanding student-athletes, and he bleeds Carolina blue. I am thrilled that he is our coach.

North Carolina basketball is a life experience shared by legions of people from all walks of life. I am privileged that I have been associated with North Carolina basketball for the last 30 years. Being part of such a followed story is something that keeps all of us attached to the Tar Heels long after we have played our final game in that Carolina jersey. My own book will talk in even more detail about my experiences at UNC, but Adam Powell has written a fair and accurate basketball history book with the spirit one would expect of a University of North Carolina graduate and lifelong Tar Heel fan.

—Phil Ford

Dean Smith calls out his famous "four corners" offense, while assistant coach Roy Williams points at the signal, during an NCAA tournament game in the 1980s. Smith learned the sport of basketball from legends such as Phog Allen and Frank McGuire, and he passed his own knowledge on to the scores of players and assistant coaches he worked with at North Carolina. Williams, an understudy of Smith's for 10 seasons on the UNC bench, returned to Chapel Hill to serve as head coach of his alma mater in 2003. Two years later, in 2005, Williams brought home North Carolina's fourth NCAA championship. (*Yackety Yack.*)

ONE

Laying the Foundation
1910–1911 to 1931–1932

The sport of basketball was invented by physical education instructor James Naismith in Springfield, Massachusetts, in the winter of 1891 in an effort to keep his male athletes in shape between the autumn football season and the spring baseball season. Played on an indoor court and originally using a soccer ball and peach baskets, basketball took little time to experience tremendous popularity growth. A mere 13 years after its inception, the game was played as an exhibition sport in the 1904 Olympics, and soon after, college campuses up and down the East Coast were acquiring rules and organizing teams. Much like today, the University of North Carolina (UNC) featured a number of athletic clubs in the early years of the 20th century. Organized by students, the clubs coordinated with similar teams at nearby colleges and played a full schedule of games. Basketball was a discipline in UNC physical education courses from the time rules had been introduced to the Chapel Hill area by Dr. Robert Lawson in 1906. However, it wasn't until 1911, when student Marvin Ritch, along with school officials, successfully lobbied to create an organized varsity squad, that UNC fielded its first team.

The team needed a staff member to serve as coach, and it wound up securing one of the greatest athletes in the world to do the job. Nathaniel "Nat" Cartmell had won medals in both the 1904 and 1908 Olympic games as a short-distance sprinter and had set world amateur and professional records in the 220-yard sprint. The University of Pennsylvania product had arrived in Chapel Hill in 1909 to serve as track-and-field coach. The UNC athletic department was struggling financially at the time and could not afford to hire another new coach. Although he knew little about the sport, after being asked, Cartmell agreed to become UNC's first varsity basketball coach. It took a few weeks to organize a schedule, but on January 27, 1911, UNC played its first intercollegiate basketball contest. The opponent was Virginia Christian College, which in later years would become Lynchburg College. The game was played in Bynum Gymnasium, which would eventually become the site of the university cashier's office. The Tar Heels proved to be the more accurate shooting team that day, and won, 42-21.

"We just picked up games as we could, some college teams around the state like Wake Forest, Atlantic Christian, and some YMCA teams like Durham and Charlotte," said Roy McKnight, a member of UNC's first varsity basketball team. "If we had 35 or 40 people out to see games in those days, it was pretty good. There wasn't much enthusiasm for basketball then."

Basketball was still in its infancy in 1911, and although glass backboards had recently been legalized, the game that the first North Carolina team played hardly resembles what fans are used to seeing today. Teams had a designated "free shooter" that shot every free throw. After a player committed his second foul, and in all future fouls, the player had to sit out, without substitution, until the next made basket, at which time the players re-assembled in the middle of the floor for another jump ball. As such, the notion of full-court basketball theory was unheard of at the time. In addition, players were disqualified after four fouls instead of five.

Playing in front of a sparse crowd of curious onlookers, UNC blew out Durham's YMCA team and edged Wake Forest in a span of three days in early February. Two more home games followed that month, and Carolina knocked off Davidson and Charlotte's YMCA club to improve to 5-0. The Tar Heels did not lose until they finally played away from home, when they lost a 38-16 game at Wake Forest. Carolina would return to Chapel Hill to defeat Tennessee, but two losses to Virginia (UVA) and an away loss to Virginia Christian, combined with a win over Woodberry Forest, left the original Tar Heels with a 7-4 record. Following the season, the UNC yearbook, the *Yackety Yack*, wrote the following words about the new team: "In 1911, for the first time in our college history, Carolina produced a basketball team; and despite the fact that we were new at the game and had a heavy schedule, we made a good record. Basket-ball adds a new branch to athletics at Carolina, and bids fair to become one of the most important."

Five monogram winners returned in the winter of 1912, but one of the team's founders, Marvin Ritch, transferred to Georgetown. The team added games against Elon College and William and Mary, which both proved to be victories for Carolina. The triumphs were sandwiched around a season-opening 29-28 loss to the Durham YMCA and a 35-20 setback at Guilford College. The Tar Heels scheduled three consecutive games against its original opponent, Virginia Christian, and easily won the first contest in Chapel Hill, 43-17. The other two games, played in Lynchburg, were different stories, as the Heels dropped 29-18 and 20-18 scores. At 3-4, Carolina needed a victory against Virginia A&M (later to become Virginia Tech) to post a winning record, but it was not to be, as Cartmell's team gave up its highest scoring total of the year in a 37-28 defeat. The only solace was the fact that several thousand fans came out to the Raleigh Auditorium to watch the game, a clear sign that interest in the sport of basketball was taking shape in North Carolina. Ten days later, UNC salvaged a final win when they knocked off Wake Forest, 18-15. The victory left Carolina with a 4-5 overall record.

"The A&M contest proved conclusively that basketball has come into its own in this state," reported North Carolina's *Alumni Review*. "Nearly 2,500 people jammed into the Raleigh Auditorium and cheered a contest that for both speed and excitement has rarely been equaled. Both teams seemed to realize the significance of the game, and each strove for first blood in this new era of athletics between A&M and the University of North Carolina. Though hard fought, the game was clean and sportsmanlike in every respect."

The Tar Heels were as experienced a team as anyone could ask for in 1913, as four players from the original squad returned for their third season on the varsity. UNC once again scheduled the Durham YMCA team at home for its first game and dropped a heartbreaker, this time by a single point, 23-22. Carolina waited nine days for its next encounter and buried Davidson in Bynum Gym. Another blowout, 41-11, over Elon, followed. From there things got ugly for the Tar Heels, as the team lost six of its next seven games. UNC salvaged another final-game victory over Wake Forest, their second in a row, which avenged a loss three weeks earlier in the school's first overtime contest.

Coming off a disappointing 4-7 record, the 1914 Tar Heels sought to find a new identity. Only three players from the 1913 team returned, although Henry Long, a member of each of the first three UNC teams, returned as the squad's manager. The team also dramatically expanded its schedule, adding 7 games to make a total of 18. The schedule expansion meant games in December, which marked the first time a UNC varsity athletic team played over two calendar years. On December 13, the earliest starting date in the program's history, the Tar Heels took a 21-15 setback to Elon on their home floor. Durham and Charlotte's YMCA teams comprised the next four games, and Carolina won three of them. The team played even better over a week-long stretch in late January and early February, beating Guilford, Elon, and Wake Forest to improve to 6-2.

Official statistics weren't kept in the early days, making it difficult to pinpoint why the Tar Heels fell apart in February and March, but for whatever reason, the team lost 6 of their final 10 games. Carolina was particularly embarrassed by UVA, giving up 67 points in a game in February and 56 points in their March season finale. Scoring 50 points was considered an impressive single-game team accomplishment at this time in history, and the fact that UVA did it twice against the Tar Heels was evidence of their dominance. In between their blowouts by UVA, the Tar Heels played eight games, starting with a loss at Wake Forest. Wins over Durham's YMCA and Guilford gave the team an 8-4 overall mark, but they would only win twice more. Carolina and Wake went at it again, this time in Raleigh, and the Demon Deacons won, 32-29. All of UNC's remaining five games were away from home, and although they struggled, they managed to knock off Woodberry Forest 25-21 to begin their road trip. A loss to the Virginia Military Academy (VMI) followed, but the Heels came together to dominate another military school, this one from Staunton, Virginia, 41-10. There was another game the following day against the YMCA team from Lynchburg, and the worn-down UNC squad dropped a 42-34 final. Virginia's 56-23 wipeout sent the Tar Heels to a 10-8 overall mark.

Nat Cartmell had retired from professional sprint running in 1912 to become a full-time coach and faculty member at UNC, but following the 1914 season, he was charged with illegally playing dice with known gamblers. Cartmell was fired, thus ending the short reign of the school's first head basketball coach. Cartmell was a well-liked figure on the UNC campus, and his dramatic exit, combined with the overall financial troubles of the athletic department, nearly spelled the end of varsity basketball at UNC before it really got started.

Only six players came out for new coach Charles Doak's first team, and it didn't take long before the squad began to struggle. Doak was a baseball man at heart and did not have his full dedication on basketball, having taken the job simply because there was nobody else to do it. UNC scheduled a demanding slate of teams, and although things started off well enough in a defeat over the Durham YMCA, in a rematch a few days later, the Y's reeled off a 10-point victory. Elon came to Chapel Hill, and Carolina won a 15-9 contest, but then they dropped another game against the Durham YMCA. Wake Forest and UNC came together in Raleigh three days later, and Carolina improved to 3-2 with a 32-20 win. The Tar Heels took more than two weeks off before rematching with Wake Forest, and a 26-23 loss to the Demon Deacons sent Carolina on a tailspin, as they only won 3 of their final 11 games to finish with a 6-10 overall mark.

The Tar Heels returned four players in 1915–1916 and added some fresh bodies for a total of seven team members. The experience of having four three-year players in their lineup paid dividends, as Carolina would go on to set a new school record for victories. UNC won against the Durham YMCA to start the year 1-0, but two days later, the Tar Heels lost in a rematch, 26-16. Carolina continued to play well in early January, claiming lopsided victories over Elon and a YMCA team from Statesville. A close loss to Wake Forest in Raleigh made the Tar Heels 3-2, but the Tar Heels returned to form when they played the University of Maryland for the very first time. Carolina dominated the Terrapins, 39-24, and then made their way to Virginia for their next six games. The first was played against UVA on

a neutral court in Richmond, and the Cavaliers continued their winning streak against North Carolina, 29-15. Over the next five days, Carolina played Virginia Tech, Roanoke, Randolph-Macon, Washington and Lee, and VMI in succession. The Tar Heels won only two of the contests, but their 25-23 victory over VMI turned the corner, as the team would win its final seven games. Carolina finished its schedule at home against Guilford, and the Tar Heels completed a 6-0 record in Chapel Hill with a 51-21 victory, which gave the team a 12-6 overall record.

As the 1916–1917 season commenced, the Tar Heels again found themselves under new leadership. Charles Doak, the UNC baseball coach before being assigned to the basketball team, stepped down before the new season. He was replaced by Howell Peacock, a former basketball star at Georgia and a UNC medical student. The bevy of graduations from the 1915–1916 team, combined with Doak's departure, forced Peacock into securing a new batch of players. The ambitious Peacock posted signs all over campus, urging young men to come out and be part of the team.

"Peacock started from scratch," recalled George Tennant, who played in 1917 and 1918. "There were only two lettermen back from the previous season, myself and Carlyle Shepard. But Peacock's call for aid was heeded, and 10 men showed up for practice, three of which made the starting lineup. Peacock soon whipped up a team of fair grade."

Carolina scaled down its schedule to only nine games in 1917 and, for the first time since 1913, played all its games in the same calendar year. UNC scheduled the Durham YMCA for its third straight home opener, and a 49-30 triumph got the team going in the right direction. A loss to Davidson at home followed, but the Tar Heels won their next two games, also at home, over Virginia Tech and VMI. Carolina traveled to Lynchburg for another neutral-court game against UVA, and this time the Blue and White were ready. The Tar Heels decisively outplayed the Cavaliers, and a 35-24 victory ended years of frustration at the hands of UVA. Sporting a 4-1 record, the Tar Heels again struggled on a rapid-fire road trip of games in the state of Virginia. Two days after their inspiring victory over UVA, Carolina was pounded by Washington and Lee, 40-23. UNC struggled in their next two contests as well, played on successive days against VMI and Virginia Tech. Losses in both games sent Carolina's record to 4-4. With a chance to secure winning records in consecutive seasons for the first time in the program's history, the Tar Heels returned home and handed Guilford a 55-28 defeat. Considering that Carolina played the 1917 season with several newcomers to the team, along with a first-year head coach, their 5-4 record was better than many people expected.

Although the United States was firmly entangled in World War I by the time the 1917–1918 squad was ready to start playing, the school increased its schedule to 12 games. Peacock went with only five players that would go on to win UNC monograms, but the scrappy team played as well as any North Carolina basketball team to that time. The Tar Heels opened their season with a pair of blowouts against the Durham YMCA. The 66-13 and 44-24 victories got the Tar Heels rolling, and in similar fashion as the original 1911 team, Carolina won its first five games. The Tar Heels next played four games in five days, all of which were on the road, winning only once. The victory, a 28-24 verdict over Guilford, was set against a 28-21 setback to Elon, a 28-23 loss to the Lynchburg Athletic Club, and a 45-35 defeat to UVA in Charlottesville. The Tar Heels returned home and won their final three, taking out Guilford, South Carolina (USC), and Davidson in succession. Carolina was particularly dominant against the Gamecocks, taking a 58-21 victory in the first meeting between the two schools on the basketball court. With an undefeated 6-0 mark at home and a 9-3 overall record, the 1917–1918 Tar Heels staked their claim as one of the top college basketball programs in the South.

"We played an aggressive, fast, rough-and-tumble game," recalled Tennant. "Scores were in the 30s and 40s, and the ball was much larger and heavier than it is now. Most of the shots were two-handed. Some of us used hook shots and maybe you'd use a backhander once in a while. The ball was so heavy you couldn't dribble much with it."

UNC continued to add to its schedule in 1918–1919, adding North Carolina (N.C.) State for the first time. In scheduling the extra games, the school created a gap in the number of games in Chapel Hill compared to games on the road. After playing its first three games at home, UNC would play 12 of its final 13 games away, with a neutral-site game against Virginia thrown into the mix. Durham's YMCA team was particularly tough this year, and Carolina lost their first home game, 25-21. Guilford and Elon were next in Chapel Hill, and the Tar Heels overwhelmed their nearby opposition. The good times continued when the team headed across the state to Guilford. A 56-23 victory gave Carolina confidence heading into the UVA game, but unfortunately the Tar Heels were not ready, and they lost a 40-29 contest to drop to 3-2. Four road games in as many days followed, and although Carolina looked good in victories over VMI and Washington and Lee, the games wore the team down. The fatigue showed over the following two days, as Carolina played a doubleheader in Blacksburg against Virginia A&M. The Tar Heels were beaten twice, and a loss to the Durham YMCA sent Carolina to a 5-5 record. The Heels played well enough to defeat Wake Forest but were unable to stay above .500. Heading to Raleigh to play UVA, UNC struggled to find the basket and dropped a 31-21 final.

Carolina continued its road trip with a game against the Charlotte YMCA, and the angry Tar Heels temporarily reversed their fortunes in a 51-46 victory. Another lopsided verdict came the next day against Davidson, and that 40-12 triumph preceded a victory against a team from Camp Jackson. UNC finished its season in Raleigh against N.C. State, and the "Red Terrors," as they were known at the time, claimed the first game between the two rivals, 39-29. Although the Tar Heels' 9-7 record in 1918–1919 was somewhat disappointing, there was no question that the roots of a solid basketball program had been built at UNC. The school was attracting a great deal of interest in its neutral-site games in Raleigh and Virginia, and the sport as a whole was experiencing added exposure and enhanced popularity. As a result, the 1920s would turn out to be prosperous years for the basketball fortunes in Chapel Hill.

Nonetheless, for the third time in five years, UNC's basketball program found itself under new leadership. World War I veteran Fred Boye took over for Howell Peacock in time for the 1919–1920 season, but unlike his predecessor, the new coach led an experienced team his first year. Seven players went on to earn monograms, including three that had lettered the previous season. The Tar Heels again played a 16-game schedule, including two games in December. Both contests resulted in victories over the Durham YMCA, the first in Chapel Hill and the second on the road. A third game against the Durham Y's went into overtime, and Carolina dropped a 34-30 decision. The loss was the second of six consecutive road games, and UNC was only able to win two of the encounters, starting with a 51-23 verdict over Guilford. On consecutive days in mid-January, the team dropped games to Davidson and to the Charlotte YMCA team.

The Tar Heels persevered in a triumph at Duke, which improved their record to 4-3. Carolina returned home for a game against Davidson and was on the right end of a 23-22 score. Four more road games resulted in three defeats, which dropped the UNC record to 6-6. The latter game of the stretch, the fourth in five days, was against Navy, who outplayed the Tar Heels for a 36-24 victory. The team returned to North Carolina and won against N.C. State, playing solid defense in a 32-12 triumph. Ten days after the N.C. State game, Carolina tipped off for the second time against UVA. A 37-31 loss took some of the wind out of Carolina's sails, as the team played poorly on offense in their final two games, which happened to be against Duke and N.C. State. Both rivals got revenge on the Tar Heels, as the Blue Devils claimed a 19-18 victory in Chapel Hill and State took a 32-21 triumph in Raleigh. The losses dropped UNC's final record to 7-9.

Boye was optimistic he could lead Carolina back to a winning record in 1920–1921, and with another experienced team, he would do just that. UNC got off to a fast start, winning their lone December game and lopsided verdicts in January over USC and Elon. UNC

entered a brutal stretch after the Elon victory, playing 11 games, all on the road, in a span of 14 days. The Heels were unable to continue their winning ways against Duke, but they shocked UVA and defeated Washington and Lee to improve to 5-1. The grueling road stretch got to the Tar Heels after the Washington and Lee contest, as the team lost its next six games. The defeats came at the hands of VMI, Georgetown, Army, Rutgers, Yale, and Navy. Carolina salvaged the final two games of the stretch. The victories propelled UNC into a six-game winning streak, which pushed their record back above .500.

On February 25, 1921, as the Tar Heels were in the midst of their home winning streak, the University of North Carolina had become a charter member of a new athletic body. At a meeting in Atlanta, 14 members of the old Southern Intercollegiate Athletic Association (SIAA) had organized a new league, which was to be appropriately named the Southern Conference (SC). The decision was motivated by the desire to create a conference basketball tournament, in addition to having a workable number of conference games for each league member. With 30 schools in the SIAA by the early 1920s, it was impossible to play every school even once during the regular season, and many schools were going several years between playing certain opponents. UNC was more than happy to make the move, and several of their biggest rivals, including Wake Forest, Clemson, Virginia, Virginia Tech, and Washington and Lee, followed them to the new league.

The six-game streak ensured a winning record for Carolina, but the team lost its focus when they rematched with State on March 2. NCSU sneaked out a 32-31 win, which prevented UNC from setting a new school record for victories in a single season. Another blowout win against Duke, this one by a 55-18 score, ended the season at 12-8. It was the third time in school history that North Carolina finished undefeated at home, and it served as a prelude to one of the finest eras in the history of Tar Heel basketball.

Although the Tar Heels wound up playing without an official head coach in 1921–1922, the school's first season in the Southern Conference, the team proved to be the best yet to play at Carolina. Behind the school's first standout, Cartwright Carmichael, UNC went on to win 15 games. Carmichael, a native of Durham, teamed up with his brother Billy, a member of both the 1920 and 1921 teams, as the first sibling tandem to play on the same UNC basketball squad. The team was escorted to road games by football and baseball coach Bob Fetzer, who would often go up in the stands and watch the games like any other spectator. The Cartwrights were good shooters and solid defenders, and although UNC lost two of its first three contests, each to the YMCA team from Durham in front of standing-room-only crowds, the Tar Heels won eight in a row in January and February.

"Cart was just as graceful as he could be," remembered Monk McDonald, who played with Carmichael in 1923. "He could shoot from any part of the court. Cart looked better missing a shot than most players today when they make one. He had grace and skill and speed. He was just a complete ballplayer."

UNC's first victory was a 44-28 triumph over USC in Chapel Hill, and the winning streak began with a 32-28 verdict at Wake Forest. A 30-17 victory at N.C. State followed, and the Tar Heels reeled off three consecutive home wins from there. The winning ways continued with an overwhelming 50-24 score at Elon, and Wake Forest once again fell as the Heels improved to 8-2. Three days later, Carolina knocked off VMI on the road to set a new school record for consecutive victories. Unfortunately, the team got cold in their three games prior to the SC Tournament and dropped all three encounters. The first was at Washington and Lee, as the Generals won, 38-25. Virginia and Army were next, and the Heels were on the wrong ends of both final scores.

UNC's first trip to the SC Tournament was quite an experience. The Atlanta Athletic Club had renovated the fabled Atlanta Auditorium into a showcase for the best college basketball in the South, and the event was a hit from the outset, as basketball fans came in droves. The tournament was so big, in fact, that fans actually hung from the girders high above the auditorium when seats were no longer available. With a 3-3 record, the Tar Heels tied for

seventh place in the SC standings and matched up against Howard in the first round. The Tar Heels were feeling their shots and advanced to the second round with a 35-21 win. Carolina's second-round opponent, Newberry College, was new to top-tier college basketball but played hard, nearly toppling the cagers from Chapel Hill. Nonetheless, the Tar Heels held on for a 32-27 win, which meant a third-round game against the University of Georgia.

Georgia was still a few years away from becoming an elite team in the Southern Conference, and a 33-25 Carolina triumph set up a semifinal match against Alabama. The Crimson could not find the basket, as UNC's stellar defense paved the way for a 20-11 victory. The Tar Heels met surprising Mercer in the championship game, and in the team's fifth game in as many days, the Blue and White left everything out on the floor. Posting their highest point total of any individual game in the tournament, Carolina won, 40-26, to hoist North Carolina's first-ever SC Tournament title. Carmichael led the way with five field goals and eight free throws, while several other UNC players had good outings. The Tar Heels still had two games to play, and although they dropped another game to Washington and Lee, they went to Durham and knocked off Duke, 29-23, to finish with a 15-6 overall mark.

The majority of Carolina's nucleus returned in 1922–1923, and although Billy Carmichael graduated, his brother Cartwright went on to earn All-SC honors for the second year in a row. He would also be named first-team All-America that season, becoming the first UNC athlete in any varsity sport to earn such distinction. UNC ran through its entire regular-season schedule unbeaten and took a perfect 14-0 record to Atlanta for the SC Tournament. The season got off on the right foot with a pair of victories over the Durham YMCA and was followed with wins over Wake Forest and Mercer, both in Bynum Gym. The old arena, remembered for a second-floor running track that hung over the court, was in its final full season as UNC's exclusive basketball venue. The next season, the Tar Heels would begin playing in a new building.

After knocking off Mercer, the Tar Heels went on the road for five games. Carolina exacted revenge on Washington and Lee and posted victories over VMI and Lynchburg. Duke and Wake Forest were next, as the Heels won on the home floors of two of their biggest rivals. The University of Florida came north to Chapel Hill for the first meeting between the two schools, and UNC cruised in a 59-14 triumph. Another victory against Duke prepared Carolina for back-to-back meetings against N.C. State. The Red Terrors did not have a particularly solid team, and Carolina blasted them in the first meeting in Raleigh, 39-9. N.C. State brought a better game when the teams played two days later, but the Tar Heels again prevailed. The only thing standing between a perfect season was Virginia, and the Heels claimed a 39-16 victory. With a flawless 5-0 record in league play, Carolina headed to Atlanta as the Southern Conference's No. 1 seed.

As a result of their finish in the league standings, the Tar Heels played a weaker opponent in Mississippi College in the first round. A 28-21 triumph set up a second-round matchup against Mississippi State. UNC was expected to win, but for whatever reason, the team had a bad day. The Tar Heel defense had allowed an average of just over 21 points a game coming in, but they struggled defensively to contain Mississippi State. Although it was close, Carolina dropped a disappointing 34-32 setback. The defeat ended the team's season at 15-1. Although losing their final game in 1923 was a bitter pill for the UNC players and fans to swallow, it would motivate the team to reach new heights the following year.

For the first time in three seasons, UNC had an official head coach in the winter of 1923. In Norman Shepherd, the team had a leader capable of taking them to the next level. Shepherd inherited returning senior Cartwright Carmichael, who earned his third All-Conference distinction and his second All-American selection. Also joining the fray was Jack Cobb, another Durham native with good passing and rebounding skills. Although he was only a sophomore, the six-foot-two-inch forward made the All-American team. The 1923–1924 Tar Heels would gel into arguably the finest college basketball team to that time, a compilation of fine shooters and defenders that went on to make history.

"I had inherited a very good group of boys from the team before," Shepherd recalled years later. "Carmichael and (Bill) Dodderer were exceptionally good, and I had coached Cobb on the freshman team. Carmichael and Cobb were so fast and quick with their faking and feinting and breaking, and Carmichael could drive to the basket with unbelievable speed and hold himself in the air for a long time, like he was suspended."

Carolina opened up the season on the road and knocked off a club team from Durham and the Charlotte YMCA team in December. With a spaced-out schedule in the month of January, Carolina was able to get more rest between its games and, as a result, tore through the month with a 6-0 record, beating their opposition by an average margin of nearly 25 points a game. February continued to bring success to the Tar Heels, as the team toppled VMI and Catholic College. Maryland was next, and they gave the team its toughest matchup thus far in the season. Playing in College Park, the Tar Heels pulled away, however, for a 26-20 victory to improve to 12-0. UNC continued its road trip with three games in three consecutive days, starting with Lynchburg. Carolina prevailed by 10 and followed it up with a 19-16 victory over Washington and Lee. The win propelled the team into a showdown at Virginia. The Tar Heels played another solid defensive game and returned home with a 33-20 triumph. The Generals and Cavaliers had been particularly tough adversaries over the years, and beating them in consecutive days was an impressive accomplishment, even for a team as talented as the Tar Heels. Playing in the new Indoor Athletic Center, which almost immediately became known as the "Tin Can," the team enjoyed a tremendous week in mid-February. In a span of three games, UNC defeated USC, 53-19, William and Mary, 54-16, and N.C. State, 44-9.

Sporting an 18-0 mark, Carolina headed over to Durham for a game against Duke. The Blue Devils gave the lighter shade of blue everything they wanted, but the Heels held on for a dramatic 23-20 victory. It was UNC's most difficult remaining challenge, as the team finished out the regular season with a trio of solid wins. The finale was in Chapel Hill against Washington and Lee, and a 26-17 triumph gave the Tar Heels a perfect 22-0 record to go along with their second consecutive SC regular-season title. UNC headed to Atlanta confident and overwhelmed Kentucky, 41-20, in the first round of the SC Tournament. The second round was much of the same, as the Tar Heels dominated Vanderbilt, 37-20. The semifinal against Mississippi State was a little more of a challenge, but Carolina pulled away in the second half for a 33-23 verdict, earning revenge from their lone setback in 1923. Shepherd's team was a single victory away from a perfect season, and in the championship against Alabama, Carmichael and Cobb helped UNC pull away down the stretch. Making a number of clutch shots, Carolina overcame Alabama's tenacious defense, while playing a stingy game of their own, to complete their 26-0 masterpiece by a score of 26-18. Carmichael and Cobb were each named to the All-Tournament team, while the Helms Foundation named North Carolina the national college basketball champion. In the era before the NCAA tournament, the Helms Foundation was the recognized body that awarded the national champion. The victory set off a spirited celebration in Chapel Hill, which lasted well into the next morning.

"Carolina students went wild when news of the victory came," reported the *Greensboro Daily News.* "Hundreds waited in the streets in front of the telegraph office and cafes for the first flash. Then, dormitory doors and windows flew open, and the campus resounded with a chorus of yells, next followed by snake dances and finally a bonfire on the athletic field. The bell in Old South Building rang for more than an hour and told of the victory for miles around. Chapel Hill has seldom seen a happier night."

Sportswriters in Atlanta couldn't say enough about the clean-cut and sportsmanlike North Carolina team, which had proven its worth over four grueling days of action. One journalist argued that the entire UNC team should have been All-Conference, while another referred to the team as "shadows and ghosts" on defense. As a result of their lightning-fast speed and the adjectives used by the sportswriters, the UNC basketball team earned the nickname "White Phantoms" during their championship run.

Although Cobb returned to the North Carolina lineup for the 1925 season, head coach Norman Shepherd did not, deciding instead to pursue a business opportunity outside of the United States. His replacement was Monk McDonald, a three-year letter winner and the first former player to become head coach at UNC. In addition to Cobb, McDonald inherited Bill Dodderer, who had joined his more celebrated teammates on the 1924 All-SC team. The Tar Heels went unchallenged in their first five games, all coming in the Tin Can. Carolina took to the road for their next nine games, and the trip started well, with wins over Wake Forest, Duke, and Maryland. UNC met Harvard next, and in a difficult encounter, the Crimson played the North Carolinians tough and pulled out a 23-22 victory to end UNC's 34-game winning streak. Although the streak ended, the mark set a new standard of excellence for college basketball in the South.

UNC played on each of the next four days after the Harvard loss and struggled to keep it together. The Crescent Athletic Club handed Carolina a 32-24 defeat, and Navy defeated them again, 39-20. The team saddled up and knocked off VMI but lost another contest to drop to 9-4. A 27-17 win at N.C. State maintained Carolina's unblemished conference mark, although a loss to USC two days later was the school's first defeat at home in more than three years. McDonald got the team back on track after the USC setback, as the White Phantoms went on to overpower Duke, 34-18, and Wake Forest, 43-24, in succession. N.C. State was held to only 10 points in Carolina's next victory, while Virginia could only muster 15 points to UNC's 26. The Tar Heels finished with a 31-15 victory over Washington and Lee, which gave Carolina their second consecutive undefeated regular-season championship in the Southern Conference.

UNC returned to Atlanta's gaudy SC Tournament spectacle as the No. 1 seed and handily dispatched of Virginia Tech in the first round. Louisiana State (LSU) provided a little more challenge in the second round, but Carolina took control for a 14-point win. Georgia Tech had a feisty and aggressive team, but the experienced White Phantoms held strong. Playing the slow, methodical basketball style of the day to near perfection, Carolina overcame Tech's strong shooting to post a 34-26 victory. Georgia was next in the semifinal, and the Phantoms held control of the ball for most of the game, advancing to the championship with a 40-19 win. Tulane University was the final obstacle, and Carolina again shot the ball well in a 36-28 triumph, earning another SC championship.

Although North Carolina couldn't keep a head coach in the mid-1920s, the school had quickly grown a reputation as one of the top college basketball programs in the South. The tradition continued in 1926 under Harlan Sanborn, who, like his predecessors, would serve only one season as head coach at UNC. Jack Cobb returned for his third varsity season, while the team also returned monogram winners Bill Dodderer and Sam McDonald. Carolina's new home venue, the Tin Can, proved to be quite a formidable place to play, and the 1926 White Phantoms went a perfect 10-0 in the small rectangular steel building. As a result of its design, the Tin Can was very difficult to heat, and it turned into an icebox during the winter. The Carolina players and fans grew accustomed to the conditions inside the Tin Can over the years, while opponents often found themselves shivering their way through a defeat.

"The Tin Can was always freezing," remembered Bo Shepherd, Norman's younger brother, who would become UNC's head coach in 1931. "They had icicles in the corners. To stay warm the electricians put those big-wattage bulbs under the benches, and we had blankets and wore heavy sweat clothes. Later on they did get central heat in there, but it was never adequate. You couldn't dress in there."

UNC opened in Durham and knocked off the Y's 42-35 to open another season with a win. The Durham team came to Chapel Hill three days later, and this time Carolina opened up an even bigger lead. The 41-19 victory started a four-game run of wins, including verdicts over Wofford, Clemson, and Guilford. UNC lost a road game at Wake Forest but returned home to knock off Duke, Elon, and N.C. State, all by double digits. Taking to the road to play Virginia, the Phantoms put everything together in a 47-16 victory. Following a 32-25

win over Catholic, UNC met a couple of teams that had defeated them the year before. Without the friendly atmosphere of the Tin Can to draw on, the Heels were beaten again by Navy and Harvard, and they dropped another game, this one to Maryland, to fall to 10-4. Carolina's three losses had been by a combined five points and served as character builders for the team's stretch run.

The Heels knocked off VMI and Washington and Lee on consecutive days and destroyed Florida back in Chapel Hill. After another home victory, this one over Wake Forest, Carolina made the short trek to Raleigh to take on N.C. State. State decided that they couldn't beat UNC in a straight-up game, so they decided to stall. In the days before continuous action, teams could theoretically retain possession of the ball the entire game if they consistently won the post-score jump ball. State won most of them on this night and held the Tar Heels to an all-time single-game low of eight points. N.C. State didn't do much better, but their 17-8 victory was their first over North Carolina in five years.

The White Phantoms would not lose again after the N.C. State debacle, and they continued their recent domination over Duke with a 44-21 win in Durham. After burying Davidson at home, Carolina entered the SC Tournament for the third straight season as the regular-season champs. Taking on Clemson in the first round, UNC held possession the vast majority of the time and made plenty of shots in setting a season high with 52 points. A 31-point win over Clemson put UNC in the second round against Virginia, and the Cavaliers were determined to upset their archrival. Although UVA played close, the Tar Heels held on for a dramatic 27-25 victory. Mississippi was next for Carolina, and the team advanced to the final with a 38-23 triumph. Mississippi State was the resistance in the final, and once again Carolina played superbly. UNC completed another sweep of the Southern Conference with a 38-23 win, its second in two days by that exact score. Back in Chapel Hill, a large crowd had assembled in Memorial Hall to hear a telegraphic play-by-play of the championship game, and the results made for another festive evening in town.

In the days before widespread radio and television coverage of college basketball, the accomplishments of North Carolina's teams of the mid-1920s went largely unnoticed other than in the towns and cities where they played. Despite their lack of exposure and recognition, the White Phantoms from 1924 to 1926 were three of the most successful basketball teams in school history. Jack Cobb, who left UNC as the Helms Foundation National Player of the Year, had averaged better than 15 points a game during his senior season, a tremendous figure at the time. In three seasons with the varsity, Cobb led the Tar Heels to a 66-10 record, earning All-SC honors each season.

The 1926–1927 White Phantoms featured a lot of new faces, including head coach James Ashmore. UNC had only one player returning who had earned a monogram in 1926, but the squad grew to be a competitive one quickly. Playing a heavy dose of early games against local YMCA teams, UNC prepared itself for another run through the Southern Conference. The Phantoms knocked off Greensboro's Y's in its opener but lost to the group from Salisbury. Charlotte's unit put up little resistance, and Carolina took a 21-point win to improve to 2-1. A doubleheader with Durham's Y's followed, and UNC prevailed in a pair of 20-point victories. The Tar Heels played their next five in the Tin Can and started with a 64-5 domination of Hampton-Sydney. Georgia played the Tar Heels closer a few days later, but UNC continued its winning ways. It wasn't until Carolina played Charlotte's monogram team that the team lost again. That defeat was repeated by Wake Forest, who came to Chapel Hill and surprised the Tar Heels, 30-23.

UNC went on another roll, beating N.C. State, Duke, Virginia Tech, Virginia, and VMI in succession. A pair of games against Maryland in College Park followed, and Carolina split the encounters. Navy was UNC's third opponent in three days, and the Midshipmen continued their dominance, 31-26. N.C. State once again tried their slow approach against UNC in Raleigh, but the White Phantoms controlled most jump balls and earned a 19-13 victory. Carolina returned to Raleigh for a revenge victory over Wake Forest, but the team

dropped a second game to Maryland. Duke was the opposition in the regular-season finale, and UNC finished with a 16-point win. Although the Heels had failed to win another regular-season championship, the team entered the SC Tournament with a 7-3 league record and a 15-6 overall mark. Playing Tennessee in the first round, Carolina advanced with a convincing 32-17 triumph. Auburn was the foe in the next round, and the Phantoms played solid defense in a 28-15 verdict. The Tar Heels were looking to win an unprecedented fourth consecutive SC Tournament, but Georgia's Bulldogs stood in the way. Although Carolina had outplayed Georgia in the Tin Can, the Bulldogs had most of the crowd in Atlanta pulling for them this time around. The Tar Heels were unable to pull out another title, dropping a 23-20 final score.

Ashmore's second season, in 1927–1928, was another successful one, as the Tar Heels went 8-1 in the Southern Conference and a perfect 10-0 in the Tin Can for the third time in five years. With an outstanding demonstration in ball control, the team started its season with a 40-5 whitewashing of the Durham YMCA. The win was followed by a pair of triumphs over Salisbury and Charlotte's club teams. Carolina went on a road trip over the holidays, playing a series of three games against Tulane. The White Phantoms were the better team in the first and third games and dropped the middle match of the series. UNC returned home and remained in North Carolina for the next month. The stretch was kind to the Heels, who started with a second victory over the Charlotte monogram squad.

After a pair of verdicts over Guilford and Georgia, Carolina met Wake Forest in the Raleigh Auditorium, where they claimed a 16-point win. Another pair of home games, against Virginia and a team from High Point, resulted in two more victories. Traveling back to Raleigh to face N.C. State, Carolina won its eighth in a row by dispatching of its rival, 31-21. The winning streak continued with a double-digit win over Duke and a 26-22 win over Virginia in Charlottesville. Now holding a 10-game winning streak, the Phantoms finished their regular season strong. Duke was no match against the UNC offensive and dropped a 32-23 final. N.C. State was the next to fall, ironically by the same 31-21 score as the first game between the teams.

The regular season ended in the Tin Can, with a 29-17 whipping of Wake Forest. The Tar Heels finished tied for third place in the conference standings and drew LSU in the first round of the annual tournament. UNC had a target on its backs, for although they had been dethroned as conference champions the year before, the White Phantoms were still considered one of the elite programs in the Southern Conference, and beating them was considered quite an accomplishment. LSU played the finest game in its history to that time, controlling possession on an equal level as the Tar Heels and scoring 44 points, the most given up by a North Carolina defense in six years. In a stunning upset, UNC took its first defeat ever in the opening round of the SC Tournament, 44-38.

Rufus Hackney returned to the North Carolina fold in 1928–1929 and led the team in scoring for the second year in a row. Although this season's team got off to the worst start in team history, they would once again reach expectations in league play. Starting on the road for a series of games in the Midwest, the Tar Heels struggled to find the basket in a 43-20 loss to Butler. Although they shot a little better against Ohio State, another defensive lapse resulted in a 13-point defeat. Louisville wasn't as powerful as Butler and Ohio State, but Carolina had another sluggish offensive game as they dropped a 27-19 final.

The first 0-3 start in school history didn't faze UNC's spirit, as they went to Kentucky and beat the Wildcats, 26-15. The Heels played again the following day at Tennessee and pulled out a 28-26 victory. After a week off, Carolina evened its record with a win at Davidson. Following a defeat at home to USC, UNC played its third game in as many seasons against Wake Forest in the Raleigh Auditorium. This time the Phantoms were far better and toppled a struggling Deacon team, 42-19. N.C. State traveled to Chapel Hill a few days later, and UNC moved above .500 with a win. Then Carolina went back on the road and defeated Georgia.

UNC continued to schedule difficult games against men's club teams apart from its SC slate and met the powerful Atlanta Athletic Club (AAC) the day after beating Georgia. The AAC was a sound technical basketball team and held the Tar Heels to only 18 points to their own 34. The loss prepared them for a rematch with USC, and UNC improved to 7-5. The White Phantoms then entered the meat of their conference schedule and got a pair of important victories over Virginia and Virginia Tech in the Tin Can. After a poor performance in a 36-20 defeat at Duke, Carolina knocked off Virginia and Maryland on the road in consecutive days. UNC headed even further north to play Princeton and dropped a 20-19 heartbreaker.

The Tar Heels played four of their final five in Chapel Hill and finished on a positive note. The stretch began with a 24-point victory over Wake Forest and an 11-point win in Raleigh over N.C. State. A big game in the Tin Can followed against Duke, and this time the Tar Heels prevailed, 27-24. Davidson provided a break from the highly competitive grind of recent weeks, as the Carolina offense enjoyed a field day in a 45-7 wipeout. VMI was the opposition in the last regular-season encounter, and UNC improved to 16-7 with a 32-19 triumph. With a 12-2 record in SC play, the White Phantoms entered the annual tournament as the No. 2 seed. A favorable matchup with Mississippi State in the first round resulted in a 43-18 victory, which set up a semifinal encounter with Duke. It was the third meeting of the season between the two teams, and the Blue Devils got the best of the Tar Heels in the rubber match. A combination of cold shooting and an inability to retain possession killed Carolina's chances, as they bowed out with a 34-17 loss to finish the season 17-8.

The Tar Heels had 12 different players that went on to earn monograms in 1929–1930, the largest number thus far in school history. The Phantoms lost their opener to the Raleigh YMCA squad but won their next four in a row. On January 10, Carolina played the Greensboro YMCA team for the second time in five days, and in a truly amazing performance, the Tar Heels pounded them, 88-25. The 88 points put up by the Tar Heels easily broke the previous school record and would last for another 15 years. A loss to Davidson the following day took some of the shine from their dominant victory, but the Tar Heels won four out of their next five to start the season with an 8-3 record. The onset of February turned Carolina's fortunes upside down, as the team lost six of its next eight games. Two of the losses came to Duke, while in between, Carolina dropped games at Washington and Lee and Maryland, and at home against N.C. State and Loyola of Chicago. The Tar Heels bounced back with a win over Wake Forest but lost again the following day to Maryland. The team won its final three regular-season games to avoid a losing record, but they finished with a 4-7 record in league play to finish 16th in the SC standings. That meant a difficult matchup with Georgia in the first round of the SC Tournament, and the Phantoms were on the wrong end of a 26-17 score. The loss ended UNC's season with an overall mark of 14-11.

The 1930–1931 unit returned several prominent performers from the previous season's rebuilding team, and in what turned out to be James Ashmore's final year as head coach, the Tar Heels improved by seven spots in the SC standings. The team opened up strong with victories over the Durham YMCA, Raleigh YMCA, Guilford, and Randolph-Macon, all in the Tin Can. Following another heartbreaking road loss to Davidson, the Tar Heels won three in a row with triumphs over Furman, USC, and Wake Forest. Virginia Tech snapped Carolina's seven-game home winning streak by handing UNC a 31-28 setback on January 23, but the Phantoms won again four days later over N.C. State. The Tar Heels played their next seven on the road and dropped consecutive contests to Duke and N.C. State to fall to 8-4. Carolina avenged their loss to Virginia Tech with a 30-24 victory in Blacksburg, and they knocked off VMI and Virginia in consecutive days. UNC continued heading north and ran into back-to-back buzz saws in Washington and Lee and Maryland. Washington and Lee defeated the Tar Heels, 39-31, while the Terrapins prevailed in College Park, 33-31.

Returning home did not help Carolina's cause, as they lost to both Davidson and Duke. Wake Forest provided a welcome reprieve for Ashmore's team, and a 45-25 victory ended

their four-game skid. Home wins over VMI and the University of the South sent Carolina into the SC Tournament with a 14-8 overall record. The White Phantoms played Vanderbilt in the first round and gutted out a 23-20 victory. The next day, UNC met Maryland, and once again the two teams played a neck-and-neck battle. Maryland prevailed in the final minute for a 19-18 victory, which gave the Tar Heels their second loss of the year to the Terrapins by a combined total of three points.

Before the 1931–1932 season, Bo Shepard took over as head coach of the White Phantoms. The brother of former UNC skipper Norman Shepard, the new coach inherited many holdovers from the Ashmore years. The Tar Heels got off to a fast start under their new skipper, winning their first six games by an average margin of more than 16 points. N.C. State brought Carolina back to Earth with a 19-18 triumph in Raleigh, but UNC won three more, including a 37-20 revenge victory over Duke. Maryland again played a spoiler role with a 26-25 verdict on February 8, but Carolina held tough in a 26-24 victory on the road at Virginia. A victory in the Tin Can over Davidson preceded a 24-18 loss to Duke in Durham, which sent Carolina's record to 11-3. Maryland came to Chapel Hill six days later, and the White Phantoms finally knocked off the Terrapins, which had beaten Carolina in five consecutive games dating back to 1930, by a 32-26 score. A victory over Washington and Lee and a loss to N.C. State finished UNC's regular season at 13-4 overall and 6-3 in the Southern Conference, good for fifth place in the standings.

Shepard's Tar Heels headed into Raleigh's Memorial Auditorium for the SC Tournament a confident bunch, having proved themselves during the season to be one of the league's top teams yet again. UNC posted an impressive 35-25 victory over Tennessee in the first round and followed it up the next day with a 43-42 nail-biter over Kentucky and young Adolph Rupp, who was in his second season as head coach of the Wildcats. A semifinal matchup with Auburn provided little resistance, and a 51-31 Carolina victory set up a championship game showdown with Georgia.

The Bulldogs had enjoyed a solid regular season and entered the finals with an 18-7 overall record. The Tar Heels were not intimidated, however, and hung tough throughout. Unfortunately, the Bulldogs scored a late basket and UNC was unable to counter. In the era before shot clocks and fast-paced transition offenses, Georgia held on for a 26-24 victory for that school's first and only SC title. The game proved to be North Carolina's last in the "old" Southern Conference, as the next season brought major changes to the program's future schedules.

Nathaniel "Nat" Cartmell was the first head basketball coach at UNC. A gold and silver medalist as a short-distance sprinter in the 1904 and 1908 Olympics, Cartmell served as the UNC coach from 1911 to 1915, posting a 25-24 overall record. Cartmell was also the track-and-field coach at UNC for several years. (*Yackety Yack.*)

The 1911 UNC basketball team, the first in school history, assembled for this photograph taken by the school yearbook, the *Yackety Yack*. The team was organized by student Marvin "Philly" Ritch (front row center, with ball in hand). The original Tar Heels won six of their seven games in Chapel Hill's Bynum Gym, on their way to a 7-4 overall record. (*Yackety Yack.*)

VARSITY BASKET BALL SQUAD, 1911

Cartwright Carmichael was the first All-American athlete at North Carolina in any sport. A fast and graceful player, Carmichael led the 1924 White Phantoms to the Helms Foundation national championship. A three-time All-SC selection from 1922 to 1924, "Cart," as he was called by his teammates, was named All-American both his junior and senior seasons. (*Yackety Yack*.)

One of the great teams in the history of the old Southern Conference, the 1924 Tar Heels put together a perfect 26-0 record, sweeping four consecutive games in the league tournament in Atlanta. As a result of their speedy transition play and stifling defense, the sportswriters at the event labeled the UNC team as "shadows" and "ghosts," which led to the popular nickname "White Phantoms." Following their victory over Alabama in the finals, the Helms Foundation awarded North Carolina the national championship. (*Yackety Yack*.)

The first three-time All-American basketball player at North Carolina, "Mr. Basketball" Jack Cobb was a member of three consecutive SC regular-season and tournament champions from 1924 to 1926. The UNC captain in both 1925 and 1926, Cobb was a first team All-SC regular season and tournament selection both years. During Cobb's three seasons on the varsity, the Tar Heels posted a record of 66-10. (*Yackety Yack*.)

The Indoor Athletic Center, more affectionately known as the "Tin Can," is shown here in 1924, the year it was constructed. The Tin Can provided a tremendous home court edge for North Carolina over the years, as the Tar Heels compiled a 120-18 record in the facility from 1924 to 1938. In the building renowned for its lack of an efficient heating system, players and spectators shivered through many a cold winter night in Chapel Hill to watch the Tar Heels play there. (*Yackety Yack*.)

TWO

The "New" Southern Conference Years 1932–1933 to 1951–1952

The first two decades of basketball at UNC had been fruitful for the school, with four SC regular-season titles, four SC Tournament titles, and a Helms Foundation national championship. The Tar Heels had become one of the respected college hardwood opponents in the South, and their near miss in 1932 was evidence that Bo Shepherd had the program growing again. Over the years, the Southern Conference had experienced its own growth, so much so that the league had more than 20 members by the winter of 1932. In December of that year, 13 schools located west and south of the Appalachians left to create a new league, which would be named the Southeastern Conference (SEC). For the remaining members of the Southern Conference, it was now possible to schedule two regular-season games against each league member, a tradition that became commonplace in college basketball conferences over the next several decades. With the sudden departure of so many schools that had previously played on their schedule, UNC wound up playing a scaled-down slate of 15 games in 1932–1933.

In an era when the teams assembled for a jump ball after every made basket, it was essential for Shepherd to find a player capable of rebounding and consistently getting his team possession off the tap. Ivan "Jack" Glace, a good athlete of decent size who hadn't even made his high school team in Pennsylvania, turned out to be skilled in both, and he became one of Carolina's key players. The six-foot-four-inch Glace was one of the first prized recruits for Shepherd, whose solid recruiting helped the Tar Heels remain at or near the top of the Southern Conference during his tenure.

"There was no such thing as athletic scholarships or grants-in-aid in my day," recalled Shepherd. "In fact players had to sign a paper swearing that they hadn't received any aid for athletics to the University of North Carolina or any school in the conference. So what you had to do, you had to set your sights on several boys that you wanted to work on, and you had to go out and get jobs for them. There was no cash involved, and that was legitimate aid because it had to go through what was called a Self-Help Committee. So the boys actually worked for what they got."

The Tar Heels got off to another good start in January, winning their first seven. The opener, a 66-9 embarrassment of Guilford in the Tin Can, stands to this day as one of the most lopsided wins in the history of UNC basketball. The Tar Heels finally fell at Duke 36-32 on January 31, as Eddie Cameron led the Blue Devils to a 17-5 record. The loss sent UNC into a two-game tailspin, as they lost at Maryland and Navy by sizable margins. The Heels won over VMI and Washington and Lee, but another loss to Duke, this one in Chapel Hill, dropped their record to 9-4. Shepard's team got a pair of wins to gain some steam heading into the annual postseason tournament, and they played cohesively in the first round against Virginia Tech. A 32-27 triumph set up a match with USC in the semifinals. The Tar Heels and Gamecocks had not met during the regular season, but the schools wound up playing one of the great games in the history of the old SC Tournament. After two overtime periods, USC finally prevailed by a final score of 34-32. The disappointing defeat kept the Tar Heels from meeting Duke in the championship game, while dropping the team's final overall record to 12-5.

The Tar Heels returned to the upper echelon of the Southern Conference in 1934, winning 12 conference games and 18 contests overall, the most for the team since 1926. Senior Dave McCachren was named captain and joined his younger brother Jim to form another solid sibling tandem. The McCachrens, natives of Charlotte, helped create a pipeline of basketball talent that the North Carolina program leaned on throughout the decade.

"The city of Charlotte furnished a kind of nucleus for our teams, because in those particular years they had a very fine basketball program in the YMCAs there," said Shepherd. "And also, Charlotte High School was one of the earliest schools that really went in for basketball hard."

Carolina won 12 of 14 games in January and defeated Duke, whom they hadn't beaten in two seasons. They followed that up with four in-state triumphs over the next two weeks. Wake Forest was again bested, this time 41-24, and the Tar Heels blew out N.C. State 45-24 to improve to 15-2. Davidson was next to fall, and three days later, Shepherd's team went into Durham and knocked off Duke 30-25. The regular season was concluded with a 45-30 loss to USC, although UNC decisively earned the "Big Five" title. With a 12-2 record in league play, the Tar Heels tied for second place in the standings and entered the SC Tournament in Raleigh with high hopes. Virginia, whom the Tar Heels had beaten by only a point a month earlier, provided UNC's challenge in the first round. This time around Carolina took command, and a 27-18 victory set up a rematch with Duke in the semifinals. The Blue Devils, angered by Carolina's sweep during the regular season, came up with a stifling defensive performance. The Tar Heels were held to a season low in points, as Duke ended their season with a 22-18 upset victory.

The defeat at the hands of Duke in the conference tournament did not set well with the returning UNC players in 1935. Carolina fans were getting used to highly productive Januarys from their team, and this edition of the Tar Heels did not disappoint. The team won their first 11 contests, including triumphs over Elon, Wake Forest, and Virginia at home, and Davidson, Washington and Lee, VMI, Virginia Tech, and Maryland on the road. UNC prevailed 30-19 over Navy to avenge their defeat from a year prior, and they closed out their run with victories over the Crescent Athletic Club and the New York Athletic Club. Those two victories wound up paying big dividends for the school, as New York City entrepreneur Ned Irish, who was affiliated with Madison Square Garden, invited North Carolina for a game the following season. The prestige of Madison Square Garden was unmatched by any other indoor athletic arena in the United States at the time, and the appearances would help the UNC program flourish. When the Phantoms took the floor on January 23 to play Army in West Point, the team was playing its fifth road game in six days. The worn-out Tar Heels were no match for the well-conditioned Cadets, and they returned to Chapel Hill on the wrong end of a 29-19 final score.

Shepherd's boys got back to their winning ways with another victory over Virginia Tech and followed it up with impressive verdicts over N.C. State and Wake Forest. The Tar Heels

had a bad night in Durham on February 5 and fell to Duke 33-27 to drop to 14-2 overall, but it would be the team's final loss of the season. The Phantoms finally found a way to knock off USC, claiming a 32-31 victory down in Columbia, and the victory sent the team into a nine-game winning streak to close out the year. Returning home, the Tar Heels defeated Davidson 38-26 and, three days later, knocked off Duke in the Tin Can, 24-20. A difficult game in N.C. State was next, but Carolina played a complete game and left Raleigh on the positive end of a 37-35 score. Finishing up, the Heels overwhelmed USC, 42-17, and VMI, 33-20, to close out a perfect 9-0 slate at home. What was more, North Carolina entered the SC Tournament as regular-season champions for the first time in nine years.

USC was the resistance in the first-round game, and the UNC seniors exacted revenge on the Gamecocks for their stunning victory two years earlier. In their best offensive performance of the season, the Tar Heels exploded for 46 points in a 21-point victory. N.C. State was the semifinal opposition and played Carolina to the wire for the third straight time. Fortunately, the Tar Heels snagged a critical possession down the stretch and held on for a 30-28 win, which moved them into the finals. Washington and Lee was always a tough encounter, but Carolina was not to be denied. Behind solid defense, UNC won the program's fifth SC title with a 35-27 triumph.

Bo Shepherd had become a hero on the UNC campus thanks to his work in resurrecting the school's basketball fortunes, but the coach was battling health problems. Unable to give his undivided attention to basketball, Shepherd stepped down after the 1935 season, opening the door for Walter Skidmore. Skidmore kept the good times rolling in Chapel Hill during his first season, as he kept the Tar Heels winning. Skidmore, like his predecessor, tapped the high school and YMCA ranks of Charlotte for much of his talent. A former high school coach, Skidmore had won 42 of 43 games at the prep level and 22 of 23 games leading the UNC junior-varsity team before his promotion.

The Phantoms opened at home with a narrow 24-23 victory over Clemson and followed with three more victories against Davidson, Wake Forest, and Virginia Tech. Starter Melvin Nelson sprained his ankle before UNC's third road game of the season, played at Washington and Lee, and the Phantoms dropped a 28-25 decision in Lexington. Following a 13-point win in the Tin Can over Virginia, Carolina traveled to New York to play one of the finest college basketball programs in the country in New York University (NYU). Playing without Nelson and Earl Ruth, the White Phantoms were overwhelmed by the hot-shooting home team and dropped a 55-33 final score. The tough loss prepared UNC to enter its conference slate with confidence, and victories at home over N.C. State and USC improved the team's overall record to 7-2. After a victory at VMI, the Phantoms engaged in a thriller with Virginia. Although the teams finished regulation tied, the Cavaliers got the best of UNC in the overtime period and upset the defending conference champs, 33-30. The team regrouped by winning their next four, starting with a 44-32 verdict over Maryland. The next three resulted in sweeps against league rivals, as Carolina bested Virginia Tech, USC, and Wake Forest. Duke gave the Tar Heels its second overtime loss in two weeks, 36-34, but the team rallied to knock off Navy, a team that had been a thorn in the side of UNC for years, 39-25.

The win over Navy catapulted Carolina into its finest stretch of basketball all season, coming at the most opportune of times. The White Phantoms dominated Davidson and followed it up with a two-point victory in Raleigh over N.C. State. Duke was UNC's next road obstacle, but the visitors squeaked out ahead, 30-28. Carolina's final two regular-season games went into overtime, but the Phantoms held on for a one-point victory at Clemson and a four-point victory at VMI to finish the regular season 18-4. Carolina's 13-3 conference record secured the No. 2 seed for the second year in a row, and the team found little trouble advancing past the first round. UNC ended Virginia's season with an 18-point rout, avenging their loss in Charlottesville from back in January. N.C. State was the semifinal opponent, and the two teams played another nip-and-tuck affair. Once

again the Phantoms proved slightly better, winning their third of the year over N.C. State, 31-28. In all, Carolina's three victories over N.C. State in 1936 were by a grand total of seven points.

Washington and Lee met UNC for the second straight year in the championship game. The Generals outplayed the North Carolinians in the first half and went into halftime with a 31-19 advantage. The Phantoms were quite angry at their performance during the intermission and came out a different team in the second half. UNC rallied to tie the score, and with 90 seconds remaining, Andy Bershak, a star on both the hardwood and the gridiron, scored to give UNC a 42-40 lead. The Generals could not score any more thanks to the Tar Heel defense, and a late free throw and field goal gave UNC a 50-45 victory. Carolina's second consecutive SC championship had come under challenging circumstances, with a first-year head coach taking over a team with only four returning players. In a demonstration of grit and sheer execution, the 1936 Tar Heels finished at the top of their game to make their own mark in UNC basketball history. Captain James McCachren repeated as an All-SC guard, while Bershak led the team in scoring.

Skidmore's 1937 Tar Heels opened with the embarrassment of a YMCA team from Leaksville, North Carolina, 59-12. More wins would not follow immediately, however, as Carolina dropped decisions to Wake Forest and Davidson. The Davidson game was the first of seven road encounters for UNC, and although the trip started on a down note, the team won over VMI and Virginia Tech. A second annual game with NYU resulted in a 37-30 defeat, but the Tar Heels rebounded to beat St. Joseph's, N.C. State, and Wake Forest in succession. Returning to Chapel Hill, Carolina continued its winning streak with a 33-15 win over Virginia. Three more games in the Tin Can followed, and UNC continued its home domination over Maryland, N.C. State, and Davidson. Following a 23-point win at Virginia, the Tar Heels outlasted Maryland in College Park. Duke was the next opponent, and UNC improved to 13-3 with a 41-35 triumph. The streak would last for two more games, as the team earned victories over Virginia Tech and VMI. The Heels traveled to play Washington and Lee, and the pressure of winning 12 straight finally got to Skidmore's team. In a dismal offensive performance, Carolina scored only 19 points, its lowest output in two seasons, in a 10-point loss.

UNC ended its regular season with a 37-32 triumph over Duke and returned to the SC Tournament as the league's No. 2 seed for the third year in a row, which ironically drew a rematch with Duke in the first round. Although the Blue Devils again played UNC close, the Tar Heels pulled away this time around for a 34-30 victory. Wake Forest was the opposition in the second round, and Carolina avenged its first loss with a slim two-point victory. UNC was now one victory away from the school's sixth SC championship and second "three-peat" in a span of 14 years. The opponent again was Washington and Lee, the league's top seed and Carolina's toughest rival at the time. The Tar Heels shot the ball better this time around but gave up a season-high in points to the Generals, who finally sidestepped North Carolina and won the league title, 44-33.

College basketball was forever changed prior to the next season by rules that helped modernize the sport. Starting that year, teams no longer assembled in the middle of the floor for a jump ball after made baskets. The new rules called for jump balls only at the start of each half and for teams to take the ball out from the baseline under the opposing team's basket after a made shot. The new rules opened up the sport, allowing it to be played at a more continuous pace without as many interruptions. As a result, the game became more fast paced and higher scoring in the coming decades.

On January 4, 1938, a new era of UNC basketball history was ushered in when the White Phantoms took the floor for the very first time in Woollen Gymnasium. Woollen, a brick and stone structure located in the heart of the UNC campus, was built adjacent to the Tin Can. Although attendance for college basketball games in the late 1930s paled in comparison to modern standards, Woollen's capacity was sufficient to handle Carolina's fan base at the

time. Although UNC played some final games in the Tin Can that season, a 47-20 victory over Atlantic Christian ushered in the new arena in style.

The win was the first of seven straight for the Heels, including a 44-point blowout of Guilford and a pair of close victories over Davidson and Wake Forest. The streak continued on a road trip to Virginia, as the Tar Heels defeated Virginia Tech, VMI, and Washington and Lee. The run came to an end with a 10-point loss at Wake Forest, and the team then lost another pair of games to drop to 7-3. Carolina's next eight were all in Chapel Hill, and the team completed an undefeated season at home with a 39-31 win over N.C. State and six consecutive double-digit verdicts, coming against Maryland, Clemson, NYU, Davidson, Duke, and VMI. Washington and Lee was the victim in the final game ever played in the Tin Can, as the Tar Heels prevailed, 42-39. The venerable old structure was a beloved part of the landscape at the UNC for several more decades, but the building, renowned for its echoes and intense cold during the winter, had been outgrown by the popularity of the team. Nonetheless, the Tin Can had been kind to Carolina over the years. In its 14 years of service as UNC's primary basketball venue, the home team won 120 games against only 18 defeats.

UNC took to the road for its final two regular-season games and split the pair after a victory at N.C. State and a setback at Duke. With a 13-3 regular-season record in SC play, the Tar Heels emerged as the No. 1 seed for the first time since 1935. For the fourth year in a row, Carolina met Washington and Lee in the SC Tournament, only it was in the first round. Washington and Lee again played a terrific offensive game against the Tar Heels and avenged their two regular-season defeats to the favored Phantoms. The Generals took control in the first seven minutes and, behind 18 points from Bob Spessard, went on to a 48-33 upset to end Carolina's season at 16-5.

The 1938–1939 season proved to be a disappointing one by North Carolina's lofty standards, but it was due more to the team's inexperience than a lack of talent. The Tar Heels returned only two players from the previous year's team, as several underclassmen earned a spot on the varsity. One such player, George Glamack, proved to be a mainstay on the roster for the next three seasons. Glamack, a native of Johnstown, Pennsylvania, had suffered a football injury as a younger man that left his left eye completely blind for several months, and it never healed properly. One of the more resourceful players in college basketball history, Glamack learned to use the lines painted on the floor to assess his shots. Blessed with solid ball-handling skills and the ability to shoot well with either hand, Glamack went on to average better than nine points a game as a sophomore, utilizing his deadly hook shot for the majority of his conversions.

"I designed a Braille system all my own, watching the black lines on the floor near the basket," explained Glamack. "I never saw the basket, but I saw the backboard. It was so big and it was so white, I just got to my spot on the floor and shot from there. I took a long time to develop it, but I developed it."

The Tar Heels opened again with Atlantic Christian in Woollen Gym and prevailed by a large margin for the second straight year. Princeton came to Chapel Hill next and handed UNC its first loss, but the team rebounded for a 44-31 win over Catawba College. Going on the road for its next four, the Tar Heels showed immaturity by losing to Davidson and Virginia. Carolina briefly got on track with wins at VMI and Washington and Lee, but went on to lose their next five. Although the Tar Heels defeated Wake Forest on the road, they returned home to get thumped by Maryland, 66-41. Carolina played its next four at home and emerged victorious over Davidson, Duke, and Virginia.

The final game of the stretch, which also happened to be the last game of the year in Woollen, proved to be something of a glimpse into the future. In a sparkling defensive effort, UNC held N.C. State to only 25 points, while the offense took control in a 15-point win over their rivals from Raleigh. Unfortunately, a loss a week later at Duke made the Tar Heels enter the SC Tournament in its worst position in years, relegated to the No. 7 seed

after a 8-7 finish in the standings. Things would only get worse in the first-round matchup with Clemson. North Carolina had never lost to the Tigers in six previous encounters, but on this night, Clemson summoned up all its effort for a stunning upset. Although the Tar Heels had struggled all year, their 44-43 point loss to Clemson stood as one of the most stunning and disappointing losses up to that time in school history.

UNC's record of 10-11 marked the first time in 19 years that North Carolina had failed to produce a winning record in men's basketball. Although Walter Skidmore had produced a successful overall mark of 65-25 during his four years in Chapel Hill, which included two SC regular-season titles and a tournament title, he was unable to live down the team's mediocre performance in 1939. The UNC coach walked away from the program before the following season, making way for Bill Lange, who, at the time, was an assistant on the UNC football team. Lange, who emphasized possession and ball handling, inherited a talented team, one that would quickly get the Tar Heels back in the hunt. Aided by newcomers in 1939–1940, UNC tore through their first 14 games unbeaten. Glamack enjoyed a breakout season, averaging 17.6 points a contest in an era when teams typically averaged between 35 and 50 points a game. As result of being ambidextrous, Glamack was able to pull his hook shot from either side, with remarkable accuracy. Adept at getting position in the paint, Glamack was a nightmare to stop defensively. As a result, he would earn National Player of the Year honors.

In the most thrilling game of the early-season run, the 9-0 Phantoms defeated Wake Forest, as Glamack tossed in three buckets over the final three minutes to preserve a 54-51 victory. Two nights later, Carolina ran over The Citadel, 66-36, tallying its highest point total of the season. VMI was next to fall, as the team played cohesively to win by 29. The next game in Woollen was all Glamack, who lit up N.C. State with 28 points. The 11-point victory over N.C. State preceded a contest at Navy, which gave Carolina a scare before the Tar Heels pulled out a 44-40 win. The Phantoms were finally beaten when they traveled to Wake Forest, where the Deacons held on for a 42-36 triumph. Clemson, the defending Southern champs, were next, and the Tigers were outplayed to the tune of a 39-31 score.

The victory over Clemson figured to be a lift, but the Phantoms followed with their worst game of the year at Virginia. The Cavaliers held Carolina to a measly 25 points, as they ran up and down the floor for a 19-point win. Following a 41-28 win over Davidson, the Tar Heels folded again, giving up a 12-point lead in a 50-44 loss to Duke. Although they had another second-half blowup, the Phantoms held on to beat the semipro McCrary Eagles by eight, and subsequently overwhelmed N.C. State once again, this time by a 60-36 score. Following a 17-point victory over Clemson, the Phantoms got revenge on Duke with a 31-27 triumph. Glamack was again the hero for Carolina, scoring 20 points.

The Tar Heels entered the SC Tournament as the No. 2 seed and met Banks McFadden and Clemson for the second time in three games. The Tigers again struggled to contain Glamack, and sophomore Bobby Rose also came to play as UNC advanced, 50-41. A rubber match with Wake Forest was next, and Glamack thrilled the capacity crowd in the Raleigh Auditorium with a 28-point outing, well over half his team's total. The "Blind Bomber" nearly outscored Wake by himself, but several other Tar Heels had good games as they moved into the finals with a 43-35 win. A third encounter with Duke awaited, and the Tar Heels played superior defensively. Although they scored their lowest point total of the tournament, the Phantoms decisively outplayed the Blue Devils and brought another SC championship to Chapel Hill with a 39-23 victory.

"We lost three games in early and mid-season, and were generally regarded as just another team," Bill Lange said after the season. "But our boys got to clicking at the right time, and played some great ball in the Tournament."

The White Phantoms were looking for big things once again in 1940–1941, as Glamack returned for his senior season. The only member of the previous year's junior class to be named a consensus All-American, Glamack had gained national recognition for his exploits. After

winning their home opener over the Greensboro YMCA, the Phantoms lost a disappointing 33-32 decision to the Hanes Hosiery side. Angered at the defeat, UNC went on a four-game tear, beating Guilford, the McCrary Eagles, and Lehigh, along with a rematch victory over Hanes Hosiery. The Tar Heels traveled up North and dropped a pair of games, each by the same 42-41 score. The first defeat, which came at the hands of Fordham, was in Madison Square Garden, and the Blind Bomber dazzled the spectators with a 21-point performance. The New York City sportswriters were in awe over Glamack, whose shooting touch was unlike anything they had seen before, and the publicity wound up helping UNC at the end of the season.

"I never read the articles about me while I was playing," Glamack said years later. "I just cut them out and put them away. Then one day I started reminiscing, and I went through all the clippings and I said, 'Oh, my God, did I do that?' Frankly, I didn't have one newspaper story that was uncomplimentary. I didn't realize how good I was."

Carolina finished its road trip with wins over Washington and Lee and VMI, and they returned home to outplay Wake Forest, 61-45, but dropped their next contest against NYU, 53-49. The White Phantoms took to the road for their next four outings and started with important conference victories over N.C. State and Maryland. Navy continued to be a thorn in the side of the North Carolinians, taking a 42-34 triumph, but the Tar Heels returned to form with a win over Wake Forest. Carolina was still undefeated in SC play and found its niche over the next three weeks. Playing seven straight in Woollen Gym, the Tar Heels defeated Virginia Tech, Maryland, Davidson, Duke, Clemson, N.C. State, and Washington and Lee. The Tar Heels won all but one of the games by double-digits and knocked off four by more than 20 points. Glamack made headlines all over the country with his 45-point performance against Clemson, which easily surpassed the previous UNC school record for points in a game.

The 18-5 Tar Heels were a victory away from an undefeated regular season in league play, but Duke successfully shut down Glamack and the UNC attack. The White Phantoms had averaged over 50 points a game during their seven-game winning streak, but the Blue Devils held them to only 33. Duke clung to a slim lead over the final minute and prevailed by two points. The regular season ended with a nine-point win over Davidson. With a 14-1 record in conference play, the Phantoms earned the No. 1 seed in the SC Tournament. That meant another matchup with Duke, whose slower approach and focus on Glamack once again proved problematic. The teams played down to the wire again, but the Blue Devils took the lead near the finish and held on for a 38-37 victory.

In past years, the loss to Duke would have signaled the end of the season. However, two years earlier, the NCAA had started a new national tournament, featuring the nation's best teams. Although they were not the recognized SC champions, North Carolina's impressive regular season, combined with the star power of Glamack, merited an at-large berth in the Eastern Regionals, which were held in Madison Square Garden. It would be the first of many appearances for UNC in the NCAA tournament in the coming decades. The White Phantoms met Pittsburgh in the first game and struggled against their approach. Pittsburgh played a slower, more deliberate game than anything UNC had seen during the regular season, and the White Phantoms were held to their season low in points. Glamack was harassed by the Pittsburgh defenders, and Carolina's national championship aspirations ended with a 26-20 defeat.

In his final college game the next night, Glamack made history against Dartmouth. Playing in a consolation game, the Blind Bomber set a new single-game NCAA tournament record with 31 points. Glamack's total would not be bested for another decade, although it was not enough to lead his team to victory. Dartmouth held on for a 60-59 victory, which happened to be UNC's sixth defeat of the season by two points or less. Despite the disappointing showing in the Eastern Regionals, the Tar Heels of 1941 had substantially raised the bar of the UNC program.

Without the Blind Bomber, the next couple of years proved to be a struggle, although the White Phantoms remained competitive. The 1941–1942 team won its opener but was outplayed by the Hanes Hosiery men's club in its next contest. Undaunted, UNC reeled off three wins, all of which were away from Chapel Hill. Traveling to Philadelphia for another road contest, Carolina was upended by St. Joseph's, 33-28. The Tar Heels returned home for their next three and defeated Fordham, Wake Forest, and Clemson by comfortable margins. UNC was sitting at 7-2 but struggled at Columbia, where they lost their first league game of the year to USC, 38-36. The Phantoms were up and down for the next few weeks, for after outplaying N.C. State at home, they were rolled by Wake Forest. Home triumphs over VMI and Davidson were followed by a 52-40 defeat to Duke, which dropped them even further in the SC standings. It got no better five days later, when UNC went to Raleigh and were shocked by State, 32-30.

Carolina won four of their final six but lost at Navy and Duke to finish with a 14-8 record. Their 9-5 conference total gave them the No. 7 seeding and a date with Wake Forest in the first round of the SC Tournament. The Demon Deacons had proven themselves against the Tar Heels six weeks earlier and for the second game in a row played tremendous defense. UNC could only muster 26 points, their second lowest total of the year behind the 20 they had scored in their previous contest against Wake Forest. The Deacons held on down the stretch for a 32-26 victory.

The 1942–1943 White Phantoms were even greener than the previous season, with only one returning player. Although the team started off with double-digit victories over the McCrary Eagles, Charlotte YMCA, and a team from Fort Bragg, it was their most productive streak of the year. Heading north, the Tar Heels lost back-to-back verdicts against Maryland and Virginia. High Point was unable to stay competitive in a 56-27 defeat, and Carolina got some revenge on Wake Forest with a 12-point win in Chapel Hill. However, the team continued its up-and-down nature by losing three of their next four. A pair of close victories over VMI and Wake Forest followed, but Davidson embarrassed the Tar Heels on the road, 57-41.

The Phantoms played in Woollen for their next five and blew out Clemson to start the home stand. Duke came to town and played spoiler, dropping the UNC record to 9-7 with a 51-39 win. Lange's troops earned season splits with N.C. State and Davidson, the latter a 50-27 demolition, but Maryland had UNC's number again, 40-31. Carolina dropped a two-point stunner at Richmond and finished their home slate by overwhelming USC. Duke crushed the Phantoms a week later in Durham, and the 43-24 defeat wound up being the team's final game. As a result of their 8-9 record in SC play, the Tar Heels finished in 11th place, which did not merit an invitation to the tournament. It was the first time since joining the Southern Conference that North Carolina did not participate in the celebrated event, making for plenty of grumpy people in Chapel Hill.

Bill Lange returned for the 1943–1944 season, and Carolina scheduled a heavy dose of military and men's club teams in December. Although the team started the year 4-6, it was good preparation for another demanding run through the Southern Conference. Starting with a 43-37 win at home over Davidson, the White Phantoms won their next nine games, most by healthy margins. The Phantoms dropped two, a game in Greensboro to a basic training unit and a 41-40 heartbreaker at home to Duke, to end their streak, but the team won against Davidson. The Tar Heels and Blue Devils played for the third time a few days later, and Carolina got its second win over its biggest nemesis, 39-30.

The regular season ended with a loss to another military side, this one from Norfolk. As a result of its 9-1 SC mark, the Phantoms earned the regular-season league championship and the top seed in the tournament. It was smooth sailing in double-digit victories over Richmond and Virginia Tech in the first two rounds. In the final, however, the Tar Heels came unglued in their fourth contest of the year against Duke. The Blue Devils, under the leadership of second-year coach Gerry Gerard, entered the game with a losing record of 12-13 but completed a dramatic three-day run by completely stifling the Carolina attack.

Held to only 27 points, their lowest total in two months, UNC was unable to keep it close, and Duke ran away with the title by 17 points.

Bill Lange accepted the athletic director's position at Ohio's Kenyon College prior to the 1944–1945 season, and UNC replaced him with Ben Carnevale, a capable young navy lieutenant who had been a star in his own right as a college player at NYU.

Carnevale arrived in Chapel Hill as part of the navy V-12 program, and he was more than happy to take over in Lange's absence. During the World War II years, when UNC held multiple military training and pre-flight programs, a number of prominent young men took up residence in Woollen Gymnasium, including baseball star Ted Williams and future presidents Gerald Ford and George Bush.

Carnevale took over a team almost completely comprised of newcomers, but two players turned out to be difference makers. Jim Jordan, a six-foot-three-inch forward, arrived at UNC from Mount St. Mary's College, where he had been leading scorer. Jordan's navy orders brought him to the ROTC unit at Chapel Hill, and he immediately became one of Carolina's best players. A tenacious rebounder and dependable floor leader, Jordan quickly became one of Carnevale's favorites. Jordan was joined on the varsity unit by John Dillon, who had spent three years playing in a Savannah, Georgia, city league and also at the Benedictine Military Academy. Dillon was an adequate ball handler and a phenomenal shooter, and by midseason of his freshman year, he would be starting.

The White Phantoms got off to a solid start, winning their first four. Among the triumphs was a 75-18 embarrassment of High Point and a 32-point win over Catawba. UNC lost to USC a day later, but the team went on another tear. The Tar Heels won their next three, coming by an average of more than 25 points. The Gamecocks again played spoiler when the teams met for their second game, and the one-point loss started a tough stretch. Carolina was an off-and-on team that January, splitting their next six games. Carnevale inserted Dillon into the starting lineup after losing to Duke, and the White Phantoms got on track with lopsided verdicts over Wake Forest, Virginia Tech, and N.C. State. Another 50-point win over High Point improved UNC to 14-5. Following an 80-46 victory over William and Mary, the Tar Heels traveled to Norfolk and dropped their second game to the Naval Air Station team, 65-46.

UNC finished strong with wins in their final four regular season games, including a 50-38 revenge victory over Duke in Durham. Carnevale's Phantoms entered the SC Tournament as something of a dark horse, but his team came together for an impressive 27-point win over N.C. State in the first round. USC had beaten the Tar Heels twice during the regular season, but UNC got a win when it counted most, outplaying the Gamecocks 39-26 for a berth in the finals. Duke was the opponent, and behind Dillon and Jordan, Carolina finished its season with a victory, 49-38. Following the season, Jordan was named second-team All-American, along with earning unanimous All-SC honors, the only player in the league to earn such distinction.

Dillon and Jordan returned to Chapel Hill in the fall of 1945 ready to make another run. Bob Paxton and Jim White joined them in the starting lineup, and the team immediately showed great promise. Opening the season against teams from Camp Lee and Camp Pickett, the White Phantoms ran out to big leads and won going away (outperforming the other team decisively at the end of a game). The team traveled to Greensboro to play another men's side, and this time the Tar Heels were beaten, 64-63. UNC wouldn't lose again for nearly a month, as they overwhelmed Catawba, Davidson, and USC in Woollen Gym, all by big margins. Carolina's next game, played in Madison Square Garden against NYU, was Dillon's coming-out party. The sophomore played his finest game yet, scoring 21 points to lead the Tar Heels to a surprising 43-41 victory. The members of the press in the Garden that night were thoroughly impressed with Dillon's accurate hook shot, so much so that several referred to him as "Hook." The catchy nickname stuck. The White Phantoms stayed on the road to defeat St. Joseph's and returned home to win their next three.

UNC was upended in their next clash, an overtime setback to Duke, but it would be their last defeat for quite a while. The Tar Heel lineup gelled in January and February and began a lengthy winning streak with a 44-32 win over Virginia on the road. Carolina played their next four away as well and toppled Virginia Tech, Davidson, High Point, and USC. Returning to Woollen, the Phantoms destroyed N.C. State, 71-34, and blasted High Point yet again, 57-16. The Tar Heels edged Camp Lee, 50-49, and then won back-to-back contests over Wake Forest, the second a 61-32 wipeout in Chapel Hill. Carolina returned home for another blowout and then pulled out a two-point victory over Maryland in College Park.

Before the Navy game, the White Phantoms earned a welcome addition in Horace McKinney. Nicknamed "Bones" as a schoolboy, the six-foot-six-inch big man had played for two years at N.C. State, then went into the service during the war. McKinney had also played at Fort Bragg for two years, but with World War II over by February 1946, he found a home in Chapel Hill. Although he was 27 years old by the time he enrolled at UNC, the eligibility rules of the era were much looser than the present day. McKinney was a colorful character, one who kept his team focused on the court and in stitches while off it. Navy had owned UNC for quite a while, but with Bones in place, the White Phantoms ended the Middies' 10-game winning streak, 51-49.

"I always enjoyed playing with Bones," "Hook" Dillon recalled. "He kept the team loose. He was always very witty, but he didn't clown around when he had to play basketball."

Carolina continued its winning ways with a 55-44 victory over N.C. State in Raleigh and followed with wins over Virginia Tech, Duke, and Catawba. The regular season came to an end, along with UNC's 17-game winning streak, with a 60-46 loss to the Little Creek Amphibious Base side. Nonetheless, the White Phantoms entered postseason play as the team to beat in the Southern Conference. As a result of their 13-1 regular season mark, the Tar Heels met Maryland in the first round and coasted to a 27-point triumph. Wake Forest was the resistance in the semifinal, and although Carolina had beaten the Demon Deacons twice in the regular season by an average margin of 26 points, this time around was different. Wake Forest slowed down the pace, and the cold-shooting Tar Heels suffered a stunning 31-29 setback. Despite the fact that Duke went on to beat Wake in the finals, the NCAA selection committee was unable to neglect UNC's impressive 27-4 regular season record. Thus, for the second time in school history, North Carolina earned an at-large berth to represent the East in the NCAA tournament.

The Tar Heels rematched against NYU in the first round, played in Madison Square Garden. Things did not go so well for Carolina for most of the game, and things got particularly bad when Dillon fouled out with 10 minutes to play. Two minutes later, White fouled out, leaving the Tar Heels in a close game without two starters and their leading scorer. Dillon had overwhelmed NYU by scoring 16 points, but fortunately for UNC, Bones McKinney stepped up and took over where he left off. McKinney scored a gritty 11 points and helped the White Phantoms hold off the Violets for a 57-49 victory.

Ohio State was next two days later in the Garden, and the teams played a nip-and-tuck battle. The Buckeyes had set an NCAA tournament record in their previous game by holding Harvard to 13.9 percent shooting, but the White Phantoms had better luck finding the basket. Behind 15 points from Hook, UNC was able to stay competitive. Nonetheless, Ohio State led by five points with less than three minutes remaining. Carolina continued to fight, cutting the score to within two in the final minute. With less than 20 seconds to play, Bob Paxton hit a critical shot, tying the game and sending it into overtime. Dillon took control for UNC in the extra period, hitting a key shot. The White Phantoms held on, 60-57, to advance to the school's first NCAA championship game.

Defending champion Oklahoma A&M (the predecessor to Oklahoma State) was waiting in the finals, led by six-foot-ten-inch Bob Kurland. Kurland led the nation in scoring during the regular season, amassing point totals virtually unheard of at the college level before his

time. The senior had scored an amazing 58 points in a February game against St. Louis and was the focus of A&M's offense.

"McKinney was at 6-6 a giant on our team," remembered Dillon, "We had never seen anyone taller than that until we saw Kurland. Kurland was seven feet and I'd never seen anyone dunk the ball before. But when Oklahoma A&M was warming up, I heard this crowd roar behind and I turned around and saw him dunk. It was really something."

"We had never seen crowds that large before," he added. "There were more than 18,000 people in Madison Square Garden in the finals. Just to play in Madison Square Garden was a thrill."

McKinney was given the task of containing Kurland, and Carolina's elder statesman did a superb job. Bones rattled the bigger Kurland, taunting him and staying in his face throughout the game. Unfortunately for Carolina, the big center was adept at drawing fouls, and McKinney went out in the second half with the score 36-33 in favor of Oklahoma A&M. Kurland took control after Bones' departure, finishing the game with 23 points to lead A&M to another national title, 43-40. Dillon, who had been impressive throughout the postseason, scored 16 points in the bitter defeat. Most observers agreed that the White Phantoms would have prevailed if not for McKinney's disqualification, and Bones's personal frustration at his controversial fourth foul lasted for years. Nonetheless, it was the first time in school history that North Carolina won 30 games in a basketball season, and it added another chapter in the program's ever-growing legacy.

With Dillon returning for another season along with Paxton and White, the Phantoms figured to have another strong team in 1946–1947. They would have to do it without Ben Carnevale, however, who left before the season to accept the head coaching position at the Naval Academy. Carnevale was replaced by straightforward Kansan Tom Scott, a longtime high school coach who had led a small college in Missouri to four conference championships over a five-year span. The team proved to be one of the scrappiest to ever play in Woollen Gymnasium, a hard-nosed collection of players that struggled for every victory it earned. The White Phantoms beat a pair of men's teams to start the season and then knocked off Catawba and High Point. Midwestern basketball was prominent at the time, and Carolina had a tough run in the Chicago area with losses to Northwestern and DePaul. The Tar Heels opened league play with a victory over Maryland but went back on the road and lost to LaSalle, 65-62. The Hook returned to Madison Square Garden, the scene of several of his greatest moments, for Carolina's next game, and the junior led UNC to a 50-48 victory over NYU. Returning home, the Tar Heels won another one over Virginia, 63-38.

Carolina struggled in late January and early February, dropping four of their next six. After a 60-47 defeat to NYU in Chapel Hill, the White Phantoms pulled it together. Behind the standout play of Dillon, who went on to earn his second consecutive All-American selection, the Phantoms finished out the regular season with eight straight victories. Carolina headed to the SC Tournament in Durham expecting to prevail, and they cruised into the championship game on the strength of double-digit victories over Richmond and USC. The final opponent was N.C. State, who had beaten the Tar Heels by a basket in overtime earlier in the year. Everett Case was quietly building a powerhouse in Raleigh, and in the first big victory of his coaching career, N.C. State went on to a stunning 50-48 victory.

The 1947–1948 White Phantoms started off on a roll, rallying behind the play of the Hook to win their first 12 games. The majority of the games were blowouts, as the Tar Heels assumed early control and ran to victory. The team caught a snag up North, however, dropping games to NYU and Temple. After another three-game streak, the Phantoms were simply pummeled by N.C. State, 81-42. Carolina shook off the loss to defeat Duke, Maryland, and William and Mary in succession, but more setbacks followed. Wake Forest defeated Carolina, 53-47, and N.C. State got another blowout over their biggest rival, 69-45. The regular season concluded with a 52-45 win over Davidson and a 56-45 setback at Duke. An 11-4 league mark gave UNC the No. 3 seed in the SC Tournament, and the

White Phantoms advanced with a 61-40 first-round win over Virginia Tech. The semifinal game with N.C. State proved closer than the two regular season contests, but the Red and White once again proved superior. In the final game of Hook Dillon's collegiate career, N.C. State held on for a 55-50 triumph.

Carolina returned only three letter winners in 1948–1949, and few were expecting a whole lot from the White Phantoms. Surprisingly the Tar Heels started fast, winning their first seven games. An early highlight was accepting an invitation to appear in Hammond, Louisiana's Camellia Bowl, where they defeated a favored University of Arizona team, 60-49. A dramatic fall was waiting, however, when the White Phantoms played NYU and took home a 24-point beating. UNC won four of its next five games to improve to 11-2, but they lost three of five from there, including a 67-36 embarrassment at the hands of N.C. State. UNC returned to form, knocking off a weak Duke team, 64-34, but after a win over Maryland, Carolina took another loss, this one to George Washington. The White Phantoms finished 13-5 in conference play, but the gap between themselves and the defending league champions from Raleigh was evident when N.C. State came over to Chapel Hill and pounded the Tar Heels by 40 points, 79-39. Scott and his team were hoping to get another crack at N.C. State in the SC Tournament, and they got it after a 79-61 win over Wake Forest in the first round. Scott tried to slow the tempo against Case's team, and the ploy helped keep UNC in the game. State pulled away late, however, and claimed a 43-40 victory on their way to a third consecutive league title.

With no real talent coming off the freshman team to help out the varsity in 1949–1950, Scott was forced to stick with his two returning starters and bench players from the previous season's squad. As a result of a limited recruiting budget and Scott's own unwillingness to scour the land for talented young players, the Tar Heels weren't bringing in the same caliber of players. Around this same time, the nickname "White Phantoms," which had been used with pride by North Carolina fans for more than 20 years, lost its appeal. The moniker slowly fazed out, and in future years the UNC team would become almost exclusively known as the "Tar Heels" by its supporters.

The team got two early wins but lost their next three contests, including a surprising defeat at the hands of Lenoir-Rhyne. Following the Christmas holiday, UNC took part for the first time in an event that would capture the hearts of college basketball fans throughout the state of North Carolina. Over in Raleigh, *News and Observer* sports editor Dick Herbert had conceived the idea of a three-day event, featuring the four nearby SC schools (Duke, North Carolina, N.C. State, and Wake Forest) and other schools around the country. Herbert relayed his idea to the coaching staff at N.C. State, and that winter the first annual Dixie Classic was held in Reynolds Coliseum. The Dixie Classic would become a widely known and highly anticipated sporting event over the next decade, while intensifying the rivalries between the quartet of local schools, which became known as the "Big Four," to a new level.

Carolina's first game in the Classic was against West Virginia, and the Mountaineers outplayed the Heels for a 58-50 win. The team regrouped for a match the following day against Duke and continued their winning ways against the Blue Devils, 59-52, in the upset of the Classic. Carolina showed it wasn't out of gas against Rhode Island, but an inadequate game on defense was the large reason they lost for the fifth time in six games, 65-60. In their first game of the New Year, the Tar Heels knocked off Maryland but dropped a game three days later to the experienced team from Hanes Hosiery. After beating Davidson in their following game, Carolina made a trip to Lexington, Kentucky, where an outstanding basketball team lay waiting. Adolph Rupp's Wildcats, the two-time defending national champions, had a seven-footer in Bill Spivey and were far ahead of any other program in college basketball at the time. Kentucky embarrassed Carolina, 86-44. Undaunted, the Tar Heels promptly went on a four-game winning streak.

Another setback, this one to No. 12 N.C. State in Woollen, dropped Carolina to 9-8, but the team went on yet another four-game tear. They were suddenly contenders again in

the SC race, but losses to George Washington and Wake Forest ended hope of a top-league finish. Although Carolina won four of their final five, a 70-44 setback to N.C. State was their ninth loss in a row to Everett Case's team. With the No. 5 seed in the SC Tournament, the Tar Heels drew William and Mary in the first round. William and Mary had played Carolina tough a few weeks earlier and came together to outplay the favored Tar Heels, 50-43. It was of little consequence, as N.C. State ran through the tournament for their fourth SC title in a row.

Scott had an assortment of bodies to work with in 1950–1951, and he wound up running several players into the lineup for significant minutes. The team won their first five, four of which were on the road, but went on a losing streak that lasted from late December to mid-January. Starting in Pikeville, Kentucky, where Carolina was beaten by Eastern Kentucky and Xavier, the team lost its next eight. The Dixie Classic was a disaster, as Scott's team was outplayed three straight days. The Tar Heels finally got back in the win column with wins over Wake Forest and Davidson but went on to lose four more in a row. The discontent in Chapel Hill was growing, but the team regrouped to knock off Wake Forest, Duke, Furman, and George Washington. Carolina had a chance to get back to .500 when they played USC, but the Gamecocks pulled out a one-point victory in Columbia. The loss put a serious dent in Carolina's chances of competing in the SC Tournament, and although they won against The Citadel, losses in the final two regular-season games to N.C. State and Duke ended UNC's season at 12-15. It was the first time in eight years that Carolina did not participate in the SC Tournament, as their 8-11 record and 11th-place finish did not merit an invitation.

UNC wasn't much better in 1951–1952, although they played decent at the start. Opening with seven games on the road, the Tar Heels won four. Carolina made a better showing at the Dixie Classic this time around but dropped another game to N.C. State, 58-51. Scott's troops knocked off Maryland and Clemson in a pair of close home games, but they dropped a two-point decision to Wake Forest. After splitting two of four in late January, the team hit rock bottom, dropping 9 of their last 11. Playing hard but not efficiently, Carolina was swept in three straight games at home to N.C. State, Wake Forest, and Duke. The Tar Heels beat The Citadel and Furman but ran out of gas in late February to drop their last five, including a 94-64 annihilation at Duke. The season ended with another 12-15 record, meaning back-to-back shutouts from the SC Tournament. Tom Scott's second consecutive losing season had plenty of people frustrated at the direction of the UNC program, and the struggling coach elected to take a change of scenery. Scott left that summer to take a job coaching the famed Phillips 66 Amateur Athletic Union (AAU) team in Oklahoma. Scott's departure meant big changes to come for the UNC basketball program, much bigger than anyone could have realized at the time.

Bo Shepard
Coach

Pictured here is George "Bo" Shepherd, head coach of the Tar Heels from 1931 to 1935. Shepherd led a revival of North Carolina's basketball fortunes during the Great Depression era, posting an overall record of 67-16 in four seasons. UNC reached the finals of the SC Tournament in 1932 and won the event in 1935, Shepherd's final year as head coach. (*Yackety Yack.*)

Glace

Ivan "Jack" Glace was an early standout at North Carolina, where he played on a SC Tournament championship team in 1935. At six foot four inches, Glace was one of the tallest players in college basketball at the time and helped Carolina maintain possession for long stretches in the days when teams assembled for a jump ball at center court after every made basket. (*Yackety Yack.*)

STATE AND CONFERENCE CHAMPIONS
Back: Coach Skidmore, Petrea, Webster, Bershak, Ruth, Kaveny, Nelson, *Manager* Willis.
Front: Mullis, Grubb, *Captain* McCachren, Wright, Franks, Bloom.

The 1936 Tar Heels, under the leadership of first-year head coach Walter Skidmore, finished with a 21-4 overall record. Carolina finished second in the SC regular-season standings with a 13-3 record and swept Virginia, N.C. State, and Washington and Lee for the school's second consecutive SC Tournament title and the sixth in school history. (*Yackety Yack*.)

BERSHAK
Forward

Andy Bershak was the first two-sport standout at UNC. A consensus All-American on the football field, Bershak was a varsity basketball player at UNC from 1936 to 1938, playing on a SC Tournament champion team in 1936 and a regular-season champion team in 1938. A fifth-round selection of the Detroit Lions in the 1938 National Football League draft, Bershak enjoyed a long career in professional football. (*Yackety Yack*.)

39

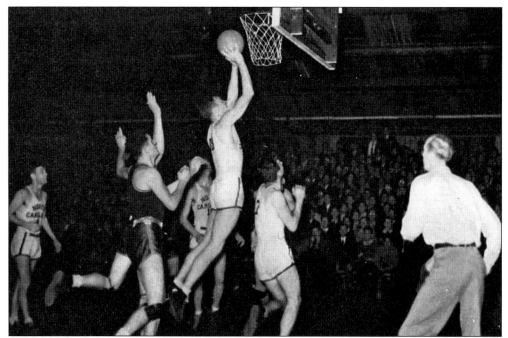

Ben Dilworth scores a basket for North Carolina in one of the final college basketball games ever played inside the Tin Can, a 57-39 victory over NYU on February 5, 1938. The team had already played its first game in Woollen Gymnasium, and they bid farewell to the Tin Can for good the following season. The 1938 Tar Heels went on to win the SC regular-season championship with a 13-3 record. (*Yackety Yack.*)

Shown here is Chapel Hill's Woollen Gymnasium shortly after its completion in 1937. Named after university business manager Charles T. Woollen, the building began hosting North Carolina's home basketball games in 1938, and it housed the SC regular-season champions in its first season. Over the next three decades, Woollen housed nine more conference championship teams, including an NCAA championship team in 1957, as the UNC athletic program made the transition from the Southern Conference to the Atlantic Coast Conference (ACC). (*Yackety Yack.*)

Walter Skidmore coached the varsity basketball team at North Carolina for four seasons in the late 1930s, posting an overall record of 65-25. Relying heavily on the school's pipeline of players from the Charlotte area, Skidmore's teams won an SC Tournament championship in 1936 and a regular-season title in 1938. Skidmore ascended to the head coaching position following a highly successful career as a high school coach and as the leader of the UNC junior varsity squad. (*Yackety Yack.*)

Here, new UNC head coach Bill Lange speaks to his team just prior to the start of the 1939–1940 season. Lange inherited a young and talented squad from the departed Walter Skidmore and guided the White Phantoms to a 23-3 overall record, which included a three-game sweep of the SC Tournament in Raleigh. A year later, in 1941, Lange guided North Carolina to its first-ever berth in the NCAA tournament. (*Yackety Yack.*)

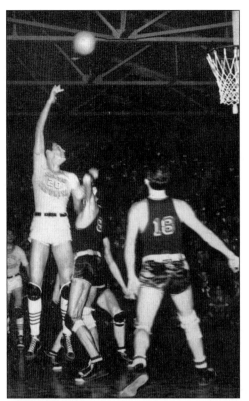

George Glamack is shown shooting one of his patented hook shots during a game in Woollen Gymnasium. Glamack suffered a football injury as a youth that severely limited his eyesight, but that didn't stop him from becoming one of the greatest college basketball players of his time. Nicknamed the "Blind Bomber," Glamack was named National Player of the Year in 1940 and 1941. Glamack averaged 20.6 points a game in 1941, leading Carolina to the school's first NCAA tournament appearance. (*Yackety Yack.*)

Here, North Carolina's 1946 starting five huddles for a group photo. From left to right are John Dillon, Jim Jordan, Horace "Bones" McKinney, Bob Paxton, and Jim White. McKinney joined the team in mid-season, and joined the others in leading the Tar Heels to the 1946 Final Four, where they lost to powerhouse Oklahoma A&M in the championship game, 43–40. Led by head coach Ben Carnevale, UNC set a new school record with 30 victories. (*Yackety Yack.*)

Coach Ben Carnevale is shown here posing for a photograph. A former star player at NYU in the 1930s, Carnevale arrived in Chapel Hill in 1944 as part of the navy's V-12 program. Taking over the 1944–1945 team in place of the departing Bill Lange, Carnevale led the White Phantoms to a 22-6 record and the SC Tournament title. A year later, Carolina posted a 30-5 record and played in the school's first Final Four, where they fell a game short of winning the NCAA championship. (*Yackety Yack.*)

COACH BEN CARNEVALE

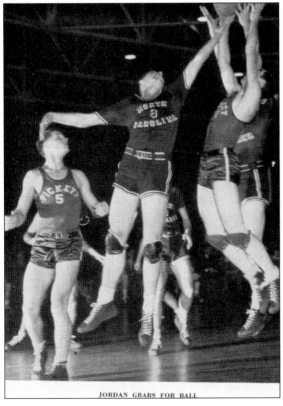

JORDAN GRABS FOR BALL

Here, Jim Jordan battles for a loose ball during a 1945 game in Woollen Gymnasium. A solid all-around player, Jordan came to UNC during World War II, when the navy transferred him to Chapel Hill. A star on Ben Carnevale's teams of the mid-1940s, Jordan was a unanimous selection to the 1945 All-SC team and earned second-team All-American honors in 1946, as he helped the Tar Heels reach the NCAA championship game. (*Yackety Yack.*)

43

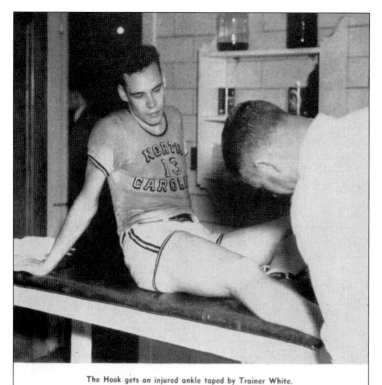

John Dillon is seen here getting his ankle taped before a 1947 game in Chapel Hill. Dillon earned the nickname "Hook" after an impressive showing at Madison Square Garden early in the 1946 season, where New York's sportswriters were dazzled by his accurate hook shot. Dillon returned to the Garden for the 1946 NCAA tournament and tallied double figures in three consecutive outings as Carolina reached the title game. Dillon went on to earn All-American honors following both the 1946 and 1947 seasons. (*Yackety Yack*.)

The Hook gets an injured ankle taped by Trainer White.

Coach Tom Scott

Tom Scott succeeded Ben Carnevale as head basketball coach at North Carolina in 1946, and he coached the Tar Heels for six seasons. Although Scott posted a 100–65 overall record at UNC from 1947 to 1952, none of his teams were able to win an SC regular-season or Tournament championship. Following back-to-back losing seasons in 1951 and 1952, Scott left UNC to coach the Phillip 66 Oilers AAU team in Oklahoma. (*Yackety Yack*.)

THREE

The "Underground Railroad" 1952–1953 to 1960–1961

In the summer of 1952, UNC was hot on the trail of a new coach, a New Yorker by the name of Frank McGuire. McGuire had just taken St. John's to the NCAA championship game and was considered a hot commodity in the collegiate coaching ranks. McGuire was familiar with Carolina, having spent time on the UNC campus during World War II while attending a navy pre-flight class. Several influential individuals, including former UNC head coach Ben Carnevale, made recommendations on behalf of McGuire, and soon after, athletic director Chuck Erickson had one of Frank's navy friends, Joe Murnick, give him a call in order to gauge his interest. Although McGuire was considering going to the University of Alabama at the time, he loved Chapel Hill and accepted the North Carolina job in August.

McGuire's first season started fast, as the Tar Heels won four home games. The Dixie Classic was less kind, as UNC was beaten in two of three contests. After that, the Heels got hot, winning six straight in January. After splitting games with Maryland and Wake Forest, Carolina took on N.C. State. The Wolfpack had won their last 15 contests over North Carolina dating back to 1947, but in a victory that would stake McGuire's claim as a contender to the N.C. State dynasty, the Tar Heels went over to Raleigh and stunned the home team, 70-69. Following two more wins, UNC was sitting at 15-3. People were starting to take notice, but the team hit a snag down the stretch, losing six of their final eight contests, including five in league play. The difficult final weeks relegated UNC to the eighth position in the SC Tournament, which forced another matchup with N.C. State. The Wolfpack had rebounded from their defeat in January to the Tar Heels with an 87-66 win in late February, and this time around they were running on all cylinders. McGuire's team never knew what hit it, bowing out, 86-54.

The spring of 1953 brought about permanent changes to UNC's athletic program. In May of that year, UNC, along with six other longstanding members of the Southern Conference, decided to break away and form a new league, the Atlantic Coast Conference (ACC). The

45

decision to form the ACC was primarily geared towards football, but it was no secret that each of the league's members also fielded solid basketball programs. Wake Forest, Duke, and N.C. State joined North Carolina in creating the best quartet of college basketball schools in any state in the country. The "Big Four" would compete on an annual basis at least twice and often three or even four times during the season. As exposure of ACC basketball spread thanks to increased radio broadcasts and television coverage later in the decade, the popularity of the sport would increase dramatically in the state of North Carolina during the 1950s.

McGuire's second UNC team of 1953–1954 started with three wins against weaker teams. A couple of weeks later, however, the Tar Heels struggled mightily in the Dixie Classic, dropping three in a row. UNC's performance in Raleigh was largely forgotten when the team began the new year strong, winning four straight. Everett Case brought his Wolfpack across town three days later, however, and State continued their winning ways over UNC with an 84-77 win. McGuire got his team focused to beat Washington and Lee, but from there the team went on another three-game losing streak. The Tar Heels stayed above .500 with a win at Clemson, and after beating Davidson, the Heels met Duke, who gritted out a 67-63 victory. Carolina took to the road for their final two games, and the troubles in Reynolds Coliseum continued when N.C. State claimed a 57-48 win. After a final triumph, the Tar Heels entered the postseason with an 11-9 record. With the new ACC tournament being held in Raleigh, Carolina had a tough draw in the first round with N.C. State, who was playing on their home floor. Skippy Winstead led all scorers with 25 for Carolina, but it was not enough, as State claimed a 53-51 win. The win propelled the Wolfpack to claim the first ACC tournament title.

Everett Case had built a basketball powerhouse at N.C. State, winning six consecutive SC titles and an ACC title, largely with players from his native Indiana. Case had a monopoly on Midwestern talent in the ACC, and combined with the popularity of the Dixie Classic, the N.C. State coach had his pick of the litter as it related to recruits. However, Frank McGuire was far from intimidated by the N.C. State machine, and he used his own background in order to compete. With the help of his close circle of friends in and around New York City, McGuire identified and warmed up to the area's finest prep players, just as he had done at St. John's. In the days before NCAA regulations prohibited using personal contacts to recruit players, McGuire's close friend Harry Gotkin scouted the city and personally made acquaintance with top players. Gotkin tirelessly worked the city's prep circles and was in frequent touch with McGuire to let him know about the local talent. Gotkin also warmed up to the players and their families, earning the nickname "Uncle Harry" along the way.

"New York is my personal territory," McGuire once said. "Duke can scout in Philadelphia, and N.C. State can have the whole country. But if anybody wants to move into New York, they need a passport from me."

In 1954, McGuire committed Brooklyn natives Joe Quigg and Pete Brennan, and Bergenfeld, New Jersey, guard Tommy Kearns, to Carolina. The trio became valuable members of UNC's freshman team in 1955, filling the void left by Lennie Rosenbluth, who was ready for the varsity. Rosenbluth, a Bronx native with a smooth shooting touch, had been lured to North Carolina by the affable McGuire, who was skilled in making young Northerners feel comfortable playing basketball in the South. McGuire and Rosenbluth had gotten to know each other when McGuire was still at St. John's, and after a year in military school in Staunton, Virginia, Rosenbluth enrolled at UNC in the fall of 1953.

"I always loved the way McGuire treated the ballplayers at St. John's," Rosenbluth recalled years later. "He treated them like men. We knew he was leaving St. John's, so McGuire basically told me he was going to either Alabama or North Carolina. I was committed to go with Frank McGuire. Luckily, he chose North Carolina."

Rosenbluth was McGuire's first star at UNC, and with a team limited in talent in 1954–1955, he became the team's go-to guy as a sophomore. A 2-0 start was promising, but the team was perhaps a little overconfident when it played at William and Mary, where they

were shocked by their former SC rivals, 79-76. It got no better a week later, when the Heels were beaten by Maryland. Keeping his team's poise, McGuire got the squad ready for the Dixie Classic, where the Tar Heels earned back some of the respect they had lost in 1953. Playing the first day against Southern California, Carolina pulled off a 67-58 upset over the No. 13 Trojans. A winner's bracket game against N.C. State pitted the Tar Heels against another powerful Wolfpack team, and although McGuire elected to slow the tempo, N.C. State opened a slight lead down the stretch and held on for a 47-44 win. McGuire's young team outplayed Duke the following evening for a 13-point win and a third-place finish in the Classic.

Carolina went on the road early in January to play at LSU and Alabama, and the Tar Heels came up short in both contests. Playing solid all-around ball, UNC returned home for victories over Wake Forest and Virginia, and they took to the road for season sweeps over USC and Clemson. Holding an 8-5 record, the Tar Heels headed back to Raleigh for another engagement with N.C. State. The league's best two teams, State held the No. 2 national ranking, while UNC was 6-1 in the ACC standings. In a reversal of their first game three weeks prior, the teams played at a fast-paced level. The Tar Heels matched the Wolfpack through an emotional thriller and gutted out an 84-80 victory. The win over N.C. State briefly had Carolina sitting at the top of the ACC standings.

The Blue Devils showed McGuire how far his team still had to go when they came to Chapel Hill and embarrassed Carolina, 91-68. The hangover of the Duke game carried over to a game a week later against Virginia, when the Tar Heels had another defensive meltdown against the Cavaliers. After giving up 98 points to UVA in a 25-point defeat, the Tar Heels dropped a draining game to Maryland, 63-61. Wake Forest and Carolina were fighting for position in the ACC, and UNC's 83-79 victory helped them stay among the first division teams. A home game against State was another chance to move up, but N.C. State got revenge on the Tar Heels, along with ensuring their place at the top of the conference, with a 79-75 win. Duke was the obstacle in the regular season finale, and the Blue Devils had their way once again, as UNC slipped to 10-10 and 8-6 in the ACC.

A fifth-place finish in the standings set up what appeared to be a favorable matchup against Wake Forest in the first round of the 1955 ACC tournament. Although the Tar Heels had beaten the Demon Deacons twice during the regular season, Wake dazzled the crowd in Reynolds Coliseum with their best offensive game of the year. Carolina gave up more than 90 points for the second straight contest, as Dick Hemric tallied 33 points. Hemric teamed with Lefty Davis, who also had a big game with 32 points, to lead the Deacon offensive. In all, Wake Forest had four players in double figures, and although the Tar Heels got 29 from Rosenbluth, Carolina again went one and out with a 95-82 defeat. The disappointing loss made UNC's season a losing one at 10-11.

Kearns, Quigg, and Brennan joined Rosenbluth on the varsity in 1955–1956, and the team started fast. Another lopsided home opener over Clemson was followed by a 12-point win over Georgia Tech in Charlotte. USC was the next victim, as UNC ran to 3-0 with a 92-75 verdict. Playing again at Woollen, this time against highly regarded Alabama, the Tar Heels raced out to a 99-77 victory. UNC made it five in a row with a six-point win at Maryland. McGuire's team entered the Dixie Classic ranked in the top five, and after beating Villanova in the first round, the Tar Heels put it all together in a thrilling 10-point win over Duke. N.C. State was determined not to lose to their archrivals, however, and the Wolfpack ran over Carolina, 82-60, to end the winning streak.

Carolina remained in the top five after the N.C. State setback and the start of the new year, but after a blowout at home over LSU, the Tar Heels were upended by Wake Forest on the road. The Tar Heels got hot again in mid-January, winning five straight games in a span of nine days, all against conference foes. The fifth victory came over the hated Wolfpack, who were turned away by four points in Woollen Gym to spark a festive night of celebration on Franklin Street. The Tar Heels couldn't get past Duke, but the team won four of its

last five heading into the ACC tournament, the only loss being to the Wolfpack, a rugged 79-73 decision. Carolina earned a 73-65 win in the rematch with Duke to salvage a tie with N.C. State at the top of the conference standings, although the Wolfpack again enjoyed the advantage of playing the ACC tournament on their home floor. Reynolds Coliseum was the largest indoor sporting venue in North Carolina at the time and was better equipped to reap financial benefits for the fledgling new conference. In the early years of the league, when popularity in college basketball was growing, it made sense for the ACC to hold its premier event in a large arena. That didn't stop McGuire from complaining about placing so much emphasis on a single-elimination tournament and awarding the ACC's only NCAA Tournament bid based entirely on its results.

The Tar Heels met Virginia in the first round, and although they made only a third of their total shots, the Cavaliers got 28 points from senior sharpshooter Bob McCarty. The Tar Heels persevered behind 35 points from Rosenbluth, who led the way to an 81-77 victory and North Carolina's first-ever victory in the ACC tournament. UNC advanced to meet Wake Forest in the semifinal. Behind young talents Jack Williams and Jack Murdock, the Deacons ended Carolina's season for the second year in a row. Williams led Wake with 27 points, while Murdock added 17. Carolina shot a dismal 25.3 percent from the field, a big reason for their 37-24 halftime deficit and ultimate 77-56 defeat.

The Tar Heels returned the nucleus of their team the following autumn, and there was optimistic hope in Chapel Hill that the team could be outstanding. However, conflicts arose in fall practice, as McGuire asked players like Pete Brennan and Joe Quigg to sacrifice their own stats in order to feed the ball to Rosenbluth, a more capable scorer. There was fear that there would be divisions and cliques in the starting lineup, considering that Tommy Kearns and Joe Cunningham had been high school rivals, and that Pete Brennan and Joe Quigg were longtime friends from their schoolboy days in Brooklyn. Fortunately, Rosenbluth was able to arrange a team meeting to air out any issues, and the group came out of the session with everything settled. The 1956–1957 Tar Heels were ready to make a run at immortality.

Rosenbluth started his senior season on a historic note, setting new school records for field goals (20) and points (47) in a 94-66 shellacking of Furman. Carolina jumped out to a quick 7-0 lead over Clemson and never looked back in their second contest, as Brennan's 28 points and Rosenbluth's 26 points paced a 19-point victory. After a slow start at George Washington, the Tar Heels poured it on late in the first half and in the second half on the way to an 82-55 verdict. At 3-0, the Tar Heels headed to Columbia for a game against USC. Although UNC led for most of the contest, the Gamecocks fought down to the wire. With seven seconds left, USC's Ray Pericola stole a pass and scored on the other end to force overtime, with the teams knotted up at 76. Kearns and Tony Radovich made clutch plays in the extra session, each converting three-point plays in the final minute. The Tar Heels held on for a 90-86 triumph, which proved to be the first of many nail-biters to come.

Maryland tried to slow it down in Woollen, but the Tar Heels forced tempo and pulled away for a 90-71 win. From there, Carolina took to the road for a three-day Northern swing. Playing first in Madison Square Garden, UNC withstood a fierce effort from NYU. The Violets knew to contain Rosenbluth, and the senior had his worst game of the year, with only one field goal and nine points. Bob Cunningham picked up the slack with 16 points, and with Quigg adding 14 points and Brennan 12, the Tar Heels pulled out a 64-59 victory. Dartmouth was the next challenger in the Boston Garden, and the Green came out fierce in building an 8-2 lead. The Tar Heels found their mark and gained control later in the half, building a seven-point lead at the intermission. UNC poured it on in the second half, outrunning Dartmouth for an 89-61 win. Again Carolina had a slow start the next night, as Holy Cross assumed the early advantage. Holy Cross led by 13 points at one point in the first half, but Carolina fought back to trail by only two at halftime. UNC's offensive guns came out in the second period, rallying with 10 consecutive points to take control. A 13-point win sent the Tar Heels into the Dixie Classic with the No. 3 ranking.

Utah was expected to give Carolina a game, but behind Rosenbluth's 36 points and Kearns's 21, it was never close. The Heels raced out to a 10-point halftime advantage and went on to win by 21. The following night's game against Duke was another solid outing, as UNC held a working margin of 10–12 points throughout. With three players scoring 20 points, the Tar Heels cruised to a 16-point win. The Dixie championship against Wake Forest was next, and the Deacons struggled with only 30 percent shooting. The Tar Heels ultimately pulled away for a 63-55 victory. After seven years of futility in the Dixie Classic, North Carolina had finally won what was widely considered the most prestigious non-postseason basketball tournament in the country. The media and sportswriters took notice, and the legend of Frank McGuire's "Yankee Rebels" began to grow.

Although the Tar Heels trailed William and Mary at halftime in their next game, Brennan's 20 points led the way to a 10-point victory. UNC returned to Woollen and spanked Clemson by 32, with Rosenbluth enjoying another big game with 34 points. Another home game the next day against Virginia turned into another wipeout, as the Tar Heels jumped out to an astounding 20-0 lead. N.C. State was on probation and suffering through a difficult season, but Carolina took no mercy on them either time they played. With four Wolfpack players bowing out to fouls in the second half, UNC pulled away for an 83-57 win. The Tar Heels moved to No. 1 after beating the Wolfpack and played their next game at Western Carolina, who dedicated their new arena on the occasion. The Tar Heels were too big and deep, however, and took home an 18-point victory. The Western Carolina game proved to be the last for Tony Radovich, whose eligibility ran out, but the team held together for a major challenge from Maryland in College Park. The Terrapins played methodically and appeared to be in control, leading by four in the final minute. In the closing seconds, McGuire used some reverse psychology on his team during a time-out, telling his players to congratulate Maryland after the game for a job well done in beating them. Cunningham and Kearns had other ideas, nailing a pair of shots to tie the score. Maryland couldn't counter, and the game went into overtime. The teams fought through the first extra session undecided, and the contest headed into a second overtime session. Rosenbluth fouled out with one minute and 30 seconds to play in the second overtime, but UNC prevailed for a huge 65-61 win, one that took the team's confidence to a whole new level.

"Rosenbluth told me after that game, that he did not intend to get beaten," Frank McGuire recalled years later. "That victory gave them a tremendous lift."

The Tar Heels returned home to play Duke, and the rivals played back and forth. Duke led at halftime, but Carolina regrouped to build an eight-point lead in the second half. The Blue Devils rallied to tie it up in the final minute, but a pair of free throws by Kearns in the closing seconds held up for a two-point win. With the pressure mounting, UNC struggled in the first half at Virginia, shooting poorly and making uncharacteristic mistakes. The Cavaliers led by four at halftime after holding Kearns scoreless, but the junior came through in the second half with 15 points. Rosenbluth added 23, and the Tar Heels sank 30 free throws. The 68-59 victory preceded a second engagement with Wake Forest, and this time around it was closer. The lead changed hands several times, but Rosenbluth hit 10 of 15 shots from the floor to help Carolina squeak out a 72-69 final.

The Tar Heels never had a problem with N.C. State, winning by an 86-57 margin. An overflowing crowd poured into Woollen Gym for Senior Night, as Frank McGuire was presented with a brand new Cadillac at halftime. His team came out fired up, as Cunningham held the nation's leading scorer, USC's Grady Wallace, to only 11 points. Brennan's 26 points and Rosenbluth's 23 were enough to take a 75-62 win. Joe Quigg was out with a virus for the Wake Forest game in Winston-Salem, and his team missed him. The teams again played back and forth throughout, with Carolina holding a one-point halftime lead. The Deacons took control and led by four with three minutes left, but their leading scorer, Jack Williams, fouled out soon after. The Tar Heels took advantage and hit some big shots of their own, going on to a five-point victory.

A perfect regular season was at stake at Duke, and UNC came out strong. After building a 13-point lead at the half, the Tar Heels fell victim to a spirited rally. The Devils came all the way back, taking the lead with less than five minutes left. Unfortunately for the home team, fouls became a serious issue, as five players were disqualified. The Duke substitutes could not keep up the pace, and the Tar Heels, behind Rosenbluth's 40 points, improved to 24-0 with an 86-72 victory. Sitting firmly in the No. 1 position, the Tar Heels moved into the ACC tournament knowing that everything would be for naught if they couldn't win their next three games. Despite their impressive regular season, they would not be invited to the NCAA tournament unless they prevailed in the ACC tournament. The first-round matchup with Clemson was no problem, as Rosenbluth established new tournament records with 45 points and 19 field goals. The 81-61 verdict over Clemson set up Carolina's fourth game with Wake Forest in 11 weeks.

UNC struggled from the field against the Deacons, shooting only 39 percent from the field, but they held the upper hand at halftime, 33-29. Behind 24 points from Jack Williams, however, Wake Forest held close and took a one-point lead with less than a minute to play. Everything was on the line for the Tar Heels, but Rosenbluth rose to the occasion. The National Player of the Year took possession and launched a hook shot from just in front of the foul circle. He was fouled in the act, and the ball banked in to give Carolina the lead. Wake Forest head coach and former UNC star Bones McKinney vehemently protested that Rosenbluth charged but to no avail. Rosenbluth hit his foul shot, and Wake was unable to tie. The 61-59 victory set up a championship matchup with USC, and McGuire's troops had one of their greatest outings. Doing no wrong in the first half, Carolina put an end to the competitive phase of the game by breaking out to a 50-23 lead at halftime. Rosenbluth's 38 points outdid Grady Wallace's 28, and a 95-75 victory sent North Carolina into the NCAA tournament for the first time in 11 years.

Yale was the opponent in the first round at Madison Square Garden, and they came out primed to pull an upset. Yale led for most of the first half, but UNC rallied to tie the game at halftime. The teams traded baskets for much of the second half, but Carolina took control with about eight minutes left. Cunningham hit several big shots down the stretch, and Rosenbluth again led the way with 29, as the Tar Heels advanced, 90-74. Moving into the next round at Philadelphia's Palestra, Carolina's rebounding was the key against Canisius. The bigger Tar Heels controlled the glass, breaking out to a 14-point halftime lead and holding on for an 87-75 victory. Syracuse tried to run with UNC the next day in the regional final, but Carolina was ready. Leading by nine points at halftime, the Tar Heels put the Orangemen away in the final six minutes. Kearns and Rosenbluth earned All-Regional honors, as Carolina moved into the Final Four with a 67-58 triumph.

Kansas City greeted the Tar Heels with open arms for the Final Four, but their opponent in the National semifinal, Michigan State, was not so accommodating. The Spartans, led by "Jumping" Johnny Green, played the powerful North Carolinians point for point through a grueling 40 minutes, as the teams were tied 29-29 at halftime and at the end of regulation, 58-58. The teams tied 6-6 in the first extra session and moved into double overtime. Michigan State took the lead by two down the stretch and were poised to take victory when Pete Brennan made a clutch play. Grabbing a rebound after a missed free throw by Green, Brennan ran the length of the floor and sank a jump shot from the perimeter with four seconds to go. As the Tar Heel bench and the legions of fans listening on the radio back in North Carolina went crazy, the final seconds ran off the clock and the game went into triple overtime, where UNC finally prevailed. A pair of steals by Rosenbluth led to lay-ups, and a pair of free throws by Kearns iced a 74-70 win.

It was fitting that Carolina advanced to play Kansas in the championship game, as the teams had been No. 1 and No. 2 virtually all season. It was imperative that the Tar Heels not be intimidated by the presence of Wilt Chamberlain, who enjoyed a psychological advantage over almost everyone he faced. In an effort to turn the mental tables on the Jayhawk superstar,

McGuire had the five-foot-ten-inch Kearns jump against Chamberlain to start the game. The ploy worked early on, as "Wilt the Stilt" was held scoreless over the first five minutes. The Tar Heels, on the other hand, came out hot, making every shot they attempted over the first 10 minutes. Shooting better than 64 percent from the field in the first half, Carolina built a 29-22 halftime lead. Kansas came right at the Tar Heels in the second half, getting the ball inside to Chamberlain. The result was foul trouble, as Quigg picked up his fourth foul and Rosenbluth and Kearns picked up their third infractions midway through the final half. Kansas worked down the UNC advantage and took a 40-37 lead with 10 minutes to play. With the game close, the Jayhawks went into a stall, which worked right into the hands of the exhausted Tar Heels. The teams played neck and neck down the wire, and although Rosenbluth fouled out with one minute and 45 seconds to play, the teams fought out the final minute deadlocked. For the first time in the history of the NCAA tournament, the championship game was heading into overtime.

McGuire knew that his team was at a disadvantage without Rosenbluth, and he elected to slow down the pace, waiting for the right opportunity to attack. Both teams scored a single basket in the first overtime session, and neither team scored in the second. Kearns had an opportunity to win the game late in the second overtime, but Chamberlain blocked his shot. For the second straight day, Carolina was playing in a triple-overtime game. UNC went to the basket more in the third session, as Kearns drove inside for a field goal and connected on two free throws to give UNC a 52-48 advantage. Kansas refused to yield, as Chamberlain made a field goal and a free throw, and Gene Elstun made a pair of free throws to give KU a 53-52 lead. With the clock winding down, the ball went to Quigg. The junior big man was fouled in the act of shooting, and he went to the line with six seconds to play. Demonstrating cool resolve, Quigg nailed both shots to give Carolina a 54-53 lead. Seconds later, Quigg made another big play, deflecting a pass intended for Chamberlain. The ball bounded out to Kearns, who took a couple of dribbles and jubilantly chunked it into the rafters of Kansas City's Municipal Auditorium.

Against all odds, the Tar Heels had won the NCAA championship, completing an amazing 32-0 season. Playing in front of a decisively pro-Kansas crowd, Carolina had done something that nobody thought they could do at the beginning of the season except for themselves. Carolina fans back home, many of whom had just watched their first televised basketball game, broke out in spirited celebration, and the next day, more than 10,000 people assembled at the Raleigh-Durham Airport to await the team's arrival home. As the Tar Heels exited the plane, they were carried to the terminal by their thrilled supporters. Gov. Luther Hodges, a member of North Carolina's 1917 team, had prepared a speech, but he was unable to deliver it amidst the roar of the masses. It was a great time to be a Tar Heel, particularly for Frank McGuire, whose talented and poised team had won over the collective hearts and imaginations of an entire state.

The magic of "McGuire's Miracle" carried over into the 1957–1958 campaign on the part of Tar Heel fans, although McGuire wisely knew that there was only one direction to go after reaching No. 1. The Tar Heels were without Lennie Rosenbluth, but Kearns and Brennan returned to the varsity. Carolina was bitten with the injury bug before the new season, as sophomore York Larese was lost for the year with a broken leg during the summer. Then, on the first day of preseason practice, Joe Quigg, whose clutch free throws had clinched the NCAA title, also was lost for the season with a fractured leg. The injuries were difficult for the Tar Heels to overcome. Carolina won its first five contests, only to be tripped up by West Virginia, 75-64, to end the team's remarkable 37-game winning streak. The Tar Heels then went on to sweep the Dixie Classic for the second year in a row. UNC played extremely well during the three-game run, knocking off ranked teams in St. Louis and N.C. State while outplaying Duke on the second day by 14 points. UNC continued to win in early January, beating Wake Forest, William and Mary, and Virginia at home to move to No. 3. Playing at Maryland was always a difficult prospect, however, and the

Terrapins handed Carolina its first conference defeat in two years. N.C. State got revenge for its loss in the Dixie Classic with a one-point win in Chapel Hill, but the Tar Heels had two of their most productive games under McGuire next, scoring 90 points in a win over Clemson and 115 in a triumph over USC.

UNC won only four of their final seven regular-season games, although they went back to Reynolds Coliseum and beat N.C. State for a second time. A 59-46 loss to Duke in the regular-season finale put Carolina in a tie for second place with State in the ACC standings at 10-4. The Tar Heels drew Clemson again in the first round of the ACC tournament, and Ray Stanley's 16 points led the way to a 62-51 Carolina victory. Next came N.C. State, and the two teams played another close one. Carolina led 24-20 at halftime and closely guarded its slim lead in the second half. Brennan tallied 23 points to lead McGuire's charges, as they held off N.C. State for a 64-58 victory, their third of the year over State. The Tar Heels defended their ACC title against Maryland, against whom they had split a pair of games during the regular season. The Terrapins were coming off an overtime victory over Duke and did not play particularly well in the first half. Things were looking good for Carolina as they took a 34-27 halftime lead, but Maryland came out of the locker room for the second half like a different team, scoring 59 points over the final 20 minutes. Junior Bill Murphy, who hadn't even scored in the Duke game, came from out of nowhere to score 19 points, while Charles McNeil led the Terrapins with 21. Carolina was unable to keep up with Maryland's pace, and dropped an 86-74 final to end UNC's reign as national champions. The rules of the day meant that Carolina wouldn't get a chance to defend their title in the NCAA tournament, despite a 19-7 overall record.

By all accounts, 1958–1959 was expected to be a rebuilding season in Chapel Hill. Although York Larese returned, the team was laden with sophomores, and all of the significant contributors from the 1957 NCAA championship team were departed. However, Larese, a schoolboy legend at St. Anne's in New York City, teamed with Doug Moe, a rugged forward from Brooklyn, to create another group of stars in McGuire's "Underground Railroad." Although Moe wasn't the best student at academic subjects, he was a sponge when it came to taking in basketball knowledge. Moe made an immediate mark as a sophomore, averaging 12 points and 7 rebounds a game to earn second-team All-American honors. Larese was a fine compliment to Moe on the perimeter, averaging 15 points a game. Joined by Lee Shaffer, a six-foot-seven-inch forward from Pittsburgh, the young Carolina team would exceed expectations. A newcomer to the North Carolina bench that season was assistant coach Dean Smith, who arrived from the Air Force Academy. Smith and McGuire had met during the 1957 Final Four, where they shared a suite along with two other coaches, Air Force's Bob Spear and Navy's Ben Carnevale. The young Air Force assistant made an impression on the UNC skipper for his basketball knowledge and his honesty. Shortly after his team had won the NCAA title, McGuire asked Smith to say a few words to the Tar Heels. Although he congratulated the team on their victory, Smith admitted that he had rooted for his alma mater, Kansas, in the championship game.

The Tar Heels started fast and furious, blowing out Clemson, Virginia, and USC. Louisville's Blue Grass Festival caught a UNC team raging out of the gates, and Notre Dame and sixth-ranked Northwestern were each taken down handily. Carolina entered the Dixie Classic ranked No. 3, and McGuire's young studs blasted Yale in the opener. Michigan State hadn't forgotten about the national championship that UNC had taken from them two years earlier, and this time the Spartans took control. UNC scored more than 20 below their average and lost by 17 points. That set up a match with Cincinnati, and their superstar Oscar Robertson, in the third day of competition. Shaffer jumped against Robertson and scored 26 points to lead the Tar Heel attack. Although Robertson scored 29 to lead all scorers, UNC went on to win by a basket, 90-88.

Carolina hit its stride in January and February, embarking on a 10-game winning streak that briefly had Tar Heels fans thinking about another NCAA title. After double-digit

wins over Notre Dame and Wake Forest, UNC defeated No. 1 N.C. State on its home floor, 72-68. The Tar Heels moved to No. 2 in the polls and knocked off Clemson, USC, Maryland, Duke, Wake Forest, and Loyola Chicago in succession. The Wake Forest game was memorable for a different reason: an ugly late-game fight in which hundreds of fans poured onto the court. York Larese had to literally fight his way off the floor during the melee, which lasted for several minutes. It was a scary situation, one that prompted the following year's Wake-UNC game to be moved to Greensboro. Carolina ascended to No. 1 after the Loyola game, and with Lee Shaffer scoring 23 points and Larese 22 points, the Tar Heels won the rematch with N.C. State in Chapel Hill, 74-67. Although losses on the road to Maryland and Virginia ended the winning streak, Harvey Salz's 21 points led UNC to a 10-point win over Duke to end the regular season.

UNC met Clemson for a third consecutive first-round ACC tournament encounter, and it turned on the jets for a 93-69 victory. Shaffer tallied 21 points against Clemson to lead all scorers, and he would do the same thing the following day against Duke, with 23 points. The Tar Heels took full advantage of Duke's down season by posting their third triumph of the year over the Blue Devils, 74-71. The championship game matchup against State had materialized, and Tar Heel fans looked forward to the possibility of a third straight victory over the despised Wolfpack. It was not to be, however, as Everett Case's team enjoyed one of its greatest days. N.C. State suffocated Shaffer on defense, allowing him only 11 points, while Moe and Larese were each held to 8 points. Lou Pacillo, who went on to earn most valuable player (MVP) honors for the Wolfpack, scored 23 points in State's 90-56 victory. Although the Tar Heels were beaten in the finals of the ACC tournament, their ability to reach the championship game meant big things. With N.C. State on probation for various infractions earlier in the decade, UNC was awarded the ACC's bid to the 1959 NCAA tournament. The Heels met Navy, coached by former UNC head coach Ben Carnevale, in the Eastern Regionals at Madison Square Garden. Despite the fact that he was in familiar surroundings, McGuire was unable to inspire his team to another magical tournament run such as the one in 1957. Navy's Jay Metzler dominated the Tar Heels with 20 points and 12 rebounds, and the Midshipmen advanced with a 76-63 win.

Carolina entered the 1959–1960 season at a disadvantage, as Doug Moe was declared academically ineligible for the first semester and starter Dick Kepley was lost for the early part of the year with an ankle injury. Although they won their first three by double-digits, UNC's lack of depth was exposed in Lexington, where the Tar Heels were swept by Kentucky and St. Louis. The Dixie Classic started off well, with solid victories over Minnesota and Duke, but Wake Forest had something for Carolina in the final. In a slow-paced game, the Demon Deacons held on for a 53-50 victory. With Moe returning to the Tar Heel fold in January, Carolina reeled off six consecutive victories, five in league play, to enter the rankings and assume the lead in the ACC standings.

Although Carolina had handled Wake Forest, 62-59, in Greensboro for its second win of the streak, the Deacons came to Chapel Hill on February 11 and abruptly ended it, handing Carolina an 80-69 setback. Unfazed, the team rallied to beat Duke, N.C. State, and Clemson in succession. Unfortunately, they ran into a roadblock against USC, dropping an 85-81 decision to exit the polls for the rest of the regular season. With three games to play, the Tar Heels finished strong, burying Maryland, Virginia, and Duke, all by more than 25 points. Lee Shaffer's 18.2 points and 11.2 rebounds per game was good enough to earn the ACC's Player of the Year Award, and Carolina went back into the rankings just in time for the league tournament. UNC's 75-50 blowout over Duke in the regular-season finale had assured a first-place tie in the league standings and a matchup with Virginia in the first round. Shaffer and Larese were twin killers, making 22 shots from the field between them and combining for 57 points in an 84-63 victory.

The win set up a fourth game with Duke, a team that Carolina had beaten three times by an average of nearly 25 points during the regular season. The 1960 ACC tournament

featured a new kid on the block in Vic Bubas, who had left Everett Case's bench at N.C. State to become the head coach at Duke. Carroll Youngkin had 30 points, and he helped the Blue Devils jump out to a 12-point lead at halftime. Carolina rallied behind Shaffer and Larese, as the pair each scored more than 20 points for the second day in a row. The game was up for grabs in the final minutes, but Duke made a late basket and held on for a stunning 71-69 win. The defeat was like a punch in the gut, for despite three easy wins in the regular season over Duke and an overall record of 18-6, Carolina's season was over.

As it turned out, the loss to Duke in the ACC tournament would be the least of Frank McGuire's worries. Over the next year, the popular UNC coach would be placed in the middle of an embarrassing set of circumstances, some out of his control and some certainly in his control. McGuire had taken less than a decade to turn around the fortunes of North Carolina basketball, and thanks in large part to loyal friends in New York like Harry Gotkin, he had lured some of the city's finest players to Chapel Hill. McGuire's "Rebel Yankees" had become a powerhouse in the most competitive collegiate basketball conference in America, and as a result, hoops had surpassed football as the most revered sport at UNC. McGuire, who was known as a "first-class or not at all" personality, spared no expense when it came to recruiting, and in the days before there were rules prohibiting it, he took prospective players out for expensive meals, always footing the bill. Although it was legal to entertain recruits and take them to dinner at the time, McGuire's freewheeling nature had caught the eye of the NCAA. The governing body began investigating the UNC program, citing excessive recruiting expenditures.

Although McGuire tried to stay out of it, the investigation weighed heavily on him as the 1960–1961 season neared. In the fall of 1960, McGuire appeared before the NCAA infractions committee, where he made his indifference to the situation perfectly clear. Although the NCAA found Carolina guilty of "excessive recruiting" and several other major infractions, the university chose to appeal the decision. Trying to keep his focus on the season at hand, McGuire asked assistant Dean Smith to assist with the NCAA appeal, and the young coach did an outstanding job working through old expense and financial statements to help prepare UNC's case, making an impression on the school's leadership along the way.

Chancellor William Aycock presented UNC's case in front of the NCAA council, which was held in a court-like setting in San Francisco in January 1961. Smith was on hand as Aycock gave a truly superior defense on behalf of UNC. The chancellor proved that no Tar Heel players had ever been given cash payments of any kind by the school, and by using financial statements, demonstrated that Coach McGuire's dinners were not extravagant when taking into account the large numbers of people that typically took part. In an unprecedented move, North Carolina's case was sent back to the infractions committee for further review, and as a result, the majority of the charges were dropped. In the end, however, the board cited the school for excessive recruiting and banned the Tar Heels from the upcoming ACC and NCAA tournaments, in addition to placing the school on probation for the 1961–1962 season.

The suspension was a bitter pill for the Tar Heel players to swallow, who were enjoying their best season since the 1957 NCAA championship team. Led by York Larese and Doug Moe, the Tar Heels were sitting in the top five when the sanctions were laid down. Larese, nicknamed "The Cobra" for his rapid-fire style of shooting free throws, made 87 percent of his shots from the charity stripe and scored 23 points a game, while Moe joined him on the All-American team with averages of 20.4 points and 14 rebounds an outing. Although they lost consecutive games in December to Kentucky and Kansas State, Carolina swept the Dixie Classic, beating Maryland, Villanova, and Duke.

UNC continued its roll in January, winning seven more games to bring their winning streak to 12. The NCAA sanctions were laid down during the stretch, which included victories over Wake Forest, Virginia, Maryland, N.C. State, Clemson, and Maryland. Carolina's frustration boiled over at Duke, as guard Larry Brown got into it with Blue Devil

star Art Heyman in the final seconds of an 81-77 defeat. Within seconds, another on-court brawl broke out, this time including some Duke football players. Brown and guard Donnie Walsh were suspended for the remainder of the season by the ACC, and the Tar Heels had a lackluster performance in a loss to USC. The team regrouped from there, finishing the season with five straight wins, including a revenge victory at home over the Blue Devils. Despite an ACC regular-season championship, an overall record of 19-4, and a final top-10 ranking, Carolina's season had come to an end.

Jersey City native Lou Brown had been recruited by Frank McGuire as part of his "Underground Railroad," and he led the Carolina junior varsity team in scoring in 1957–1958, but by the time he reached the varsity, he was relegated to a benchwarmer's role. In December 1959, Brown had made acquaintance with a man named Aaron Wagman, who was affiliated with the infamous Jack Molinas. Molinas had built a network of collegiate players that either shaved points or readily gave gamblers inside information, and by March 1961, when 37 players from 22 different schools (including four from N.C. State) were arrested for their involvement, it was evident that college basketball had a serious problem on its hands. Wagman attempted to get Brown involved, offering the financially strapped young man money in an effort to get some Tar Heel players to shave points, along with players on other collegiate teams outside the ACC.

Brown started working on his roommate Doug Moe, who returned to the UNC lineup in January 1960 after serving his academic probation. Moe refused to shave points, and when Brown asked another player, he was emphatically turned down again. Brown did arrange a meeting with Wagman in which Moe attended, and although he never shaved points, the senior accepted a $75 "gift" from the gambler. The issue could have easily died, but unbeknownst to Brown, he was being watched, both around Chapel Hill and when he was in New York, by the FBI. In March 1961, when he was implicated in the federal bust, Brown withdrew from UNC in shame. Later that year, the president of the UNC system, William Friday, made a controversial decision in regards to the Dixie Classic. Citing the potential for the event to possibly taint or even destroy college basketball in North Carolina, Friday and the UNC system elected to cancel the 1961 Dixie Classic and to subsequently do away with the event altogether.

Although the North Carolina basketball program had barely avoided a full-blown point-shaving scandal, the heat on Frank McGuire continued to intensify. In the summer of 1961, Chancellor Aycock sent McGuire a letter, stating in no uncertain terms that the program needed to clean up its act. Soon after, McGuire was offered the chance to coach the NBA's Philadelphia Warriors and their superstar Wilt Chamberlain. The position offered a substantial raise, but McGuire was legitimately torn about leaving UNC. McGuire had recently moved into a new home in Chapel Hill and had become a favored son after leading the Tar Heels to the top of the college basketball world. Coach McGuire wanted Dean Smith to come with him to the NBA and continue being his assistant, but Smith told him that he always had considered himself a college coach. One afternoon that August, Smith drove McGuire to the South Building, where Chancellor Aycock's office was located, and McGuire only needed a couple of minutes to make his resignation. Upon returning to the car, McGuire said that he and Aycock agreed that Smith should become the new coach. The next day, Dean Smith accepted the head coaching position at North Carolina, forever changing the course of history.

Frank McGuire coached at North Carolina from 1952 to 1961 and led the Tar Heels to a perfect 32-0 record in winning the 1957 NCAA championship. McGuire's teams at UNC featured a number of stars from his native New York City, including Lennie Rosenbluth, Pete Brennan, York Larese, and Doug Moe. McGuire left Carolina in the summer of 1961 to coach the NBA's Philadelphia Warriors, but he would be back in the ACC at USC within four years. (*Yackety Yack.*)

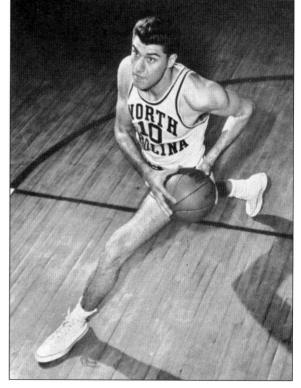

In this photograph, Lennie Rosenbluth drives to the basket. One of the greatest players to ever play college basketball, Rosenbluth was the catalyst of North Carolina's 1957 undefeated national champions. The National Player of the Year that season, Rosenbluth still holds UNC school records for career (26.9) and single-season (28.0) scoring average. Rosenbluth, whose number 10 is retired at North Carolina, is one of three players in ACC history to be named ACC Player of the Year, MVP of the league tournament, MVP of the NCAA Regional, and National Player of the Year, all in the same season. (*Yackety Yack.*)

Here, Tommy Kearns lays in two points against Wake Forest in the championship game of the 1956 Dixie Classic at Reynolds Coliseum. A second-team All-American, Kearns was a key member of the undefeated NCAA champions of 1956–1957, averaging 12.8 points and making a number of clutch plays in the late minutes of games. Kearns forced overtime with a late jumper against Maryland and hit the game-winning shot in the second overtime of that same contest. His two free throws with 11 seconds remaining made the difference in a 75-73 win over Duke. (*Yackety Yack.*)

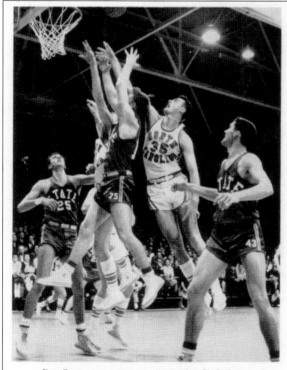

Pete Brennan taps in two points against N. C. State.

Pete Brennan is shown here tapping in two points. A first-team All-American in 1958, Brennan averaged 21.3 points and 11.7 rebounds a game that season. Brennan was a starter on the 1957 national championship team, and he made a critical play in the Final Four against Michigan State, grabbing a rebound and running the length of the floor to nail a game-tying jumper with four seconds remaining to send the game into double overtime. Carolina went on to beat the Spartans in triple overtime, setting up an NCAA championship game matchup with Kansas. (*Yackety Yack.*)

57

The 1956–1957 Tar Heels won over the hearts of college basketball fans in the state of North Carolina. The first undefeated team at UNC in 33 years, Carolina won a pair of triple-overtime games in the Final Four to win the school's first NCAA championship. The team went on to set an ACC record of 37 consecutive victories over a two-year period, a mark that stands to the present day. (*Yackety Yack.*)

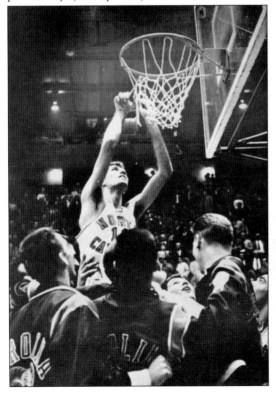

Here, Lennie Rosenbluth cuts down the net following North Carolina's 63-55 victory over Wake Forest in the championship of the 1956 Dixie Classic. The Dixie Classic, a three-day holiday tournament featuring four North Carolina schools and four other top programs around the country, was held annually in Raleigh's Reynolds Coliseum from 1949 to 1960 and was one of the most popular sporting events in the country. UNC participated every year the Classic was held and won the event in 1956, 1957, and 1960. (*Yackety Yack.*)

Lee Shaffer is shown here battling for a loose ball in a game against Notre Dame on January 2, 1960. Shaffer hauled down 20 rebounds in Carolina's 75–65 victory. The 1960 ACC Player of the Year and a first-team All-American, Shaffer averaged 18.2 points a game in 1960, leading the Tar Heels to the ACC regular-season championship. Shaffer was twice named to the All-ACC tournament and All-Dixie Classic teams during his UNC career. (*Yackety Yack.*)

Here is UNC assistant coach Dean Smith in 1960. Smith, who arrived at North Carolina in 1958, was an energetic and organized young man who assisted in the preparation of UNC's case before the NCAA infractions committee for "excessive recruiting" in 1960. When Frank McGuire resigned in the summer of 1961, both McGuire and UNC chancellor William Aycock agreed that Smith should become the new head coach at North Carolina. (*Yackety Yack.*)

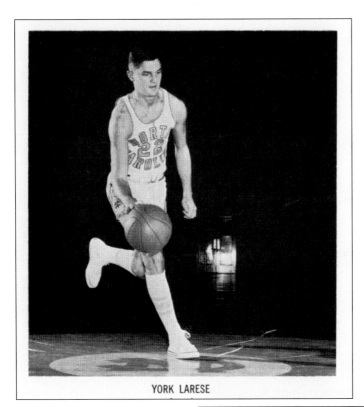

YORK LARESE

York Larese is seen here dribbling upcourt. Another in a long line of New York City players to play at North Carolina under Frank McGuire, Larese was a three-time All-ACC performer from 1959 to 1961 and a second-team All-American in 1961. One of the best pure shooters in school history, Larese made all 21 of his free-throw attempts in a 75-53 victory over Duke on December 29, 1959, setting an ACC single-game record that still stands today. (*Yackety Yack.*)

Doug Moe was a first-team All-American in 1961, averaging 20.4 points and 14.0 rebounds a game for Frank McGuire's last team at North Carolina. The Tar Heels won the ACC regular season that year with a 12-2 mark, but they did not compete in the ACC or NCAA tournaments because of probation. Moe went on to a successful coaching career in both the American Basketball Association and NBA, earning coach of the year honors with the Denver Nuggets in 1987–1988. The Nugget franchise honored Moe with a banner in 2002. (*Yackety Yack.*)

DOUG MOE

FOUR

Dean Smith Finds His Way
1961–1962 to 1980–1981

When Dean Smith took the head-coaching job at North Carolina in the summer of 1961, there were a number of obstacles in his path. The Tar Heels would play only 16 regular season games, a punishment self-imposed by the UNC administration. In addition, Smith would only be able to recruit two players from outside the states that comprised the ACC under the NCAA probation, a particularly stiff penalty considering North Carolina's reliance on New York–bred players under Frank McGuire. The departure of McGuire ended the run of the most successful coach in school history, who felt that he was never properly rewarded for winning the 1957 NCAA title.

"Frank McGuire's persona was overwhelming," recalls Woody Durham of the Tar Heel Sports Network. "The mood around the UNC campus during the summer of 1961 was that the University of North Carolina was de-emphasizing basketball. People were saying, 'Who is Dean Smith?' "

Smith's first game was on December 2, 1961, in Woollen Gym against Virginia. The rookie coach recalled going to great pains before the game to plan everything out, only to forget the game ball. Fortunately, a manager found a good practice ball near the end of the bench, and the game tipped off on schedule. The Tar Heels came out sluggish but eventually poured it on for an 80-46 victory over the Cavaliers. UNC wasn't particularly ready for Clemson's press in their next outing, but they held on for a 54-52 win. After a 76-70 defeat at the hands of Indiana, the Tar Heels met Notre Dame in Charlotte. Carolina led by 42 points in the second half, as Smith played his reserves generously in the 99-80 victory. Wake Forest dropped Carolina to 3-2, but the Heels reeled off three straight victories to improve to 6-2. Vic Bubas and his Duke squad overwhelmed Carolina in Durham, 79-57, and three nights later, the Tar Heels were on the wrong end of another lopsided score, this one to Maryland. The Tar Heels continued to struggle, dropping games to Wake Forest and N.C. State to bring their record to 6-6.

Carolina headed to the North-South Doubleheader needing wins, but after beating Clemson, the team faltered in a loss to USC. Smith's team got back on track by beating Maryland at home, but another loss to Duke sent Carolina into the ACC tournament with a 7-7 conference record

and 8-8 overall mark. The Tar Heels earned a rematch with USC in the first round, and UNC held a one-point lead at the half. The teams continued to play close down the stretch, but the Gamecocks took the lead late and held on, claiming a 57-55 victory to end UNC's season with an overall record of 8-9. It would prove to be Dean Smith's only losing season at North Carolina.

Elevating to the varsity squad in 1962–1963 was sophomore Billy Cunningham, a Brooklyn native that could jump out of the gym. Cunningham teamed with a pair of senior guards, Larry Brown and Yogi Poteet, to lead the Tar Heel attack. Cunningham made an immediate mark in his first two games, pulling down double-digit rebounding totals in wins over Georgia and Clemson. By season's end, the sophomore set a school record by averaging 16.1 boards a game. Along the way, Cunningham earned the nickname "The Kangaroo Kid" as a result of his astounding leaping ability.

Following a 75-65 victory over USC, the Tar Heels were outplayed by Indiana, 90-76. Smith was frustrated on the short trip from Indiana to Kentucky, where his team was to play against Adolph Rupp's Wildcats. However, Smith made a wise coaching decision, assigning Poteet to defend Kentucky's All-American Cotton Nash, while playing the rest of his team in a zone. The "point zone" was designed to limit a team's best offensive player opportunities with the basketball, and Poteet did an excellent job. With Nash hassled all night, Carolina persevered against Kentucky's stiff man-to-man defense and pulled out a shocking 68-66 victory.

After a win in Chapel Hill over Yale, Carolina returned to the Midwest to topple Notre Dame in overtime, 76-68. Although UNC lost its next contest at Wake Forest, the team went on another three-game winning streak. Carolina returned home against No. 3 Duke, but the Blue Devils, behind the All-American play of Art Heyman, returned to Durham with a 77-69 win. Cunningham scored 33 points and tallied 13 rebounds in an 82-68 win over Maryland, and a second loss to Wake Forest, this one by a single point, was followed by a 68-63 win over N.C. State. UNC continued its winning ways by sweeping USC and Clemson in Charlotte. In the second of the two games, Cunningham grabbed 27 boards to set a new school record. Another victory over Virginia set up a regular-season finale against Duke, but the No. 2 Blue Devils took a 106-93 victory in Durham, behind 40 points and 24 rebounds from Heyman.

The ACC tournament was at hand, and Carolina fans were pleased with the team's regular-season finish. The Tar Heels won 10 conference games against only 4 defeats, good for third place in the ACC. UNC took on USC in their first game, and five Tar Heel players finished in double figures. Led by Cunningham's 28, Carolina jumped ahead early and cruised to a 93-76 victory. The semifinal game against Wake Forest served as a chance for revenge, but the Demon Deacons got the better of Carolina for the third straight time. Frank Christie and Ronnie Watts combined for 30 points for Wake, and with Cunningham held to only 13, the Deacons escaped with a 56-55 win.

Without Larry Brown, the Tar Heels did not have a true point guard in the 1963–1964 season. The position was a revolving door all year, and as a result, the team had to depend heavily on Billy Cunningham. The team started by winning six of their first eight games but dropped a lopsided game at Kentucky, in which the No. 9 Wildcats exposed many of UNC's weaknesses. Once conference play started, things would only get worse. Carolina started at Wake Forest and Duke and dropped a 9-point defeat to the Deacons and a 20-point setback to the Blue Devils. The Tar Heels returned home to play Maryland, where Cunningham put on one of his finest performances. The junior out-jumped and out-hustled the Terrapins to the tune of 40 points and 28 rebounds, leading UNC to a 97-88 victory. The rebounding total broke his own school record set the year before, while his point total made him only the second player in UNC history at that time to score 40 in a game. After beating N.C. State in the second of a five-game home stand, the Tar Heels were shocked by Virginia Tech in double overtime, 90-88. After a two-week layoff, Carolina rebounded to beat Virginia and Wake Forest but then embarked on a seven-game road trip, of which they won only one.

Carolina entered the ACC tournament with an 11-11 overall record, but their 6-8 conference mark relegated them to a difficult matchup with USC. Behind 34 points from the Kangaroo

Kid, however, the Tar Heels bounced the Gamecocks, 80-63. Smith tried to slow Duke down in the semifinal, and the ploy worked as the teams went into halftime tied at 20. In the second half, however, the Blue Devils spread the floor and raced out to a comfortable margin. Although Cunningham scored 25 points to secure his place on the All-Tournament team, Jay Buckley's 20 points and Jeff Mullins's 19 points led Duke to a 65-49 win, ending Carolina's season at 12-12.

There were high expectations in Chapel Hill before the start of the 1964–1965 season, as Billy Cunningham entered his senior year and Bobby Lewis moved up to the varsity. For the first time in the Smith era, the Tar Heels started a season ranked in the national polls. After beating Clemson in the opener at Woollen, Carolina was defeated at Georgia, 64-61. Later that night, Smith went to dinner with the University of Georgia's new athletic director, Joel Eaves. Eaves asked Smith if he wanted to become head coach at Georgia the following year, but Smith relayed his desire to stay at North Carolina.

Carolina's trip to Columbia to play USC was a rekindling of recent ties, as Frank McGuire was in his first season as head coach at USC. The student outdid the teacher on this night, as Smith's Tar Heels outplayed McGuire's Gamecocks for an 82-71 victory. Carolina continued to build momentum by defeating Kentucky in Charlotte, 82-67, and blowing out Tulane, 111-74. Cunningham converted 21 field goals on his way to 48 points against Tulane, while controlling the backboards to the tune of 25 rebounds. The Tar Heels split their next four contests, losing to Indiana and defeating Vanderbilt, and then beating Mississippi State by four and dropping a five-point decision to Alabama. After getting blown out by 19 points at Florida, UNC began a difficult stretch of road conference games. After losing to Maryland, Carolina dropped a lopsided 107-85 setback at Wake Forest, setting the stage for one of the most notorious events in the history of the program.

The frustration in Chapel Hill over the team's underachieving had reached a boiling point, and as the Tar Heel bus pulled into Chapel Hill after the Wake Forest defeat, assistant Ken Rosemond was the first to notice a group of students hanging Coach Smith in effigy in front of Woollen Gym. A dummy, featuring a long nose to poke fun at Smith, was hanging from a noose and strung up in full view of everyone, including students that were watching from the windows of nearby dormitories. Smith stoically addressed his team briefly on the bus and let the incident go, although he was called into athletic director Chuck Erickson's office the following morning to discuss the team's problems. Billy Cunningham angrily ran off the bus and tore down the effigy. The incident spurred the Tar Heels to pull off an upset three days later against Duke. Carolina played solid perimeter defense, forcing Duke to take hasty shots. UNC shot 55 percent from the field to claim a 65-62 victory. It was a different scene outside Woollen this time around, as a large group of students assembled to greet the team's return. When asked to speak, Smith said he couldn't because the rope around his neck was a little too tight.

Carolina's rise in spirits was short lived, however, as N.C. State came to town and muscled out a three-point win. UNC split its next pair but went on to win its final seven regular-season contests. The regular-season finale, played in Woollen Gym against Duke, gave Cunningham a proper send-off. The ACC Player of the Year led his team to a 71-66 victory over the Blue Devils. Thanks to their late season rally, Carolina entered the ACC tournament with a 10-4 conference mark, placing them in a three-way tie for second place with N.C. State and Maryland. However, the Tar Heels were relegated to the No. 4 seed, which pitted them against Wake Forest. The Deacons shot 55 percent and had three players with at least 18 points, while Cunningham, in his final college game, was held to only 13. Bobby Lewis scored 27 points to lead all scorers, but Bob Leonard's 25 led the Demon Deacons to a 92-76 triumph to end Carolina's season at 15-9.

In the spring of 1965, Smith hired his first starting point guard, Larry Brown, as an assistant. Brown was an energetic and personable recruiter for the Tar Heels and, along with fellow assistant John Lotz, helped Smith lure some fine talent to Chapel Hill in coming years. In time, Brown would make his own mark as a basketball coach. It wasn't long into his coaching career before Dean Smith was selling some of the top high school basketball players in the country on

UNC. His first big catches had come in 1963 and 1964, when prep phenomenons Bobby Lewis and Larry Miller had committed to UNC. Miller was originally thought to be a lock to attend Duke, but Smith and his staff's ability to persuade him otherwise would help create a shift in power at the top of the ACC in the coming years.

Larry Miller was ready to take his game to the next level in 1965–1966, joining Bobby Lewis to create a formidable backcourt tandem. The graduation of Cunningham created a lack of size, and Smith began utilizing a daring new offensive approach. A few years earlier, during a practice session, Smith had noticed that both a man-to-man and zone-press defense could be exploited by getting the basketball in the hands of his team's best ball handler at the foul line, and subsequently spreading his players around the court in four different points. The offense, called the "Four Corners," could be quite frustrating to defend against and was particularly useful when holding the lead late in games. The approach was intended to create one-on-one opportunities, and with finishers like Miller and Lewis, it proved to be a highly effective strategy.

The Tar Heels were outrun in their opener at Clemson but rebounded for a win over William and Mary in the first game in Chapel Hill's new Carmichael Auditorium. Carmichael, which seated nearly twice as many people as Woollen Gym, was built against the old arena and would quickly become one of the nation's best venues to watch a college basketball game. Carolina went to Columbus and, behind 33 points from Miller and 31 points from Lewis, preserved an 82-72 victory over Ohio State. Returning home to play Richmond, the Heels turned on the jets and scored 127 points, the most in school history at that time, in a 51-point triumph. Carolina lost on the road to Vanderbilt, but Lewis enjoyed his finest game against Florida State, scoring 49 points to establish a new school record that stands to the present day. Lewis's hot shooting paved the way for a 115-80 Carolina victory. The team won three of four from there and entered conference play full of confidence. After overwhelming Maryland and Wake Forest, the Tar Heels met top-ranked Duke, who sprinted away from Chapel Hill with an 88-77 victory. UNC briefly regrouped after the Duke setback to knock off State but promptly dropped a game to Virginia. Continuing their up-and-down nature, the Tar Heels exploded for 115 points in a blowout over Wake Forest and then dropped a verdict in College Park to Maryland. The Tar Heels claimed a 34-point victory in Carmichael over USC, but from there they lost three straight. The Tar Heels got a couple of important conference wins in Charlotte, and after beating Virginia in the regular-season finale in Carmichael, UNC traveled to Duke and lost another one to the high-flying Blue Devils, 77-63.

Carolina entered the ACC tournament in a third-place tie in the standings with an 8-6 mark and wound up with the No. 4 seed. The Tar Heels met Maryland in the first round, and Lewis and Miller came to play. The UNC duo connected on 14 of 25 shots from the field. Although the Tar Heels trailed 36-33 at the half, UNC's combination of shooting and ball control led to a 77-70 victory and a rematch with Duke in the semifinal. Dean Smith used the Four Corners exclusively against the powerful Blue Devils, and with Bubas content to leave his team in a passive zone, the game turned into a yawner.

Although Smith was lustily booed for doing it, he persistently stuck with the Four Corners as his Tar Heels attempted only five shots throughout the entire first half. The ploy kept UNC in the game as the teams went into halftime with the score 7-5 in favor of Duke. Carolina continued its stall in the second half, attempting shots only when there were wide-open opportunities. As the game dwindled into the final two minutes, the score was tied at 20. Duke got a critical rebound at the 1-minute-41-seconds mark and waited for the last shot. Duke's Mike Lewis drew a foul and sank a free throw to give his team a 21-20 advantage. Carolina was unable to get off another shot, and they lost to finish with a 16-11 mark. Despite the defeat, Smith's innovative tactic had given his team a chance to beat a more talented Duke team, on its way to that school's third Final Four in four years.

With Lewis and Miller returning to campus in 1966–1967, along with the elevation of Dick Grubar, Rusty Clark, and Bill Bunting to the varsity, everything was in place for the Tar Heels to have a breakout season. The trio of sophomores provided balance to the Carolina attack,

while Lewis and Miller provided plenty of firepower. Starting the season with a top-10 ranking, Carolina got off to a fast start, winning their first nine games by an average margin of more than 25 points. During the holidays, Carolina played in a two-day invitational in Tampa, Florida. After blowing out Columbia in the opener, Smith began feeling the pressure of his team's success. In his book, *A Coach's Life*, Smith recalled being anxious as he sat alone in the dressing room while his team shot pregame warm-ups. He had little reason to fear, after all, as Carolina dominated Florida State, 81-54. From that night forward, Smith accompanied his team to the court for pre-game warmups.

At 7-0, Carolina suddenly found itself ranked in the top five and continued to dominate with a 45-point victory over Furman and a 23-point verdict over Ohio State. The Tar Heels were beaten by Princeton, but the team won its next seven contests, all coming against ACC foes. The streak began in Winston-Salem, as Carolina withheld a fierce challenge from Wake Forest for a 76-74 win. Miller was the hero, as the junior stole a Demon Deacon pass in the closing moments and converted a tie-breaking shot. Ranked No. 2 in the nation, North Carolina had reached the upper echelon of college basketball for the first time under Dean Smith, although an 82-80 defeat to Georgia Tech dropped the team's record to 16-2. UNC bounced back for a dominating win over N.C. State in Raleigh and traveled to Charlotte to overwhelm USC, 80-55. Clemson was the resistance the following day, and the Tar Heels gave up a season-high 92 points to the Tigers, allowing them to take advantage down the stretch and hold on for a stunning 92-88 victory. Smith's team nearly had another letdown at Maryland, but they held on for a one-point win. Virginia Tech was no match in Chapel Hill, but Carolina's 32-point victory would quickly be forgotten when the Tar Heels traveled to Columbia and were outplayed by the Gamecocks, 70-57. The regular season ended in fine fashion, however, as the Tar Heels outplayed Duke in front of another passionate home crowd, 92-79.

Although the Tar Heels finished the ACC slate with a 12-2 record, the team headed to Greensboro for the tournament without the full respect of the local press. Despite their recent success against Duke, Smith Barrier of the *Greensboro Daily News* projected the Blue Devils to win. The Tar Heels headed to the Greensboro Coliseum confident but nearly blew it in their first-round matchup with N.C. State. The eighth-seeded Wolfpack gave Carolina all it wanted, sending the game into halftime tied, but UNC advanced with a 56-53 victory. The Tar Heels outplayed Wake Forest the following day, 89-79, behind 31 points from Miller, to set up a showdown with Duke in the championship. Carolina started fast and furious, breaking out to a six-point advantage at the half. With MVP Miller scoring 32 points, and Bobby Lewis adding 26, the Tar Heels advanced to the NCAA tournament with an 82-73 win. Carolina earned a rematch with Princeton in the first round, and in an effort to relieve some of the pressure on his team, Smith had them playing volleyball early in the week. Although Princeton had come to Chapel Hill and outplayed the Tar Heels back in January, this time around UNC got revenge, claiming a 78-70 victory to move into the Eastern Regional final. Playing Boston College, Lewis had one of his fine performances, scoring 31 points on 11-of-18 shooting. The Tar Heels shot 53 percent as a team and advanced to the Final Four on the strength of a 96-80 triumph.

In the days leading up to the 1967 Final Four, which was to be played in Louisville, there was plenty of talk about the possibility of North Carolina facing off against University of California at Los Angeles (UCLA) in the championship game. UCLA had already won two NCAA titles earlier in the decade and came to Louisville unbeaten. The Tar Heels may have been looking ahead to the Bruins when they took the floor against Dayton in the national semifinal. Although they took an early advantage, UNC could not stop Dayton's Donnie May, who scored 34 points and grabbed 15 rebounds. Although Rusty Clark and Larry Miller each had double-doubles (double digits in two statistical categories), it was not enough, as the Tar Heels dropped a 76-62 decision. UNC then had to gear up for a tough Houston team in the third-place consolation game. The Tar Heels lost, 84-62, but late in the action, the UNC fans paid a warm tribute to their team, starting a "We're number four!" chant. Smith fondly remembered the chant years later, calling it a gratifying moment for himself and his team.

In the fall of 1967, Charles Scott was ready to take his place on the Tar Heel varsity, making him the first African American athlete to play on a varsity athletic team at UNC. Scott was heavily recruited throughout the state of North Carolina in 1966, but he came away most impressed with both the UNC players and coaching staff on his campus visit. He also came away impressed with Chapel Hill, a town that has always considered itself liberal by nature. The time had clearly come for integration in intercollegiate athletics at North Carolina, and although he would later be awarded for his courage in signing Charles Scott, Dean Smith has always said it was simply the right thing to do. After playing a year on the junior varsity in 1966–1967, Scott joined Larry Miller, Rusty Clark, Bill Bunting, and Dick Grubar in 1967–1968 to form an explosive starting unit. Miller would go on to be named first-team All-American, while becoming the first UNC basketball player to be named ACC Player of the Year twice.

Carolina blew out Virginia Tech and Kent State in their home openers but then lost to a good team from Vanderbilt, 89-76. UNC regrouped after the Vanderbilt setback, going on an inspiring 20-game winning streak. Although the airline lost their luggage on a trip to Portland to play in the Far West Classic, the team practiced in their boxers, earning the nickname "The BVD Boys." Carolina swept three straight in Portland and returned home to knock off Wake Forest, Duke, and N.C. State in succession. After burying Clemson by 32 points, the Tar Heels wiped out non-conference foes in Georgia Tech and Florida State. Carolina was sitting at No. 3 in the polls, sporting a 13-1 record. The good times continued to roll, as the Tar Heels won five games in a span of ten days. All, with exception of the Maryland game in College Park, were by double digits. After sweeping Clemson and USC in the North-South Doubleheader, Carolina wiped out Maryland and Virginia. With a 22-1 record, the Tar Heels endured a letdown in their final home game, which came against USC. Bobby Cremins, a USC guard who would later become a renowned coach at Georgia Tech, scored 25 points, leading the Gamecocks to an improbable 87-86 victory. Carolina lost by the exact same score in their next game, although it took Duke three overtimes to pull it off.

The Tar Heels dropped to No. 5 in the polls heading into the ACC tournament, but Smith's Tar Heels came out and ran past Wake Forest in the first game, 83-70, as Miller scored 31 points. The rematch with USC in the semifinal was every bit as passionate as the game a week earlier. The Tar Heels led by nine points at halftime, but behind the play of Skip Harlicka, who scored 24 points, USC rallied to send the game into overtime, tied at 74. The Tar Heels refused to give up their season, however, and pulled out an 82-79 victory. The opponent in the ACC championship was N.C. State, who had used the stall tactic to pull out a 12-10 victory over Duke the day before. UNC picked up the pace, but at the half, Carolina led by only five points. The Tar Heels steamrolled State in the second half, scoring 56 points. With Larry Miller scoring 21 points to earn tournament MVP honors for the second straight year, Carolina earned the most lopsided victory in the history of the event, prevailing by a score of 87 to 50.

The Tar Heels had a daunting task in the first round of the NCAA tournament, matching up against undefeated St. Bonaventure and their All-American, Bob Lanier. Although Smith considered it to be a ridiculous pairing for the opening round, with the No. 3 and No. 4 teams in the country facing off, Clark did a superior job of handling Lanier in the paint. Following their 91-72 victory over St. Bonaventure, UNC advanced to play Davidson in the regional final. Davidson coach Lefty Driesell hadn't forgotten about losing Charles Scott to North Carolina, and his inspired team led by six points at halftime. The gritty Tar Heels rallied, outscoring Davidson by 10 points in the second half to claim a 70-66 victory. Clark was named Regional MVP, while the 27-3 Tar Heels prepared to make their way to Los Angeles, where the 1968 Final Four was to be held.

Carolina refused to look ahead to UCLA this time around, electing instead to focus solely on beating Ohio State. Bill Bunting enjoyed a stellar game against the Buckeyes, scoring 17 points and hauling down 12 rebounds, while Miller led UNC in scoring with 20. The Tar Heels ran away from Ohio State in the second half and cruised to an 80-66 victory. North Carolina would play for the NCAA championship for the first time in 11 years, but their opponent, UCLA, was,

arguably, as powerful as any college basketball team that had ever been assembled. The Bruins had lost only once in the last two seasons and had gotten revenge for its only defeat, which came against Houston, in the national semifinal. The Bruins destroyed the Cougars, 101-69, to move into the final. With UCLA practically playing at home in the Los Angeles Sports Arena, the cards were stacked against the Tar Heels. UNC started the game in the Four Corners and was able to stay competitive in the first half, although it trailed by seven at halftime. In the second half, UCLA opened up its lead behind the legendary Lew Alcindor. Alcindor scored 34 points for the game, making 17 of 21 attempts from the field. The junior big man was also a defensive force, limiting Carolina's ability to get to the basket. When it was over, the Bruins had a 78-55 victory and their fourth NCAA championship in five seasons.

Larry Miller was gone by the time the 1968–1969 season rolled around, but the Tar Heels still had Charles Scott, Rusty Clark, Bill Bunting, and Dick Grubar, along with newcomer Lee Dedmon. Carolina lost a 72-70 decision to St. John's in Madison Square Garden on December 28, but it was their only defeat in their first 20 games. Opening the season with the No. 2 national ranking, the Tar Heels cruised to six early wins, including triumphs over third-ranked Kentucky and No. 12 Vanderbilt. By mid-February, the Tar Heels were 19-1, having beaten 15 opponents by 10 points or more. Carolina was finally tripped up by USC in Charlotte, as John Roche's 30 points led the way to a 68-66 Gamecock victory. UNC regrouped to beat Clemson the following day, then won games over Maryland and The Citadel. A rematch with USC in Columbia was next, and the USC supporters made a barrage of racial epithets geared at Charles Scott. One such remark enraged Dean Smith so much that he went after the individual, only to be restrained by his assistant coaches. Carolina held on for an emotional 68-62 victory, and although they lost to Duke, 87-81, in their next outing, the Tar Heels finished with a 12-2 record to claim a third consecutive ACC regular-season championship.

The Tar Heels entered the 1969 ACC tournament with a collective chip on its shoulder, as Charles Scott had been robbed of the league's player of the year award. Scott had averaged better than 22 points a game during the season on the conference championship team, but in a blatantly racist move on the part of the sportswriters, the award was given to USC's Roche, a sophomore who was on the ACC's second-place team. Playing with true passion, the Tar Heels ran past Clemson and Wake Forest in the first two rounds, as Scott averaged 17 points in the two wins. However, Scott saved his best performance for the ACC final against Duke, as he led his team to a comeback win. The first half did not go very well for Carolina, as Grubar left the game with a knee injury. The Blue Devils took an 11-point lead into halftime, and when Bunting fouled out midway through the second half, it appeared that UNC was in trouble. Unfazed, Scott stepped up and made 12 of 13 shots from the field over the final 20 minutes. The junior finished with 40 points, leaving the writers no choice but to name him MVP of the tournament. In the end, Carolina had an 85-74 victory and another trip to the NCAA tournament to look forward to. However, Scott couldn't help but make note of the fact that he felt cheated by the writers. "They put a guy ahead of me because I'm not white," he told the *Washington Post*.

Dick Grubar was lost for the NCAA tournament because of his knee injury, which forced Carolina to use its bench more in the first round against Duquesne. It was a difficult game, but the Tar Heels held on for a 79-78 victory to set up a rematch with Lefty Driesell and Davidson in the Eastern Regional final. The game went back and forth throughout, with both teams taking the lead on multiple occasions. With a little more than a minute to play, and the Tar Heels trailing by a basket, Scott hit a clutch jumper, tying the score at 85. Davidson stalled for the last shot, but Gerald Tuttle took a charge, giving UNC possession with 13 seconds to play. Smith knew that Davidson would try to limit Scott, but he got the ball on the inbounds pass. Scott took a couple of dribbles and ran some time before lofting a high arching shot with three seconds on the clock. As the buzzer went off, Scott's shot found its way through the iron. The Tar Heel bench erupted in celebration, as the 87-85 win ensured a third straight trip to the Final Four.

North Carolina returned to Louisville for the 1969 Final Four expecting to beat Purdue, but without Grubar, the team continued to play shorthanded. Rick Mount and Bill Keller were twin

killers for the Boilermakers, combining for 56 points. Carolina could not get it going and lost its chance for a rematch with UCLA, 92-65. Smith told his team to have some fun in the consolation game against Drake, but their defense came unraveled in a 104-84 setback. Despite the losses in the Final Four, UNC's run of three consecutive ACC and Eastern Regional championships had created an entirely new level of respect on the part of fans, players, and opposing coaches for the Tar Heels.

Without Rusty Clark, Dick Grubar, and Bill Bunting for the 1969–1970 season, the Tar Heels had to rely on the returning Charles Scott and Eddie Fogler, in addition to varsity newcomers Dennis Wuycik and Bill Chamberlain. After a pair of home tune-ups against Florida Southern and Mercer, Carolina got its first challenge of the year when they headed to Charlotte for a game against No. 2 Kentucky. The Wildcats were the tougher team on this occasion and gave the Tar Heels their first defeat, 94-87. The team regrouped to win their next seven games, all but one of which were outside the ACC. Although they were ranked No. 4 in the country, the Tar Heels had not been thoroughly tested during the winning streak, which was not the case when they headed down to Columbia for a game against No. 3 USC. USC controlled the tempo and outplayed the Tar Heels, 65-52. The USC game was the first of three conference games against ranked opponents, but Carolina regrouped in Raleigh against No. 10 N.C. State for a 78-69 victory, and followed it up with an 86-78 triumph over Duke and a rally past Clemson, 96-91, to improve to 12-2.

Wake Forest was next in Chapel Hill, and Carolina struggled to play good defense. Although Scott enjoyed a career game with 43 points and 9 rebounds, it was not enough. The loss to Wake Forest sent the Tar Heels into a difficult stretch, the worst six weeks for the program since the spring of 1966. Although they managed to knock off Virginia at home and Maryland twice, Carolina lost again to Wake Forest to all but end their chances of winning the ACC regular-season championship. Indeed, that honor would go to Frank McGuire's Gamecocks, who outplayed the Tar Heels once again, 79-62, on February 21. In between, Carolina edged N.C. State by a basket, overwhelmed Clemson in the North-South Doubleheader, and was upset by Georgia Tech, 104-95, in the final of that event.

Following the second loss to USC, the Tar Heels played against Virginia Tech. UNC dominated the Gobblers (as they were known at the time) in Scott and Fogler's final home game, 98-70, but were then shocked by unranked Duke in the final regular-season game, 91-83. Although they finished 9-5 in the ACC standings, Carolina's two victories over N.C. State assured the No. 2 seed in the tournament, played once again in Charlotte. The opposition was Virginia, who had given Carolina a difficult time earlier in the year. Although Charles Scott scored 41 points and hauled in 13 rebounds for his 12th double-double of the season, the Cavaliers pulled off a stunning 95-93 upset, which ended North Carolina's reign as ACC champs. Even more disheartening was the fact that Scott, arguably the best player in college basketball, was once again snubbed for ACC Player of the Year honors, and it was given to USC's John Roche. Despite the obvious injustice, Scott ended his career second in career scoring at UNC, only 38 points behind the great Lennie Rosenbluth.

The departure of Charles Scott created a large scoring gap to fill in 1970–1971, but the returning Tar Heel players were committed to playing unselfish basketball. It was easy sailing in the first three games, victories over East Tennessee, William and Mary, and Creighton. The Tar Heels got revenge on Virginia in their fourth game, opening up ACC play with an 80-75 triumph. Carolina went to Greensboro for the Big Four Tournament and was upended by N.C. State, but rebounded for a two-point win over Duke. An aggressive Utah team beat Carolina by 19, but UNC earned solid victories over Penn State and Northwestern. The Tar Heels wiped out Tulane, 101-79, to precede their biggest game of the year, a meeting with an undefeated USC team in Chapel Hill. Although USC was ranked No. 2, the Tar Heels outplayed the Gamecocks from the outset and won, 79-64, which moved them into the top 20. In their next contest, a rematch with Duke, Carolina won by five and followed that up with a 20-point decision over Clemson in Chapel Hill. The Tar Heels had been overachieving, but they again fell victim to Wake Forest, 96-84. After winning their next six games in succession, UNC headed to

Columbia for another war with USC. The Gamecocks were more prepared for Smith's attacking style this time around, and they pulled out a 72-66 victory to keep pace with the Tar Heels in the ACC standings. Not to be denied, Carolina promptly went on another three-game tear, defeating Florida State, Virginia, and N.C. State in succession. Despite a 92-83 loss to Duke in the regular-season finale, the Tar Heels shocked most ACC observers by posting an 11-3 league record, good enough to claim the regular-season championship.

UNC earned a rematch with Clemson in the first round of the ACC tournament and overwhelmed the Tigers, 76-41. The semifinal game against Virginia was a bit more of a challenge, but Carolina raced out to a 46-32 halftime lead. With Dedmon scoring 19 and Dave Chadwick adding 13 off the bench, UNC cruised into the championship game for a rematch against USC. The rubber match between UNC and USC started off slowly, as the teams felt each other out in the first half. The game went into halftime with the Tar Heels ahead, 21-19. The action picked up in the second half, but with under a minute to play, UNC held a 51-50 advantage. Dedmon reached up to block a South Carolina shot, but in a controversial call, a jump ball was declared. With three seconds remaining, the ball was tapped to USC's Tom Owens, who sank a shot at the buzzer to give the Gamecocks a 52-51 victory and a chance to compete in the NCAA tournament. It was certainly a difficult defeat, one that silenced the partisan-UNC crowd in the Greensboro Coliseum, but as result of their 22-6 record, Carolina's season was not over.

In the years before the expansion of the NCAA tournament, the National Invitational Tournament (NIT) was still a very prestigious event, in which several of the nation's top teams competed every year. North Carolina welcomed the opportunity to extend their season, and they put the loss to USC far behind them in the first round, blowing out the University of Massachusetts, featuring a promising young player named Julius Erving, 90-49. The victory came with a price however, as junior forward Dennis Wuycik was lost for the remainder of the tournament with a knee injury. Dave Chadwick entered the starting lineup and filled in admirably as the Tar Heels defeated Providence, 86-79, in the second round. The semifinal matchup against Duke was the third game of the year between the Tobacco Road rivals, and once again Carolina got the best of it, 73-67. The championship game was a rematch with Georgia Tech, and in a performance that earned him MVP honors, Bill Chamberlain hit 13 of 18 shots for 34 points, while grabbing 10 rebounds. The Yellow Jackets were unable to keep up, and the Tar Heels won the title, 84-66. The victory was significant in that it sustained North Carolina's basketball program as a national power. UNC had once again climbed the ladder of greatness, but even better things were to come the following year.

Dean Smith had a surprise in store for his ACC rivals in 1971–1972, in the first and only junior-college transfer he ever recruited into his program at North Carolina. Bob McAdoo, a six-foot-nine-inch forward, joined Wuycik, Chamberlain, and fellow newcomer Bobby Jones to create a fearsome frontcourt for the Tar Heels. Smith made an exception to his "no junior-college players" policy in the case of McAdoo, citing his academic improvement, and the reneging of Tom McMillen's original commitment to North Carolina. The six-foot-ten-inch McMillen, one of the nation's top high school prospects in 1970, had signed with Maryland a few months after verbally committing to UNC. With McAdoo in place, along with guards Steve Previs and George Karl, the Tar Heels had all the makings of another standout team.

The Tar Heels buried Rice and Pittsburgh in their first two games, but then they had a bad night against Princeton on the road, where they dropped an 89-73 decision. The team promptly went on a 10-game winning streak, beating four different conference opponents along the way. Carolina was particularly dominant during this stretch, winning every contest by at least 13 points. UNC was finally upended in Durham by Duke, 76-74, but regrouped to overwhelm Maryland. In a rare move, Dean Smith addressed the crowd at Carmichael Auditorium before the game, imploring them to treat Tom McMillen with respect. Indeed, when the Maryland center took the floor, he was greeted with loud applause. McMillen was thrown off by the warm welcome and scored only two points as Carolina prevailed, 92-72. The win was the first of five straight, all but one of which came against ACC foes. McMillen and Maryland got revenge with a 79-77

overtime win in College Park, but the Tar Heels won three of their last four to finish the regular season with a record of 21-4. Ranked No. 3 in the country, Carolina had earned the school's fifth ACC regular-season championship in six years, while McAdoo, Wuycik, Chamberlain, and Karl were each named either first- or second-team All-ACC.

Carolina got a bye in the first round of the ACC tournament, as USC's departure before the season left the league with only seven members. UNC ran away from Duke in the semifinal, breaking out to a double-digit lead in the first half and pulling away to a 63-48 win behind McAdoo's 17 points. The Tar Heels quickly assumed the upper hand in the championship game against Maryland, racing out to a 12-point lead at halftime. With Wuycik leading the way with 24 points, the Tar Heels cruised to a 73-64 victory. Although it could have gone to either Wuycik or McAdoo, the MVP trophy was given to McAdoo, who averaged 15 points in the two games. UNC advanced to the NCAA tournament once again, where they were the team to beat in the Eastern Regional. Ironically, their first-round opponent was USC, whose decision to leave the ACC had become a hot topic of discussion throughout the South. Behind George Karl's 18 points, UNC got revenge for the 1971 ACC tournament defeat with a convincing 92-69 verdict. Two days later, Carolina continued to play at a high level against Pennsylvania, as Wuycik's 18 points led the way to a 73-59 win.

The Tar Heels were back in the Final Four, and as in 1968, they would be playing in Los Angeles. Carolina was favored against Florida State in the national semifinal, but behind Otto Perry and Ron King, the Seminoles came out with a bang. Making shots all over the floor, Florida State took a surprising 13-point lead into halftime. McAdoo was one of the lone bright spots for Carolina, scoring 24 points to go along with 15 rebounds. When he fouled out at the 13-minute mark, UNC appeared to be hopelessly behind. Nonetheless, Smith invoked one final rally from his team, as the Tar Heels cut the lead to single digits in the final minutes. However, Florida State held on for a 79-75 victory, giving them the right to play UCLA for the national championship.

With Dennis Wuycik and Bob McAdoo heading to the professional leagues after the 1972 season, the Tar Heels figured to be in a rebuilding mode in 1972–1973. New rules had been enacted by the NCAA during the summer, which allowed freshmen to play on varsity teams, and as a result, rookie Mitch Kupchak stepped up and became UNC's top reserve. UNC got off on the right foot, winning their first six games, before dropping a 68-61 decision to the sixth-ranked Wolfpack in Greensboro. From there, the Tar Heels got hot again, winning nine straight, including a sweep of the Rainbow Classic in Hawaii and conference verdicts over Clemson, Wake Forest, and Duke. UNC had a rare off night at home in a loss to Virginia and followed it up with a 94-88 setback to Maryland in College Park. Although the Tar Heels rebounded to knock off Wake Forest in Carmichael, the team went over to Raleigh and was handled by N.C. State again, 76-73.

Next Carolina got wins over Georgia Tech and Clemson but was then humbled by Maryland in Chapel Hill, 95-85. After beating Florida State in New York City, the team finished the regular season sluggish. The Tar Heels were shocked by Miami of Ohio in Chapel Hill, and after a revenge victory over Virginia, UNC was beaten for a third time by N.C. State, 82-78. The regular season ended with a two-point victory over Duke.

Finishing second in the ACC standings, the Tar Heels figured to have a winnable game in the first round of the league tournament against Wake Forest, a team they had beaten handily twice during the regular season. However, the Demon Deacons came out poised, holding Carolina to only 18 points at halftime, and with nobody scoring more than 13 points, the favored Tar Heels fell victim to a 54-52 overtime upset. Despite the loss to Wake Forest, North Carolina was once again invited to the NIT in New York City. The first two rounds were a piece of cake, as UNC breezed past Oral Roberts and Massachusetts. A snag came in the semifinals, however, as the Tar Heels faced Notre Dame. The Fighting Irish pulled away in the second half for a 78-71 win. UNC beat Alabama in the consolation game to finish with a final record of 25-8.

With Bobby Jones returning for his senior season, the Tar Heels remained a top-10 team in 1973–1974, although their inferiority to the eventual national champions from N.C. State was

evident when the two teams played. For the second season in a row, Norm Sloan's Wolfpack defeated Carolina three times, including a one-point win in the Big Four Tournament, an 83-80 squeaker in Chapel Hill, and an 83-72 win in Raleigh. Combined with their two defeats to Maryland, the Tar Heels dropped five of their six total defeats to either the Wolfpack or Terrapins. Other than those setbacks, which came against two of the best three teams in America, Carolina was 22-1 during the season. UNC won its first seven, including double-digit victories over ranked teams in Houston and Kentucky, before dropping the 78-77 thriller to N.C. State in Greensboro. The Tar Heels then went on another five-game tear, including a pair of wins over Duke and triumphs over Clemson, Virginia, and Wake Forest. The second victory over Duke came in Durham, when Jones stole an inbounds pass at mid-court with four seconds left and raced down for a lay-up and a 73-71 final. The second loss to N.C. State came next, but the Tar Heels rebounded for an inspiring win over Maryland. The victory kick-started another five-game win streak, but the Terrapins got revenge in Cole Field House, 91-80. Carolina continued to play at a high level, outplaying Florida State, Miami of Ohio, and Virginia in succession to improve to 20-3.

The third loss to N.C. State seemed to linger in Carolina's home finale against Duke, as the Tar Heels were outplayed for most of the game by the Blue Devils. As the final minute ticked down, UNC was all but dead. With only 17 seconds left, Duke led by eight points. After Jones sank a pair of free throws to cut the lead to six, freshman Walter Davis stole an inbounds pass and found Jones for a lay-up. Trailing now by four, Smith elected to call a time-out. The Blue Devils again struggled to get the ball in bounds and were called for five seconds. Davis hit a jumper, and suddenly the Duke lead was only two. The Devils finally got the ball in, and Pete Kramer was fouled with five seconds left. Kramer missed the front end, and UNC's Ed Stahl got the board and called another time-out. Only three seconds remained. Smith set up a play, and Kupchak made an inbounds pass to Davis. The freshman turned and floated a high arching shot from mid-court, which miraculously banked through the rim as the buzzer sounded. As Carmichael Auditorium erupted, UNC's play-by-play man, Woody Durham, exclaimed, "Unbelievable!" Although Duke rallied to lead by four in overtime, the Tar Heels persevered for a 96-92 win, which stands as one of the most storied comebacks in the history of North Carolina basketball.

The Tar Heels carried the momentum of the Duke win into the ACC tournament, where UNC eliminated Wake Forest in the first round, 76-62. Maryland was next in the semifinals, but the Tar Heels had no answer for a powerful Terrapin team. Maryland ruined UNC's chances of an ACC championship rematch with N.C. State, 105-85. The Tar Heels met Purdue in the NIT, and the Boilermakers ensured that Carolina would not make another deep run in Madison Square Garden, eliminating Smith's Tar Heels in the opening round, 82-71.

The 1974–1975 season brought great optimism to Chapel Hill, as highly touted freshman Phil Ford made his introduction on campus. Ford immediately stepped into the starting point guard role, becoming the first UNC player under Dean Smith to start as a freshman. The Tar Heels won five of their first six, the only setback coming to a Kentucky team that would play for the NCAA title later that season. The team hit a snag in Greensboro's Big Four Tournament, dropping an overtime decision to Duke and an 82-67 final to top-ranked N.C. State. Carolina got back on track with three wins, but in a rematch with N.C. State in Reynolds Coliseum, the Tar Heels dropped another game in overtime, 88-85. UNC continued to rise in the polls, particularly after beating No. 2 Maryland on their home floor, but the team fell apart at Clemson, who moved into the rankings themselves after an 80-72 upset. The Tar Heels rebounded to win three non-conference games and then knocked off Duke, 78-70, in Chapel Hill. UNC lost two of their next three, but they ended N.C. State's nine-game winning streak in their rivalry with a 76-74 triumph in Carmichael and finished the regular season with a win over Duke.

Carolina entered the ACC tournament in a three-way tie for second place with Clemson and N.C. State and met Wake Forest in the opener. The game was close throughout, and at the end of regulation, the teams were tied at 90. In a shootout of an overtime session, the Tar Heels held on for a 101-100 victory. UNC was destined to another overtime affair the following day,

as Clemson took them to the brink. Behind Phil Ford's 29 points, however, Carolina prevailed, 76-71. N.C. State had upset top-seeded Maryland in the other semifinal, and the two bitter rivals faced off with an NCAA tournament berth at stake. UNC assumed control from the outset, building a 41-35 lead over the startled Wolfpack. Ford ran the UNC offense to near perfection, and he made eight of nine free throws on his way to a game-high 24 points. Ford became the first freshman to win the ACC tournament MVP award, as the Tar Heels earned a satisfying 70-66 victory. UNC was playing its best basketball of the season when they met New Mexico State in the first round of the NCAA tournament and advanced with a 24-point triumph. The Tar Heels moved to Providence to play Syracuse, and the Orangemen came to play. Carolina was unable to take control, and Syracuse moved to the Final Four with a 78-76 victory.

The Tar Heels returned the nucleus of their team in 1975–1976 and were the team to beat in the ACC. Indeed, the team cruised in late November and December, winning their first six contests. Wake Forest ended the streak in Greensboro, but a win over Duke kick-started another six-game winning streak. A one-point loss at home to N.C. State was discouraging, but the team rebounded to beat Maryland and Wake Forest, each in overtime. Five more wins followed, which put the Tar Heels at 19-2 heading into a game against Tulane. UNC figured to have Tulane's number, but the Green Wave sent the contest into overtime. Phil Ford hit a buzzer-beater to extend the game, and before anyone knew it, the game was entering its fourth extra session. Carolina finally prevailed in the longest game in school history, 113-106. UNC continued to win, squeaking out games over Miami of Ohio and Virginia and outplaying rivals N.C. State and Duke. Ford made all 16 of his free-throw attempts against State on his way to being named a first-team All-American. Mitch Kupchak earned the ACC Player of the Year award.

Carolina got a bye in the first round of the ACC tournament and, with four players in double figures, pulled past Clemson in the semifinal, 82-74. One win away from another ACC title, the Tar Heels met a Virginia team that was coming off upsets over N.C. State and Maryland. The Cavaliers, behind the superb play of Wally Walker, were peaking, and gave UNC fits from the outset. Virginia led by five points at halftime, and behind Walker's 21 points, the Tar Heels were defeated, 67-62. Carolina got a difficult first-round pairing with Alabama in the NCAA tournament and were eliminated, 79-64.

During the summer of 1976, Dean Smith, along with UNC assistant coach Bill Guthridge and Georgetown head coach John Thompson, had the unique opportunity to lead the United States Olympic basketball team in the Montreal games. Although some criticized the decision on the part of the Olympic selection committee to place four North Carolina players (Walter Davis, Phil Ford, Tommy LaGarde, and Mitch Kupchak) on the team, nobody could argue with the results. The Americans redeemed themselves from the 1972 Munich debacle by playing cohesive team basketball in victories over Yugoslavia and Czechoslovakia, and then playing very well in a win over Canada. In a rematch with Yugoslavia in the gold medal game, the Olympians put it all together in a 95-74 victory. It was a satisfying victory for all involved and was particularly thrilling for Smith, Guthridge, and the quartet of Tar Heels that were on the team.

The Olympic experience gave Smith and his players a leg up in preparation for the 1976–1977 season, one in which the Tar Heels clearly had one of the most talented teams in college basketball. Carolina was tripped up by Carl Tacy's Wake Forest team in overtime in their second game, but it was their only loss in their first 13 outings. With Phil Ford running the Four Corners exquisitely, the Tar Heels preserved a number of the victories in the final minutes, while putting other games away with the unique offensive approach. For the season, Ford scored in double figures no less than 29 times. After beating Duke, 77-68, to improve to 12-1, the team hit a snag, losing three of their next four games. The first two of the setbacks, coming against N.C. State and Wake Forest, were close, but the third loss was a 93-73 disaster down at Clemson.

"The Tar Heels had a terrible night in the loss at Clemson," remembers Woody Durham. "I remember seeing Coach Smith in the aisle of the team bus after that game, talking to the players with the light on. He didn't seem to be yelling, but it was evident that whatever he said got through to the team."

Carolina dropped nine spots in the national polls after the Clemson game, but the team got back on track with blowouts over Georgia Tech and Furman. It was smooth sailing in their next game as well, a 97-70 win over Maryland, but the triumph came at a steep price. Tommy LaGarde, one of the team leaders in both scoring and rebounding, tore knee ligaments, ending his season. It was the first of several crushing injuries to the 1977 team. Despite LaGarde's absence, the Tar Heels continued to roll, beating Tulane, South Florida, Virginia, N.C. State, Duke, and Louisville to close out the regular season with a record of 22-4. Carolina finished 9-3 in the ACC and, after their first-round bye in the league tournament, coasted past N.C. State, 70-56. Unfortunately for the Tar Heels, Walter Davis broke a finger on his shooting hand, and the following day, as the team was preparing for a rematch with Virginia in the ACC title game, the senior was getting treatment for his finger when he let out a scream. The outburst was too much for Dean Smith and his players, and a few of them wept openly for their teammate before the game. The Tar Heels struggled in the first half without Davis, falling behind at halftime by a single point. In the single half, with Virginia still winning, Davis urged Smith to place him back in the lineup. Once he proved he could catch the ball, Smith put him in.

"The moment Walter Davis stood up on the Carolina bench and took off his jacket was one of the most electric moments in the history of the ACC tournament," said Woody Durham. "You could have struck a match on the excitement."

Although Davis played sparingly, taking only one shot and not scoring, his presence gave Carolina the spark it so desperately needed. John Kuester stepped in and scored 14 points, winning the tournament MVP award on the way. With Phil Ford leading the way with 26 points and freshman Mike O' Koren adding 21, the Tar Heels moved past Virginia, 75-69, to earn a berth in the Eastern Regional of the NCAA tournament. Purdue nearly pulled off a first-round upset in Raleigh, but the Tar Heels advanced, 69-66. Moving to College Park for the next round, the team once again got bitten by the injury bug. Playing a strong Notre Dame team, Phil Ford made a pair of critical free throws in the final seconds for a 79-77 victory, although he hyperextended his elbow as the clock ran out. Ford was still hurting as the Tar Heels prepared to play Kentucky, but the team put together another gutsy rally, beating the Wildcats, 79-72.

North Carolina went to Atlanta's Final Four looking like they had just fought a war, as LaGarde, Davis, and Ford were all injured. Nonetheless, Davis and Ford suited up and played in the national semifinal against a high-scoring Nevada–Las Vegas (UNLV) team. UNLV jumped out to a six-point halftime lead with their run-and-gun style, but Dean Smith crossed them up in the second half by going to the Four Corners. Ford demonstrated heart with his 12 points and 10 assists, while the freshman O' Koren played his best game yet, with 31 points. The Tar Heels knocked off the Runnin' Rebels, 84-83, to move into the NCAA final. Marquette's Al McGuire was retiring after the game, and his inspired Warriors refused to let their coach go out in defeat. Marquette took a 12-point halftime lead, and although the Tar Heels rallied to tie the game at the 14-minute mark of the second half, the Warriors refused to yield. Carolina went into the Four Corners after tying the game, but a blocked shot by Bo Ellis helped Marquette take the lead and ultimately win, 67-59. It was a heartbreaking loss for North Carolina, and although some criticized Dean Smith afterwards for sticking with the Four Corners down the stretch, there was no question that the offensive approach was one of the reasons UNC got as far as they did in their tournament.

Phil Ford returned for his senior season in 1977–1978, and number 12 forever etched his name in the hearts and minds of Tar Heel fans. The eventual National Player of the Year, Ford left North Carolina as the school's leading scorer. UNC opened with the No. 1 ranking and would stay in the top five for most of the season. Carolina won 12 of its first 13 games, including wins over rivals Duke, N.C. State, Clemson, and Virginia, and a highly regarded Cincinnati team. UNC was outplayed by a strong Duke team on January 14, but Smith's team reeled off three more triumphs. Wake Forest continued to be a thorn in UNC's side, beating the Tar Heels for their third loss, and after wins over Clemson and Mercer, Carolina was stunned by an inferior Furman team.

Ford and the Tar Heels got it back together to win three more games, but UNC lost to a ranked Providence team on the road. After two more victories, the Tar Heels endured their worst stretch of basketball all year, and at the worst of times. Carolina dropped three of their final four contests, although Phil Ford made a memorable final impression on the fans at Carmichael Auditorium when he scored a career-high 34 points in his last home game, leading his team to a four-point win over Duke. Wake Forest's Carl Tacy was the one ACC coach who seemed to have a grasp on containing the "Four Corners," and, for the third time in four contests, his Demon Deacons found a way to beat the Tar Heels. The 82-77 loss to Wake relegated Carolina to the tough West Regional in the NCAA tournament, and UNC's season ended at the hands of San Francisco, 68-64.

Assistant coach Bill Guthridge nearly accepted the head coaching position at Penn State just after the 1978 NCAA tournament, but he decided at the last minute to remain at Carolina. He would be joined on the bench during the 1978–1979 season by newcomer Roy Williams, an ambitious young coach who had attended UNC earlier in the decade. Carolina returned Mike O' Koren and sophomore Al Wood, and the team once again got off to a good start. The Tar Heels were upended by top-ranked Duke in their third game, but it was their only setback in starting the season 10-1. Wake Forest continued to be a problem, beating Carolina in Winston-Salem, but the team rebounded to get revenge over Duke, 74-68. It was the first of four consecutive victories over ranked teams, as the Tar Heels rolled through Arkansas, N.C. State, and Wake Forest. Clemson pulled off an upset of the nation's No. 2 team on their home floor, and the Tar Heels were shocked for the second straight year by Furman in Charlotte. Carolina needed overtime 24 hours later to beat Virginia Tech, but that win got the team going again. UNC won five straight heading into their last regular season game at Duke. Smith felt that his team's best chance to win came in the Four Corners, but the first half wound up being a complete stall. At halftime, the score was 7-0 in favor of the Blue Devils. UNC came out more aggressive in the second half, but the defending ACC champions held on for a 47-40 victory.

After a bye in the opening round of the ACC tournament, Al Wood and Mike O' Koren led the way to a 102-79 blowout over Maryland in the semifinals. A rematch with Duke was at hand, as this time, the Tar Heels refused to give in. In a victory that helped seal the National Coach of the Year award for Dean Smith, Carolina outworked and outplayed the Blue Devils. Behind 16 points from MVP Dudley Bradley, Carolina went on to a 71-63 victory. Another seeding in the Eastern Regional pitted UNC against Pennsylvania, and although the game was in nearby Raleigh, the Tar Heels struggled to pull away. The Quakers, on their way to the Ivy League's last Final Four, pulled off a surprising one-point victory, which prematurely ended Carolina's season.

The 1979–1980 season was another good one for the Tar Heels, as Mike O' Koren earned All-American distinction for the third time and Al Wood made the second team. Freshman James Worthy entered the picture and was an immediate contributor, although he would be lost for the season with a broken ankle in the team's 14th game, a loss to Maryland that ended North Carolina's 25-game winning streak in Carmichael Auditorium. Despite the setback, the Tar Heels held a 10-4 record at that point and would win six more in a row from there. Maryland was on its way to the ACC regular-season title and beat the Tar Heels 70-69 in College Park, but UNC won four of its last five to close out the regular season. O' Koren was a force in the first round of the ACC tournament, scoring 26 points on 9-of-10 shooting from the field, as Carolina advanced past Wake Forest. Carolina met Duke in the semifinals, and although they had beaten the Blue Devils by 25 points less than a week earlier, it wasn't UNC's day. Behind Mike Gminski's 24 points, Duke raced out to a seven-point halftime lead and won going away, 75-61. The Tar Heels were forced to travel to Denton, Texas, to play Texas A&M in the first round of the NCAA tournament. The Aggies were the champions of the Southwest Conference and played Carolina point for point. The teams battled through regulation, and the first overtime tied, but Texas A&M took control in the second overtime session. The UNC defense came unglued, and although Al Wood finished with 26 points, the Tar Heels were beaten, 78-61.

Although Mike O' Koren had graduated prior to the 1980–1981 season, the UNC coaching staff had an ample replacement, in the form of six-foot-nine-inch freshman Sam Perkins. Perkins

played only two years of organized basketball before college, and the Carolina coaches heard about him through a service station attendant who happened to root for the Tar Heels. Perkins was a capable scorer with long arms and consistency, who, in time, would become one of UNC's great players. James Worthy returned to the fold and helped round out Carolina's starting five, along with Al Wood, Jimmy Black, and another freshman, Matt Doherty. The Tar Heels beat some good competition, including Georgetown and Arkansas in the Alaska Shootout, and improved to 5-0 with wins over Mercer and Duke. Wake Forest handed the team its first loss, but a win followed over South Florida. Bob Knight brought his Indiana team to Chapel Hill on December 20, but the Tar Heels were too much in a 65-56 victory.

Following another pair of victories, the Tar Heels lost back-to-back games for the first time in three seasons. Entering the meat of its schedule, UNC beat a top-10 Maryland team and then lost to No. 3 Virginia in Charlottesville. Carolina got hot in mid-January and finished out the month with six straight victories, including a 74-60 verdict on the road against a top-five Wake Forest team. Virginia had ascended to the No. 1 ranking when they came to Chapel Hill on February 3, and Terry Holland's Cavaliers snuck out of Carmichael Auditorium with a one-point overtime victory. Carolina returned to the top 10 after a pair of non-conference victories, but they promptly fell back out after a loss to Wake Forest. Four more wins followed, but Duke prevailed on the final weekend of the regular season, handing Carolina yet another one-point overtime loss.

The Tar Heels entered the postseason set to make a run, and behind 22 points from Sam Perkins, the team breezed past N.C. State in the opening round of the ACC tournament. Perkins again led Carolina in scoring the following day, but the game was much more difficult to win. Wake Forest took UNC to the wire, but the Heels held the lead in the final seconds and preserved a one-point victory to move into the final against Maryland. The Terrapins featured a number of future NBA players, like the Tar Heels, and once again UNC fans bit their nails through a close finish. Although the Terrapins led by four at halftime, the Tar Heels rallied to take the lead in the second half. Al Wood's 19 points and James Worthy's 18 points paved the way to another single-point verdict, which gave Carolina its fourth ACC tournament title in seven years. Carolina played outstanding basketball in the West Region of the NCAA tournament, overwhelming Pittsburgh in the opening round and holding off a tough Utah team in the second round. Kansas State, the alma mater of Bill Guthridge, met the Tar Heels for the right to go to the Final Four, but it was all UNC in the St. Louis Checkerdome. Wood led the way with 21 points and 17 rebounds, and with Perkins and Worthy each making the All-Regional team, UNC rallied past the Wildcats, 82-68, to make the school's sixth Final Four under Dean Smith.

A familiar foe awaited Carolina in Philadelphia's Spectrum, as Virginia was the opposition in the national semifinal. The Tar Heels made Ralph Sampson a defensive focus, and the Virginia big man was held to only 11 points. The game was tied at halftime, but Virginia was unable to contain Wood. On his way to setting a national semifinal record that still stands more than two decades later, Wood played the game of his life, scoring 39 points and adding 10 rebounds. The Tar Heels scored 51 points over the final 20 minutes and moved to the NCAA final on the strength of a 78-65 win. Pres. Ronald Reagan was shot and wounded hours before the scheduled tip-off of North Carolina's rematch with Indiana, and although there was talk of postponing the game, it wound up being played. Worthy picked up three fouls in the first half, and although the game was close at the intermission, Indiana pulled away in the second half. Behind 23 points from future NBA superstar Isaiah Thomas, the Hoosiers went on to a 63-50 win.

Unfair though it was, a number of people criticized Dean Smith after his team's sixth defeat in the Final Four in 15 seasons. People said that Smith couldn't win the big games, despite the fact that he had won plenty of big games just to get his team in position to play in the Final Four. The criticism endured through the summer of 1981, but Smith and his staff knew they were returning a talented and hungry team to campus that fall, one that was capable of finally winning Smith his first NCAA title. As it turned out, the 1981–1982 season was the start of a new era at North Carolina, one in which Smith would never again be labeled as "the best coach to have not won a national championship."

Guard: Larry Brown

Guard Larry Brown earned All-ACC honors in 1963 and became one of Dean Smith's first assistant coaches in 1965. A legendary head coach in his own right, Brown led UCLA to a Final Four in 1980 and the University of Kansas to the NCAA title in 1988. The leader of nine different teams during his professional coaching career, in 2004, Brown led the Detroit Pistons to the NBA title to become the first head coach in the history of basketball to win both an NCAA championship and a NBA championship. (*Yackety Yack.*)

Billy Cunningham (number 32) deflects a shot during a 1965 game in Woollen Gymnasium. Cunningham, known as "The Kangaroo Kid" for his astonishing leaping ability, averaged 24.8 points and 15.4 rebounds a game during his career at North Carolina. Cunningham played and coached for a number of years in the NBA, earning world championships with the Philadelphia 76ers as a player in 1967 and as a head coach in 1983. (*Yackety Yack.*)

One of the greatest pure shooters in North Carolina's history, Bobby Lewis set a school record by pouring in 49 points against Florida State in December 1965. A two-time All-American, Lewis averaged 22.1 points a game during his career, the third-highest total in school history. As a senior in 1967, Lewis scored 31 points against Boston College to lead the Tar Heels to their first Final Four under Dean Smith, earning Eastern Regional MVP honors along the way. (*Yackety Yack*.)

North Carolina played its first game in Carmichael Auditorium in December 1965, and the building quickly earned a reputation for having one of the most electric atmospheres in college basketball. Dean Smith's Tar Heels were nearly unbeatable at Carmichael, posting a 169-20 record in the 20 seasons the school played there exclusively. Carolina had six undefeated seasons at home during the Carmichael years, including a stretch of 25 consecutive home victories from 1977 to 1980. (*Yackety Yack*.)

Here, Larry Miller lunges forward for two points. Miller was named ACC Player of the Year in both 1967 and 1968, making him the only UNC basketball player in history to earn the honor twice. Miller was also named the ACC tournament MVP twice, and he led the Tar Heels to league titles and trips to the Final Four in 1967 and 1968. The sharp-shooting lefty scored in double figures in 64 consecutive games at North Carolina, setting a school record that hasn't been equaled. (*Yackety Yack*.)

The jubilant Tar Heels are shown here gathering for a team photograph following their 87-50 blowout of N.C. State in the 1968 ACC championship game. Led by All-American Larry Miller, UNC went on to play UCLA for the national championship later that spring and finished the season with a overall record of 28-4. It was the second of three straight ACC championships and Final Four appearances for North Carolina in the late 1960s. (*Yackety Yack*.)

Here, Rusty Clark lays in two points against Wake Forest. The 6-foot-11-inch Clark, who attended UNC on the prestigious Morehead Scholarship, was the first true center to play at North Carolina under Dean Smith. Clark averaged 14.7 points and 10.2 rebounds a game from 1967 to 1969, helping the Tar Heels reach three consecutive Final Fours. Clark was the MVP of the 1968 NCAA Eastern Regional, where he helped the Tar Heels advance past St. Bonaventure and Davidson. (*Yackety Yack.*)

Head coach Dean Smith is seen here speaking to a television commentator following a UNC game in the late 1960s. The medium of television helped create widespread interest in college basketball and in time would turn the North Carolina Tar Heels into a household name across the United States. (*Yackety Yack.*)

Here, Charles Scott drives to the basket during a 1968 NCAA Eastern Regional game against St. Bonaventure. Scott, the first African American to earn an athletic scholarship at UNC, led the ACC with an average of 27.1 points per game in 1970. A gold medalist at the 1968 Olympics, Scott set a record by scoring 40 points in the 1969 ACC tournament final against Duke. Scott played in two Final Fours at North Carolina and went on to have a 10-year career in the NBA. (*Yackety Yack.*)

Eddie Fogler is shown defending the ball during a game in Carmichael Auditorium. Fogler played on two Final Four teams at North Carolina in 1968 and 1969 and served on Dean Smith's bench as an assistant coach for 15 years. Fogler also served as head coach at Vanderbilt and South Carolina and was twice named SEC Coach of the Year. (*Yackety Yack.*)

The second African American scholarship athlete in North Carolina basketball history, Bill Chamberlain, was the star of UNC's run to the 1971 NIT championship. Chamberlain tallied 24 points against Massachusetts in the first round and scored a career-high 34 points in UNC's 84–66 championship game victory over Georgia Tech, which earned him tournament MVP honors. (*Yackety Yack.*)

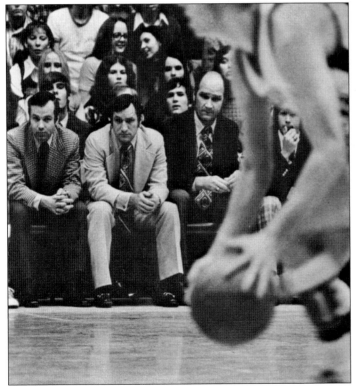

North Carolina head coach Dean Smith (center), along with assistants Bill Guthridge (left) and John Lotz (right), watches from the bench during a game in Carmichael Auditorium in the early 1970s. Lotz was hired by Smith in 1965 and became a valuable recruiter for the Tar Heels. Guthridge came to Chapel Hill in 1967 and turned down several head coaching jobs over the years to remain an assistant at North Carolina for the next three decades. (*Yackety Yack.*)

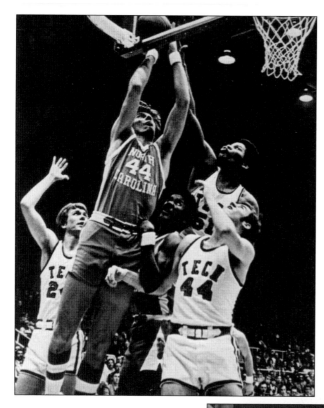

Here, Dennis Wuycik takes the ball strong to the basket. One of the toughest competitors to ever play at North Carolina, Wuycik was named All-Conference, All-ACC tournament, and MVP of the Eastern Regionals in 1972, as the Tar Heels advanced to the Final Four. Wuycik remains one of UNC's career leaders in free throw and field-goal percentage. (*Yackety Yack.*)

Bob McAdoo is shown reaching for a rebound in a 1972 game at N.C. State. The only junior-college transfer ever awarded a scholarship by Dean Smith at North Carolina, McAdoo played one season at UNC, helping lead the Tar Heels to the 1972 ACC championship and a berth in the Final Four. McAdoo averaged 19.5 points and 10.1 rebounds a game to earn All-ACC and All-American honors. (*Yackety Yack.*)

Here, George Karl is seen here pushing the ball downcourt during a 1973 game in Chapel Hill. Karl averaged 13.8 points a game during his UNC career and went on to play five seasons of professional basketball in both the NBA and ABA. The current head coach of the Denver Nuggets, Karl led the Seattle Supersonics to the NBA Finals in 1996 and the Milwaukee Bucks to the Eastern Conference Finals in 2001. (*Yackety Yack.*)

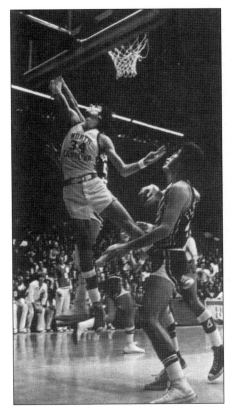

Here, Bobby Jones works hard under the glass during a 1974 game in Carmichael Auditorium. Jones led the ACC in field-goal percentage three times during his UNC career and was named one of the 50 greatest players in league history in 2002. In 1983, Jones won the NBA's first "Sixth Man" award as a member of the NBA champion Philadelphia 76ers, coached by fellow UNC alumnus Billy Cunningham. (*Yackety Yack.*)

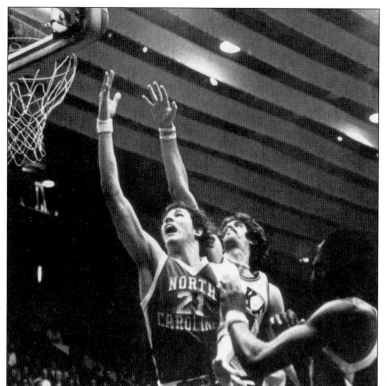

Mitch Kupchak is shown battling for a rebound in a game against Duke. The ACC Player of the Year in 1976, Kupchak averaged 17.6 points and 11.3 rebounds a game, as the Tar Heels won the regular-season championship. A second-team All-American, Kupchak later played on the 1976 U.S. Olympic team, coached by Dean Smith, which won the gold medal in Montreal. Kupchak currently serves as general manager for the NBA's Los Angeles Lakers. (*Yackety Yack.*)

Arguably the greatest player in North Carolina basketball history, Phil Ford is still the all-time leading scorer for the Tar Heels, with 2,290 points. Best known for his skill in running UNC's Four Corners offense, Ford was named consensus National Player of the Year in 1978. A three-time first-team All-American and member of the 1976 U.S. Olympic team, Ford was the first freshman under Dean Smith to start his first collegiate game. (*Yackety Yack.*)

Here, Tommy LaGarde shoots in a game against Clemson in the Greensboro Coliseum. LaGarde led the ACC in shooting percentage as a junior in 1976, and he was having another fine season the following year when he severely injured his knee in a game against Maryland. The senior was out for the remainder of the season. The 1977 UNC team went on to get beaten in the NCAA title game, but many believe the Tar Heels would have won the national championship with a healthy LaGarde in the lineup. (*Yackety Yack*.)

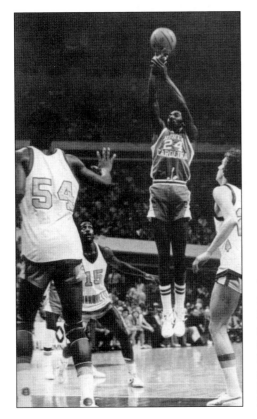

Walter Davis is seen taking a shot during the 1977 NCAA championship game against Marquette. "Sweet D," as he came to be known, scored in double figures 27 times during his senior season, earning first-team All-ACC honors. A member of the 1976 U.S. Olympic team led by Dean Smith, Davis was the 1978 NBA Rookie of the Year and a six-time All-Star in the professional ranks. (*Yackety Yack*.)

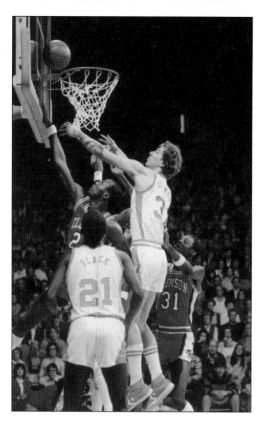

Mike O' Koren is shown tipping in two points during a home game against Clemson. A rare four-year starter at North Carolina, O' Koren poured in a career-high 31 points in UNC's national semifinal victory over UNLV in 1977, when he was just a freshman. A three-time All-American at UNC, O' Koren currently serves as an assistant coach with the NBA's New Jersey Nets. (*Yackety Yack.*)

Here, Al Wood scores two of his career-high 39 points against Virginia in the 1981 Final Four, on his way to establishing a national semifinal scoring record that lasts to the present day. Wood led Carolina with 18.1 points a game his senior year, earning first-team All-America honors in guiding the Tar Heels to the NCAA championship game. Wood played in all 126 UNC basketball games from 1977–1978 to 1980–1981. (*Yackety Yack.*)

FIVE

Winning the Big One
1981–1982 to 1996–1997

Losing to Indiana in the NCAA title game was a big disappointment to the Tar Heels in 1981, but Smith and his returning players knew that they had a good chance of returning to the Final Four in 1982. Only Al Wood was gone from the starting nucleus, and a talented newcomer was on his way. North Carolina had learned about Michael Jordan during his junior year at Laney High School in Wilmington, North Carolina, where he had grown several inches and was showing great promise. The UNC coaches saw untapped potential in Jordan, and they invited him to their summer camp between his junior and senior years of high school. Although he admittedly grew up an N.C. State fan, Jordan and his family soon grew loyal to Smith and his assistants, and he committed to North Carolina during his senior year. Jordan would be a fine complement to an already stacked lineup.

James Worthy, on his way to being named National Player of the Year, teamed with sophomore Sam Perkins to create a formidable frontcourt tandem. Worthy and Perkins each earned first-team All-American honors, and with the indispensable Jimmy Black playing solid backcourt defense and running the attack from point guard, the Tar Heels were difficult to stop in either a man-to-man or a packed zone. Matt Doherty, a selfless role player, did all the little things to help Carolina win games, and Jordan came on throughout the season to earn ACC Rookie of the Year laurels. Smith had Jimmy Braddock and some other solid players off the bench, but as the season wore on, he depended more and more on his immensely talented starting unit.

Sports Illustrated elected to make the Tar Heels the focus of its October 1981 preseason college basketball edition, but Smith allowed only himself and his four returning starters (Black, Doherty, Perkins, and Worthy) to grace the cover. Jordan hadn't been named a starter yet, and despite *Sports Illustrated*'s protests, no freshman without game experience speaks to the media at North Carolina. Jordan picked up defensively in preseason practice, earning a starting position, and the Tar Heels defended its No. 1 ranking early in the year. The team won each of its first eight games in November and December, including wins over top-10 teams in Tulsa and Kentucky. After a 64-40 victory over William and Mary to start the new year, the Heels began conference play with a 16-point win at Maryland.

Sitting at 10-0, Carolina's next opponent was Virginia. It was the first matchup between the ACC rivals since Al Wood had broken Cavalier hearts in the Final Four in Philadelphia.

Ralph Sampson was back for his junior year, and Virginia was ranked No. 2. Carmichael Auditorium was its loudest ever, so loud, in fact, that the Cavalier players couldn't hear the starting lineups from the public address announcer. The teams were back and forth for most of the game, but the Tar Heels took the lead down the stretch and iced the game in the Four Corners. UNC maintained its top ranking with a 65-60 triumph. Road games at N.C. State and Duke followed, and Carolina continued its determined play with a pair of double-digit victories. The flu bug caught Sam Perkins in late January, and the team played flat against Wake Forest. Scoring a season-low 48 points, UNC allowed the Demon Deacons to pull off an upset and briefly knock them from the No. 1 ranking. The Tar Heels rebounded with a 12-point win at Georgia Tech and then took the annual game from Clemson in Chapel Hill, 77-72. Following a solid 14-point victory over N.C. State in Carmichael, Virginia returned the favor when the teams played in Charlottesville. UNC couldn't get it going, and the Cavaliers won, 74-58.

Blowouts over Furman and The Citadel followed in Charlotte, but the Maryland contest at home went down to the wire. Carolina pulled out a 59-56 win, and other than the game down at Clemson on February 20, the Tar Heels were not challenged again in the regular season. Following their 84-66 win in Chapel Hill over Duke, UNC regained the No. 1 ranking in time for the ACC tournament. The team played a precise, low-scoring affair with Georgia Tech in the opener, prevailing by a 55-39 score. Carolina led N.C. State by only three points the following day in the semifinal, but behind 16 points from Perkins, the Heels advanced to the championship game, 58-46.

Ralph Sampson and the Cavaliers were waiting on Sunday, and the game would go down in history for what happened in the final seven and a half minutes. The teams were back and forth for much of the first half, as Worthy and Perkins scrapped down low with Sampson. Although the UVA big man scored 12 points to lead his team, Worthy outdid him with 16. Jordan came out hot early in the second half, hitting four field goals to help Carolina keep pace. His final basket, which came at the 8-minute-44-second mark of the second half, proved to be the last field goal for the Tar Heels.

UNC led by a point, 44-43, with 7 minutes and 34 seconds remaining, when Smith called the Four Corners. His hope was to lure the Cavaliers outside in order to get opportunities for his frontcourt. UVA, however, elected to sit back. Almost five minutes ticked off the clock. Virginia head coach Terry Holland realized that his team had to somehow retain possession and ordered his squad to start fouling in the final minutes. UNC finally hit the bonus with 28 seconds left. Matt Doherty made the first of his attempts but missed the second. Trailing 45-43, the Cavaliers were slowed up as the Tar Heels used the fouls it had to give. The strategy finally forced a turnover, and Doherty made two free throws to ice it. The Cavaliers made an insignificant final bucket for a 47-45 final score.

Afterwards, both the Tar Heels and the Cavaliers were criticized for the way the second half played out, as the need for a shot clock in college basketball was becoming more and more evident. By the next season, the ACC instituted a provisional 30-second clock of its own, along with a three-point line.

Carolina's victory over the Cavaliers ensured an advantage in the NCAA Regionals, where they would play in Raleigh. Heavily favored in their first-round matchup with James Madison, the Tar Heels got a dose of their own medicine. The Dukes slowed down the action, giving themselves a chance to win. Although it was close, Carolina gutted out a 52-50 win to advance. Alabama struggled defending UNC's balanced attack in the next round, as Perkins and Black each enjoyed solid outings. A 74-69 victory over the Crimson Tide set up a game with Villanova, and once again, the Tar Heels were too much. A 70-60 win over the Wildcats ensured another trip to the Final Four.

The Tar Heels refused to cut down the nets after their NCAA Regional triumph over Villanova, saying that the nets they wanted were hanging in the Louisiana Superdome. Carolina headed to New Orleans as the favorite, although they would be facing a Houston

team led by future NBA stars Akeem Olajuwon and Clyde Drexler, along with All-American guard Rob Williams. Unimpressed, the Tar Heels came out firing, racing to an early 14-0 lead. Black more than held his own against Williams, allowing him only two points and not a single field goal. Perkins torched the Cougars with 25 points and 12 rebounds, while as a team, Carolina shot a phenomenal 76 percent in the second half. It was enough for a 68-63 victory and another shot at a NCAA title.

UNC's opponent in the championship game was Georgetown, a young and up-and-coming program under the leadership of John Thompson. Thompson was an assistant alongside Smith on the 1976 Olympic team and one of his best friends. The Hoyas were led by freshman star Patrick Ewing, who was told before the game to block everything the Tar Heels threw up in the first few minutes. Indeed, the seven-footer got called for five goal tending violations on UNC's first nine field goal attempts. The game was eight minutes old before the Tar Heels finally watched one of their shots fall through the net. Neither team broke out to a big lead, and the Tar Heels trailed, 32-31, at halftime.

Georgetown attacked the Tar Heels with a tough press throughout the game, although Black, UNC's durable point guard, did not turn the ball over a single time. The freshman Jordan quietly put together his most complete game of the season, while Worthy played the best game of his young career. In a performance that would earn Worthy MVP honors, the man who would become known as "Big Game James" scored 28 points, making 13 of his 17 attempts from the field. Nonetheless, with less than four minutes to play, the game was still very tight. Jordan received a pass and lofted a high bank shot over Ewing, which fell in and gave Carolina a three-point lead, 61-58. The Hoyas refused to yield, feeding the ball to Ewing. The big man rimmed one through to make the score 61-60, and after UNC missed the front end of a one-and-one, Eric "Sleepy" Floyd, a rival of Worthy's from his high school days in Charlotte, got a good look at a shot that bounced off the front of the rim and fell through with 57 seconds left, giving the Hoyas a 62-61 lead.

The Tar Heels ran off several seconds before Smith called a time-out. Smith expected the Hoyas to come out in a zone, hugging the inside against Perkins and Worthy. The option, if that were the case, was to get a good shot from the perimeter. Before leaving the huddle, Smith told Jordan that if he were open, to "knock it in." Georgetown indeed came out in a tight zone, and Black found Jordan wide open on the left side. The freshman caught a crosscourt pass and coolly drained a jumper with 16 seconds to play. As the Superdome erupted, the Hoyas chose not to call a time-out, instead pushing the ball upcourt. In one of the strangest finishes to an NCAA final, Georgetown's Fred Brown made an errant pass directly into the hands of Worthy out near the jump circle. Jordan had gotten in the passing lane of Brown's intended pass recipient, and Worthy was in the right place at the right time. Worthy tried to run out the clock, but Georgetown fouled him with two seconds left. The Tar Heel bench was going crazy in celebration, but a composed Dean Smith calmed down the situation. Worthy missed a pair of free throws, but Georgetown's desperation 50-footer was well short.

Classy in victory as he had always been in defeat, Smith went over and hugged his friend Thompson, then joined his team in celebration. Smith used a pair of gold-plated scissors to cut down the nets, while back in Chapel Hill, thousands of Tar Heels fans poured out onto Franklin Street, creating quite a memorable scene. Carolina blue paint was splashed everywhere, as UNC fans reveled in a victory more than two decades in the making. Never again would Dean Smith have to answer questions about his inability to win the Big One, although after the game, he made the statement that he didn't feel like a better coach than he was two hours prior to winning his first NCAA championship.

Jimmy Black graduated, and James Worthy went into the NBA before the 1982–1983 season, which forced the UNC staff to bring along some young players more quickly than they would have wished. Freshman Brad Daugherty was still 16 years old when he arrived on the UNC campus, but the 6-foot-11-inch center was thrown into the lineup early and

often. The Tar Heels were defeated in their first two games, an overtime defeat to St. John's and a four-point loss to Missouri. They appeared beaten in their third game against Tulane, when Jordan stepped to the fore. With Carolina trailing by a basket with four seconds to play, Jordan stole a Tulane inbounds pass and shot a whirlwind 24-footer, which miraculously sank at the buzzer. It took three overtime periods, but the Tar Heels finally prevailed, 70-68. Two more wins followed, but UNC dropped to 3-3 with a loss at Tulsa. Although the Heels destroyed Texas Pan-Am by 56 points the next day, the Tulsa loss dropped Carolina out of the national rankings as they headed to Hawaii for the Rainbow Classic. The Tar Heels played sharp in wins over Texas Tech and Oklahoma, and buried Missouri in a rare same-season non-conference rematch, 73-58.

The sweep of the Rainbow Classic got the Tar Heels going, and the team won its next 12 games, reclaiming the No. 1 ranking by early February. On February 10, Virginia came to Chapel Hill. The Cavaliers flat-out overwhelmed Carolina for most of the game and held a commanding 16-point with less than nine minutes to play. The Tar Heels crept back, pulling to within 10 at the 4-minute-12-seconds mark and went on a 7-0 run over the next minute and a half to make the score 63-60 with 2 minutes and 54 seconds to play. UVA tried to stall out the clock, but the Tar Heels sent Ralph Sampson to the line with 1 minute and 30 seconds left. The senior missed the first shot, and Carolina drove downcourt. Braddock missed a long shot, but Jordan came through with a rebound and putback. Leading by one, Virginia guard Rick Carlisle brought up the ball, and Jordan came through with a steal. Jordan dribbled the lane and soared in for a slam dunk, giving Carolina the lead, 64-63. The Cavaliers were unable to convert on their next possession, and Jordan sealed UNC's remarkable comeback victory with a rebound, reaching over his taller teammate Sam Perkins.

"Michael Jordan told me later that the 1983 Virginia game in Carmichael Auditorium was the most complete game he had played up to that point," recalled Woody Durham.

Carolina's amazing comeback against Virginia was the team's 18th straight victory, but the Tar Heels lost their next three, a home game to No. 12 Villanova and road games at Maryland and N.C. State. Dropping out of the top 10 once again, the Tar Heels finished strong, winning each of their final four regular-season games by double digits. The streak secured another No. 1 seed in the ACC tournament. Carolina won its third game over Clemson in the first round, as the Tar Heels ran away in the second half. UNC led by only five at the half, but Doherty and Jordan each scored 28 as they advanced, 109-75.

N.C. State was the semifinal opponent, and the teams played close. Jordan fouled out in the second half with only 13 points, and in the final seconds with the score tied at 72, Perkins got a good look at a long jumper from near the bench, but it clanked in and out to force overtime. UNC led 82-76 with less than two minutes to play in the extra session, but after N.C. State made two free throws, Dereck Whittenburg hit a three-pointer to make the score 82-81. Perkins got good position on a shot but had a bad angle on the glass, and the ball rimmed out. A Wolfpack player got the ball a step quicker and Sam ran into him, ending his day with his fifth foul. After two free throws, State had a 9-0 run, and the "Cardiac Pack," as they came to be known, would go on to a 91-84 win. Jim Valvano's 1983 Wolfpack were a team of destiny, running through the NCAA tournament field to win the national championship that spring.

Carolina knocked off James Madison for the second year in a row in the first round of the NCAA tournament, and headed to Syracuse for the Eastern Regionals. The Tar Heels bested Ohio State, 64-51, in the Sweet 16 and were a win away from the Final Four when they met Georgia. Perkins stirred up some controversy before the game when he innocently said he didn't know anything about the Bulldogs, where they were located or what conference they played in. Hugh Durham's Bulldogs pushed the Tar Heels out of their comfort zone and won in an 82-77 upset. Georgia went on to lose to N.C. State in Albuquerque. Later that night, Michael Jordan was seen shooting by himself in Carmichael Auditorium. The runner-up to the National Player of the Year Award as a sophomore, Jordan had big things in mind for his future.

Sam Perkins elected to return for his senior season in 1983–1984, and *Sports Illustrated* once again tabbed Carolina as the preseason No. 1. Michael Jordan struggled early in the season, but Perkins picked up the slack as the Tar Heels won their first eight games, including triumphs in invitational events at Stanford and in New York City. Jordan relaxed and started playing his best ball of the season after that. The Tar Heels were loaded with talent, including senior leader Matt Doherty, improved sophomore Brad Daugherty, and a speedy freshman point guard from New York named Kenny Smith.

Smith started his first game and immediately showed his talent, guiding the Tar Heels to wins in their first 17 games. Ranked No. 1 throughout the stretch, Carolina buried most of its opposition, although it had two close games, at home against Virginia and in Cameron Indoor Stadium against Duke. Playing 10th-ranked LSU in Chapel Hill with a 16-0 record, Smith attempted a lay-up when he was hit from behind. The freshman fell hard and broke his wrist, forcing him out of the action for several weeks. It was a stunning blow, but Jordan's 29 points and 11 rebounds led the way to victory over the Tigers. Sophomore Steve Hale took Smith's spot in the starting lineup, and the UNC machine continued chugging along until they played Arkansas on February 12th. Dean Smith's 21-0 Tar Heels could not remain unbeaten, as the Razorbacks took advantage of its crowd and an uncharacteristically rattled UNC team to squeak out a one-point win.

Carolina got back on the right path, maintaining its No. 1 ranking with wins in its final five regular-season games. Kenny Smith returned for Duke, but the Tar Heels were out of synch. The Blue Devils led by two in the final seconds, but Matt Doherty sent the game into overtime with a buzzer-beating jumper. Although it took two overtimes, the Tar Heels finally wore down Mike Krzyzewski's hungry young team, 96-83. The ACC tournament figured to be a cakewalk for Carolina, and it was smooth sailing in the first round, as Doherty scored 22 and Perkins 20 in a 78-76 win over Clemson. However, the Tar Heels were tripped up in the semifinals by the same Duke team that had nearly beaten them in Chapel Hill. The Blue Devils, featuring a talented group of sophomores, came right at Carolina and built a 40-32 halftime lead. UNC put together a second half rally to make things interesting, but behind 21 points from Mark Alarie and 16 from Johnny Dawkins, Duke captured a 77-75 victory.

Even with the loss in the ACC, UNC entered the NCAA tournament as a favorite to earn a berth in Seattle's Final Four. The Tar Heels overwhelmed Temple after getting a first-round bye, but in the Sweet 16, Carolina met an old foe in Indiana. Indiana head coach Bobby Knight used an effective strategy, pushing the tempo and aggressively defending Perkins and Jordan. The Tar Heels looked out of it at the 5-minute-35-second mark, when they trailed by 12 points. Although Jordan fouled out, Carolina went on a gutsy run, outscoring the Hoosiers by 10 points over the next three minutes. It wasn't enough, however, as Indiana held on for a 72-68 victory. The loss was a hard one to swallow for Carolina fans, who had watched their team sit at No. 1 for nearly four months and finish with a 32-4 mark.

Although the 1984 Tar Heels had failed to reach the Final Four or win the ACC tournament with one of the best teams in school history, the accolades poured in after the season. Michael Jordan, who led Carolina with 19.4 points a game, was named National Player of the Year and, along with Sam Perkins, was named a consensus first-team All-American. Both players were selected to represent the United States in the 1984 Olympics, and with Jordan leading the way, the Americans won the gold medal in Los Angeles. Unfortunately for the Tar Heels, both players had played their final college games. Perkins' graduation and Jordan's early exit to the NBA placed plenty of question marks on Dean Smith and his team heading into the 1984–1985 season.

Although Carolina started the season unranked, the team came together and played above their supposed capabilities. The team now relied heavily on Kenny Smith and Brad Daugherty, and the pair became two of the top players in the ACC. Smith went on to break Phil Ford's single-season school record with 235 assists, while averaging 12.6 points a game.

Daugherty led the ACC in rebounding, while finishing in the league's top 10 in scoring, field-goal percentage, and free-throw shooting. The Tar Heels blew out their first four opponents, then secured an early ACC contest, 79-73, over Wake Forest in Greensboro. Following a sweep of Wichita State and Arizona State, Carolina traveled to Hawaii for a holiday invitational. UNC improved to 8-0 by beating host Hawaii Pacific, but they were beaten by Missouri, 81-76, in their next outing.

After wins over Stetson and Florida State, the Tar Heels met Maryland. The defending ACC tournament champions featured superstar Len Bias and led throughout the game. Leading by three with fewer than 30 seconds remaining, the Terrapins had a chance to ice the game from the free throw line. Keith Gatlin missed, however, and with 17 seconds to play, Kenny Smith nailed a jumper. UNC again fouled, and once again Maryland failed to convert. Dave Popson got the ball and scored with nine seconds left, and the Heels held on for an inspiring 75-74 victory. Following a win at Virginia, UNC found itself in the top five with a 12-1 record, but the team's inexperience caught up with them in January, as they lost four of six contests. UNC dropped out of the top 10, but the team rallied to win its next five. N.C. State proved the better team the second time around, but the Tar Heels swept Wake Forest and got revenge over Clemson. Georgia Tech had one of its best teams in years under Bobby Cremins and pulled out a 67-62 win in Atlanta. Nonetheless, Carolina knocked off Duke, behind 23 points and 12 rebounds from Daugherty, to create a three-way tie atop the ACC standings.

Atlanta's Omni had not been very kind to Dean Smith and his teams over the years, and the 1985 ACC tournament nearly ended before it started for Carolina. Wake Forest, which had finished 5-9 in the league standings, entered the game as the No. 7 seed, but behind Delaney Rudd's 24 points, the Demon Deacons made it more than interesting. Carolina had to come from behind to force overtime, but they took control in the extra session and won going away, 72-61. A rematch with N.C. State was set up in the semifinals, and the teams played at a slow pace. N.C. State led 23-22 at halftime, but Kenny Smith's 16 points paved the way for a 57-51 victory and another crack at Georgia Tech. The Yellow Jackets had been members of the league for less than a decade and made their first stand as a major player in the ACC championship game against Carolina. Although UNC played its style for most of the first half and led by five at halftime, Georgia Tech rallied behind tournament MVP Mark Price, who scored 16 points. Georgia Tech calmly sank a number of important shots down the stretch and held on for a 57-54 victory.

After beating Middle Tennessee by 19 points in the first round of the NCAA tournament, the Tar Heels were forced to play Notre Dame in the second round in South Bend, although UNC was considered the "home" team. Guard Steve Hale had severely injured his shoulder in the previous game, and Carolina struggled. The Irish had the ball in the final minute poised for the last shot, but a series of outstanding defensive plays helped the Tar Heels advance. Sophomore Curtis Hunter rounded up a loose ball and passed ahead to Smith, who converted a slam dunk in the final seconds. Smith then stole a Notre Dame inbounds pass to secure UNC's 60-58 win. The Tar Heels went on to Birmingham for the Southeast Regionals, where they dispatched of Auburn, 62-56. Carolina was one win away from another trip to the Final Four when they ran into another team of destiny, in this case Rollie Massamino's Villanova squad. Villanova slowed the action and played a frustrating style of defense against the Tar Heels, and on their way to winning the NCAA title, the Wildcats moved past Carolina, 56-44.

With Smith and Daugherty returning in 1985–1986, the Tar Heels were again cast as a serious national contender. In addition to another fine team in Chapel Hill, there was a buzz throughout the state of North Carolina about the completion of the new student activities center on the UNC Campus. Built entirely out of private funds at a cost of approximately $34 million, the new arena more than doubled the capacity of Carmichael Auditorium. Although the arena, named in honor of Dean Smith, wasn't ready for the season opener,

Carolina blasted UCLA in Carmichael, 107-70. After beating Iona, they swept three straight games in the Great Alaska Shootout.

Once again sitting at the top of the college basketball world, the Tar Heels enjoyed the remainder of December, winning eight straight games. Running on all cylinders, Carolina beat all but one of the opponents by at least 30 points, including a 129-45 win over Manhattan, which set a new school record for largest margin of victory. UNC's next game, played against N.C. State on January 4, was the last regular-season home game played in Carmichael Auditorium. The Tar Heels sent the old arena out in grand fashion, beating up on Jim Valvano's Wolfpack, 90-79, in the 117th consecutive sellout since 1973. The win gave North Carolina a final record of 169-20 in Carmichael.

Carolina had two weeks before returning to Chapel Hill, which allowed enough time for the finishing touches to be made to the Smith Center. The Tar Heels next headed to Madison Square Garden, where Daugherty collected 33 points and 11 rebounds in a 24-point win over Fordham. Still unbeaten at 15-0, UNC returned to North Carolina and soundly beat down Wake Forest, with Daugherty enjoyed another outstanding game with 31 points and 14 rebounds. In all, Daugherty posted a double-double in 32 of 34 games he played in during the 1985–1986 season, helping him earn first-team All-American honors. After beating Maryland, 71-67, in College Park, the scene was set for the first game in the new arena. A capacity crowd of more than 21,000 filed into the Smith Center on the evening of January 18, as the Tar Heels welcomed No. 3 Duke to town. Mike Krzyzewski had his Blue Devils on the verge of greatness, and although they held close throughout, Carolina remained No. 1 with a 95-92 triumph. Three more consecutive wins followed, including home verdicts over ranked Georgia Tech and Notre Dame, but Carolina was finally upended at Virginia, 86-73.

The Tar Heels remained No. 1 after the Virginia game, and although they needed overtime to outlast No. 2 Georgia Tech in Atlanta, UNC won its next four. Carolina was expected to handle Maryland in its new home, but behind Len Bias, the Terrapins shocked the home fans in Chapel Hill with a 77-72 overtime victory. Even worse for UNC was the fact that Hale went out with a collapsed lung. With one of their senior leaders lost throughout the remainder of the regular season and the ACC tournament, the Tar Heels fell apart, losing three of their last four. The defeats included road setbacks at N.C. State and Duke, who had since surpassed Carolina as the No. 1 team in the country, and a 10-point loss to Maryland in the first round of the ACC tournament. Hale returned for the NCAA tournament, but UNC's late-season stumble relegated them to the tough Midwest Region. Carolina got past Utah and Alabama-Birmingham in the first two rounds in Ogden, Utah, but succumbed to a Louisville team that would go on to win Denny Crum his second national championship. Louisville prevailed, 94-79, ending UNC's season at 28-6.

Brad Daugherty was taken No. 1 in the 1986 NBA Draft, but Kenny Smith returned to Chapel Hill for his senior season. Joined by a solid cast of returning players, including Joe Wolf, David Popson, Jeff Lebo, and Curtis Hunter, UNC was tabbed the preseason No. 1 team. The senior-laden group was accompanied by incoming freshmen J. R. Reid and Scott Williams, who each made valuable contributions. Reid made a lasting impression his first season, averaging 14.7 points a game and making a team-high 58 percent of his shots to earn Rookie of the Year honors. The Virginia Beach native even made the cover of *Sports Illustrated*, as the Tar Heels rode high for most of the season.

Although they were beaten in their third regular-season game at UCLA, the 1986–1987 Tar Heels were one of the quickest and most aggressive teams in school history. Behind Kenny Smith, who set a new UNC career assist record, and the supporting cast, Carolina won 10 of 11 games in November and December, averaging a 24.5-point margin of victory. The only real challenge came against Southern Methodist University in Dallas, as UNC needed overtime to secure an 88-86 verdict. Carolina continued its winning ways in January, knocking off LaSalle and Maryland. Duke couldn't get it done on their home floor, and

UNC advanced to 13-1 with the 85-77 win. The victories continued to pile up, as the Tar Heels defeated five more conference foes in succession. The last of the wins, coming against Clemson and ACC Player of the Year Horace Grant, was quite a struggle, as Carolina rallied from a substantial first-half deficit on the road. Smith, who was barely given clearance to play in the game, led the Tar Heels with 41 points.

UNC had moved back into the No. 1 ranking just before beating Clemson, but Kenny Smith's knee troubles were evident. The senior standout had missed the Georgia Tech game in Chapel Hill, but the team's 37-point blowout over the Yellow Jackets had them feeling like they could win without him. His performance at Clemson spoke for itself, but the point guard was forced to undergo surgery. UNC struggled without their star guard in South Bend, where Notre Dame was always a difficult challenge. The Tar Heels had their chances, but the Irish handed the Tar Heels their second defeat, 60-58.

In a recovery that was nothing short of amazing, Smith returned to the UNC lineup in time for a 96-79 win over N.C. State. The victory got the Tar Heels back on track, and although they barely won at Virginia in their next outing, Carolina finished the regular season with nine straight wins. The streak ensured a second undefeated conference run in four years for the Tar Heels, making them prohibitive favorite in the ACC tournament, which was being held in Washington, D.C. Friday's first round saw a slew of upsets, but Carolina outplayed Maryland by 21 points, with Popson's 23 points leading the way. Virginia was the opposition in the second round, and the Cavaliers again played the Tar Heels to the wire. UVA led Carolina at halftime and for much of the game, but with regulation winding down, Scott Williams sank a short jumper to send it into overtime, tied at 72. The game was undecided after the first extra session, but Carolina took control in double overtime for an 84-82 victory.

N.C. State entered the championship game as a heavy underdog, but the Wolfpack forced UNC out of its game plan. The Tar Heels played poorly in the first half, allowing State to break out to a seven-point halftime margin. Reid finished with 17 points to lead UNC, but the Heels could not put away the Wolfpack. State clung to a one-point lead in the final seconds, and the Tar Heels were unable to convert. Despite the disappointing 68-67 loss, Carolina was awarded the No. 1 seed in the East Region of the NCAA tournament, where they handily dispatched of Pennsylvania and Michigan in the opening rounds. The Sweet 16 matchup with Notre Dame was a chance for redemption, and UNC's 74-68 win set up an Elite Eight game against Syracuse. The Orangemen featured three future pros in Ronnie Seikaly, Sherman Douglas, and Derrick Coleman, and they immediately took command. The favored Tar Heels trailed throughout most of the game, and although they rallied to pull within 77-75, they were unable to get any closer. Carolina missed its opportunity to tie or take the lead, and Syracuse moved on to the Final Four, 79-75. Although the Tar Heels had tied a school record with its 32-4 overall record, the disappointment among UNC fans lasted well into the summer. In all, UNC's four defeats in 1986–1987 had been by a combined 12 points.

Kenny Smith was gone the following season, but fan-favorite Jeff Lebo returned, along with J. R. Reid. Nonetheless, UNC had only one returning senior and was not expected to do a whole lot against top-ranked Syracuse in the season opener. Smith had suspended Reid for the game because of a fight, and the Tar Heels looked beaten, down 14 points in the second half. In an inspiring rally, however, UNC cut the lead down to a single basket in the final seconds, and freshman Pete Chilcutt hit a turnaround shot to force overtime. Carolina prevailed, 96-93, to fire up a promising season. Although they were beaten on the road at Vanderbilt in their fifth contest, the Tar Heels opened the season 13-1. Lebo and Ranzino Smith were deadly outside shooters, while Reid became an All-American.

Duke bested the Tar Heels by a point in Chapel Hill on January 21, 1988, but the team continued to respond. UNC won seven of its next eight, including tight wins over Georgia Tech and Virginia and a two-point win at N.C. State. Temple arrived in the Smith Center

undefeated and the nation's No. 1 team, and John Chaney's Owls outplayed the No. 5 Tar Heels by 17 points. UNC rebounded to defeat Clemson and Georgia Tech, but the team was tripped up once again by Duke, 96-81, in Durham.

Carolina's 11-3 record in ACC play was good enough for another top seed in the league tournament, and Reid and Scott Williams combined for 41 points in a 83-62 triumph over Wake Forest. Maryland also couldn't find an answer for UNC's frontcourt trio in the semifinals, and the Tar Heels got a third chance against Duke. The teams played even through the first 20 minutes, going into halftime tied, but Danny Ferry's 19 points led the way to a 65-61 Duke win and the school's first three-game sweep over UNC during a season. Carolina was forced to play out West in the NCAA tournament, although they handled North Texas and Loyola-Marymount with ease in the first two rounds. Dean Smith was concerned about Loyola-Marymount's fast style of play, but his Tar Heels shot an NCAA tournament-record 81 percent from the floor. Moving into the regionals in Seattle, Carolina ended Michigan's season for the second year in a row, 78-69. The final was against a good and fast Arizona team, and the second-ranked Wildcats completely outplayed UNC. The Tar Heels were held to a season-low in points, as Sean Elliott and company advanced to the Final Four with a 70-52 victory.

The Tar Heels returned the vast majority of its talent in 1988–1989 and entered the season poised to stay near the top of the ACC. Although they were tripped up by Missouri in late November, Carolina ran through December with wins in all seven games. With several potent scorers, UNC would go on to set a school record by scoring more than 3,300 points, including seven individual games with more than 100 points. UNC was 13-1 in early January but dropped a one-point decision at home to Iowa and a blowout at Virginia to fall out of the top 10. Unfazed, the team reeled off four more victories, although a pair of tough road losses at Clemson and N.C. State followed. Six more wins in February had Carolina back in the top five, although Georgia Tech pulled off a last-second miracle in Atlanta to drop the record to 25-6. UNC still had a chance to win the ACC regular-season title, but Duke came into Chapel Hill and shocked the Tar Heels with a last-second 88-86 victory.

Dean Smith had caused a stir in UNC's first meeting at Duke, publicly expressing displeasure with a sign in the stands that had ridiculed J. R. Reid. The Blue Devil players had responded with a win in the Smith Center, and the backdrop of the 1989 ACC tournament was one of pure hostility between the two storied programs. The teams did their parts to ensure a rematch in the championship game, as UNC dispatched of Georgia Tech and Maryland, and Duke knocked off Wake Forest and Virginia. Duke's three-game sweep in 1988 had been the first time in nearly two decades that UNC hadn't beaten the Blue Devils at least once during the regular season, and with another league title on the line, the teams went blow for blow. The Tar Heels jumped out to a quick 12-point lead, but Duke fought back. In a hard-fought, physical affair, the teams were tied at five different points in the second half, and with less than two minutes left, Carolina had the ball. Junior guard Steve Bucknall drove inside and converted a crucial three-point play, which gave UNC the advantage, 69-66. The play all but secured victory for Carolina, as Duke failed to score and had to start fouling. J. R. Reid claimed the MVP trophy with his 14-point effort, and the Tar Heels went into the NCAA tournament confident.

Holding a No. 2 seed in the Southeast Regional, the Tar Heels ran over Southern University, 93-79, in the first round. Smith was upset that his team was not given a more favorable draw after winning the ACC tournament, for its next opponent, UCLA, proved to be quite a handful. The Bruins led throughout, but the Tar Heels rallied for an 88-81 win. A Sweet 16 matchup with Michigan marked the third straight year UNC met the Wolverines, but this time around Michigan was ready. Led by Glen Rice, Michigan refused to lose yet again to the North Carolinians, as Rice's 34 points paved the way for a 92-87 victory. The Tar Heels played a solid game, but they ran against a foe that was on its way to winning the NCAA championship. The loss, no matter how disheartening, could not take away from

the fact that Carolina won at least 27 games for the ninth straight season. In addition, the team finished with a No. 4 final ranking.

The 1989–1990 Tar Heels missed the leadership of Jeff Lebo and the solid play of J. R. Reid. As a result, they were a little down from UNC's standards. That was evident in Hawaii's Maui Invitational, when the Tar Heels needed a small miracle to come back against Lefty Driesell's James Madison team in the season opener. UNC trailed by nine with under a minute left, but a combination of clutch shots and poor free-throw shooting by the Dukes gave Carolina a chance. King Rice banked a high runner as the clock expired to give UNC an 80-79 win. The Heels came back strong the next day but were run over by Missouri in the Invitational championship game to return to the mainland 2-1. Alabama was tough on their home floor and outran the Tar Heels 101-93 in Tuscaloosa. UNC got a couple of warm-up wins before playing Georgetown in the Meadowlands in the first season of the ACC-Big East Challenge. The Hoyas were riding high again and took UNC down by 12. Another loss, this one to Iowa, had the Tar Heels sitting at 4-4 and suddenly out of the national polls. It was a restless time around Chapel Hill, but the rebuilding team got three straight in late December, including a 121-110 shootout over Kentucky, to get back in the rankings at No. 24.

Carolina went to Denver and was tripped up again, this time by Colorado State, and limped home following a win over Colorado out of the polls again. Tune-ups over Old Dominion and Pepperdine could not help the Tar Heels get past Maryland, who won in College Park, but UNC overwhelmed Virginia and Duke. Three more in a row, double-digit wins over State, Wake Forest, and Clemson, had UNC at 15-6. However, Smith and his team ran into a brick wall at Georgia Tech. UNC got by Miami but had a letdown in the Smith Center against N.C. State. State's 88-77 win on February 7 was the start of a tough three-week stretch, as the Heels lost four of five. There were plenty of people wondering if Carolina was NCAA tournament material, and the term "bubble" was thrown around Chapel Hill when talking about the team. The Tar Heels needed a win over Georgia Tech, and Smith rallied his team to get a tough 81-79 win. The Tar Heels then went into Durham and outplayed the No. 5 Blue Devils for a season sweep, 87-75. Back-to-back wins over good teams guaranteed a spot in the NCAA tournament, but the team struggled in their first round ACC tournament game against Virginia. Terry Holland's tandem of Bryant Stith and Anthony Oliver combined to bounce UNC from the festivities on Friday afternoon. The game was close throughout, with Carolina ahead a point at halftime, but Virginia pulled away in overtime and took a 92-85 victory.

The early exit in the ACC relegated Carolina to the No. 8 seed in the tough Midwest region. After knocking out Southwest Missouri State in the first round, 83-70, Carolina drew top-seeded Oklahoma. Billy Tubbs's Oklahoma team entered the game ranked No. 1 and double-digit favorites, but the Tar Heels played close. UNC successfully slowed down the Sooner attack, and the teams went back and forth to the final minute, with Carolina holding possession and trailing by a point. As the shot clock wound down, Rick Fox stepped up and hit a clutch three-pointer from well behind the line, giving UNC a two-point advantage with 55 seconds left. Oklahoma converted on a three-point play of its own, but King Rice was fouled, and tied the game at 77. Fox missed the second shot, but the ball bounced off a Sooner, and UNC had it with eight seconds left. Hubert Davis got the ball and drew the attention of Oklahoma's defense, then passed off to Fox, who drove inside as the final seconds ticked off and floated a six-foot bank shot over the arms of the Oklahoma forwards. The ball sank through the net as the buzzer sounded, giving the Tar Heels a 79-77 upset and the school's 10th straight trip to the Sweet 16. The euphoria of beating the nation's No. 1 team did not last, as senior Kevin Madden's career ended with a severe knee injury in practice. Madden's absence was felt in the regional semifinal against Arkansas, as Nolan Richardson's Razorbacks pulled away, 96-73, to end Carolina's season at 21-13.

The Tar Heels brought back a solid foundation in 1990–1991, with seniors King Rice, Pete Chilcutt, and Rick Fox, along with a talented group of underclassmen. Dean Smith also lured

one of the top recruiting classes in the country, as Indianapolis's Eric Montross teamed with New York City talents Derrick Phelps and Brian Reece. The freshmen provided valuable depth as Carolina started the year strong. There was a trip-up against USC in Charlotte, as the Tar Heels took a two-point loss, but it was their only setback in their first 14 games. The victories included triumphs at home over ranked teams in Connecticut, Kentucky, and Alabama, which kept the Tar Heels in the top 10. Following a 32-point win over Maryland to open ACC play, Carolina pulled out a double-overtime game in Charlottesville over Virginia thanks to a last-second shot by Rice. UNC was unable to continue the win streak at Duke. The Blue Devils won by 14, starting Carolina's toughest stretch of the year. The team split their next four contests, winning at Wake Forest and Clemson but dropping games to Georgia Tech and N.C. State. The setback to the Wolfpack was the first of a two-day doubleheader against State, and Carolina got its revenge with a 22-point verdict in Chapel Hill.

That win sparked the Heels to prevail in their next six, all coming by no less than 11 points. Firmly entrenched in the top five, Carolina went to Georgia Tech and ran over the Jackets, getting a 91-74 final to improve to 22-4. Duke got the Tar Heels again, however, in the final regular-season game, as the Blue Devils took the regular-season ACC title. That didn't matter to the Tar Heels, who had a spirited week of practice leading up to the ACC tournament. Clemson and Virginia stood in the way of a rematch with Duke in the ACC championship game, and the Tar Heels pulled through to get the game they wanted. In one of the more well-executed efforts by a UNC team in years, Carolina went out and dominated Duke from the outset. When it was over, the Tar Heels had a 96-74 victory and the school's second ACC title in three years.

Heading to the NCAA tournament as the No. 1 seed in the East Regional, Carolina buried Northeastern and Villanova in the first two rounds in Syracuse. Moving to New Jersey's Meadowlands for the Sweet 16, the Tar Heels pulled away from Cinderella Eastern Michigan, 93-67, setting up a game with Temple for the right to play in the Final Four. Although Temple refused to yield and Mark Macon's 31 points kept the game close right to the end, Carolina persevered for a three-point win, earning the Tar Heels their first national semifinal berth since winning it all back in 1982. Smith met a familiar face in Indianapolis's Final Four, as he prepared to face his protégé, Roy Williams, and Kansas. Although the two teams ran virtually identical offensive and defensive sets, the night belonged to Kansas. Kansas held the Tar Heels to just 38.4 percent shooting, and although Hubert Davis scored 25 points for UNC, the Tar Heels were eliminated, 79-73.

Davis returned for his senior season in 1991–1992, and although the Tar Heels missed the presence of Fox, Chilcutt, and Rice, the team remained highly competitive. After winning their first four games against inferior competition, Carolina crushed No. 6 Seton Hall in the Meadowlands by 29 points. Another win followed over Central Florida, but UNC lost to ACC newcomer Florida State in Tallahassee, 86-74. The Heels regrouped for four impressive wins, including a 34-point verdict over Clemson, but they lost their second game in New York City to Notre Dame. Three more double-digit wins came next, but the Tar Heels were subsequently outplayed by N.C. State in Raleigh by 11 points. Smith's scrappy team rallied yet again, moving back into the top 10 after victories over five conference rivals. Two of the wins, which came against Duke and Wake Forest, became instant classics.

UNC knocked off the defending national champions from Durham in overtime, as sophomore Eric Montross played through two different deep cuts on his head to score 12 points in the 75-73 win. Three nights later, Carolina dug themselves a deep hole in the Smith Center against Wake Forest. The Demon Deacons built a 22-point first half lead, and although the Tar Heels made some rallies, Wake Forest still held a 20-point lead with less than 15 minutes to play. Carolina slowly crept into the margin, cutting Wake's advantage to 11 at the 6-minute-17-seconds mark. In inspiring fashion, UNC went on a 10-0 run, cutting the lead to a single point in the final minute. After Pat Sullivan tied the game from the free-throw line, Brian Reece stole a pass to give the Tar Heels a chance to win. Reece got the

ball and worked into the lane, and although he missed his first effort short, the sophomore followed his shot and scored as the final horn sounded, giving Carolina a remarkable 80-78 victory and the school's biggest comeback in history.

After beating Clemson, the Tar Heels hit a cold patch, losing four consecutive games for the first time since the 1964–1965 season. UNC rebounded to beat Georgia Tech in their home finale but were then beaten by Duke just prior to the ACC tournament. Wake Forest was taken down in the first round, 80-65, as George Lynch and Hubert Davis combined for 43 points. The pair tallied 41 more points together the following day, as Carolina outplayed Florida State, 80-76. The Tar Heels met Duke in the ACC title game, but the Blue Devils, on their way to a second consecutive national championship, got 25 points from Christian Laettner and 20 points from Grant Hill in a 94-74 triumph. Carolina moved into the NCAA tournament for the 18th straight season, and after handling Miami of Ohio in the opener, the Tar Heels bested Alabama, which featured future NBA stars Latrell Sprewell and Robert Horry, by a 64-55 score. Ohio State was enjoying its finest season in years and was the top seed in the Southeast Regional. Although the game was relatively close throughout, Ohio State ended Carolina's season at 23-10 with a seven-point win.

With 10 returning players that were either juniors or seniors in 1992–1993, Dean Smith felt that his team could make a serious run in March. George Lynch, who became only the second ACC player to tally 1,500 points, 1,000 rebounds, 200 steals, and 200 assists during his career, was the team's inspirational leader, while Eric Montross, Brian Reece, and Derrick Phelps all made key contributions as juniors. In addition, the Tar Heels had sophomore Donald Williams, a deadly outside shooter. Carolina cruised through their first eight games before dropping a game in Hawaii to Michigan on a last-second tip-in. Ironically, the Tar Heels and Wolverines were not finished with one another. UNC won nine more in succession after the Michigan loss, including one of the most storied comebacks in school history. The season before, Florida State's Sam Cassell had made a controversial statement, calling the Smith Center audience a "wine and cheese crowd."

Cassell brought his Seminoles back to Chapel Hill on January 27, 1993, and helped them build a 17-point halftime advantage over the stunned Tar Heels. Florida State was running on all cylinders but was perhaps a bit overconfident in the second half. Although the Seminoles stretched out their lead to 21 points at the 11-minute-33-seconds mark, Carolina refused to yield. Trailing by 19, the Tar Heels reeled off 15 unanswered points, pulling to within 73-69 in a matter of minutes. The teams played back and forth for the next couple minutes, but with 1 minute and 59 seconds to play, Montross scored to cut the score to 77-76, Florida State leading. The Seminoles were unable to get off a shot on their next possession, as Lynch raced in front of a pass and dribbled downcourt for a dunk, bringing the crowd to its feet and putting Carolina ahead for the first time since the opening minutes. They wouldn't trail again, outscoring Florida State 31-6 over the final nine minutes for an 82-77 victory.

The Tar Heels were beaten in their next two contests, road games at Wake Forest and Duke, but they would prove to be UNC's final setbacks of the regular season. Carolina was an inspired, motivated team in February, winning seven consecutive games after the Duke loss to move to No. 1 in the polls. UNC went down to Tallahassee and earned another win over Florida State, then they buried the Blue Devils and Demon Deacons in rematches to enter the ACC tournament with a 26-3 record. The Tar Heels crushed Maryland in the first round and then got 16 points from Reece and 14 points from Montross in an 18-point win over Virginia. Unfortunately, Derrick Phelps, having injured his back attempting a lay-up against the Cavaliers, was out of the lineup as Carolina prepared to meet Georgia Tech in the ACC championship. Without their dependable floor leader, UNC had a letdown. The Yellow Jackets fought off Carolina for a 77-75 victory, although the Tar Heels remained in the Eastern Regional of the NCAA tournament.

The Tar Heels looked sharp in their first two games, as Phelps returned to the lineup and led UNC to routs over East Carolina and Rhode Island in Winston-Salem. Returning to

the Meadowlands for the Sweet 16, Carolina allowed a good Arkansas team to build an early 11-point lead. UNC rallied to take the lead in the second half, and although it went down to the final minute, Carolina advanced, 80-74. UNC again fell behind by double digits in the regional final, as Cincinnati jumped out to a 29-14 advantage. The Tar Heels recovered, tying the game down the stretch. Carolina got the ball with eight-tenths of a second left, but Brian Reece's dunk attempt rattled out. It was Carolina's first overtime game of the season, but the gritty team endured and pulled out a seven-point win.

The 1993 Final Four featured three No. 1 seeds, along with a Kansas team that was coming off a victory over top-seed Indiana. A rematch with the Jayhawks was inevitable for Carolina, but this time around Carolina took the upper hand. UNC led for most of the game and took a 78-68 victory to move into the NCAA championship game for the first time since 1982. Michigan outlasted Kentucky in overtime in the other national semifinal, setting up a rematch from the thriller in Hawaii back in December. However, the stakes were much higher this time around. Michigan jumped out to a 10-point lead in the first half, but the Tar Heels rallied, controlling the tempo and taking a 42-36 halftime advantage. The teams were back and forth for much of the second half, but as the game crept into the final six minutes, Michigan appeared to be taking control. The Wolverines led, 67-63, at the 4-minute-30-seconds mark, but the Tar Heels scored nine unanswered points. Donald Williams, who scored 25 points to lead all scorers, connected on a three-pointer to start the rally, and after baskets by Phelps, Lynch, and Montross, UNC led by five.

Michigan rallied behind Ray Jackson and Chris Webber, who each scored in the final minute to cut the UNC lead to 72-71. Pat Sullivan was put to the free-throw line with 20 seconds left, and he made one of the two attempts. Webber rebounded the missed second shot and looked upcourt. After stumbling a couple of steps, which drew an emotional response from the UNC bench who thought he traveled, Webber dribbled up the floor and got cornered along the sideline. Inexplicably, Webber called a time-out, although his team did not have one. That meant a technical foul and an opportunity for the Tar Heels to secure Dean Smith's second NCAA title. Final Four MVP Donald Williams stepped to the line and coolly drained two free throws, giving his team a four-point lead. Seconds later, the Tar Heels had a 77-71 victory and another national championship on the floor of the Louisiana Superdome. It was another festive evening in Chapel Hill, as the 34-4 Tar Heels earned UNC's third NCAA championship.

Dean Smith returned much of his starting nucleus in 1993–1994, along with highly touted freshmen Rasheed Wallace and Jerry Stackhouse. The Tar Heels began the new season ranked No. 1, but after winning their first two games and breaking out to a big early lead over Massachusetts in their third outing, the Tar Heels broke down defensively and lost in overtime, 91-86. Carolina regrouped after the Massachusetts setback, winning 10 straight games. Nine of the victories were by 13 or more points. Playing Georgia Tech on January 12, 1994, the first real dent in the UNC armor was exposed, as the Tar Heels were dominated, 89-69. The team had another breakdown a week later, losing on the road to Virginia. A win over Clemson was sandwiched between the two losses. Falling to No. 4 in the polls, Carolina went on another winning streak, beating seven straight opponents. The Tar Heels defeated top-ranked Duke, 89-78, which helped them move back to No. 1. Unfortunately for UNC, Georgia Tech came calling again and handed the Tar Heels their first loss in Chapel Hill in 25 games, 96-89. Another loss came five days later against Clemson, as it became more and more apparent that there were chemistry issues on Carolina's talented squad. The team came back to win three more games but then lost to Wake Forest in Winston-Salem. Duke had crept back ahead of UNC in the polls when they met in Durham, but the Tar Heels won by 10.

After blowing out Florida State in the first round of the 1994 ACC tournament, the Tar Heels prepared to play Wake Forest again. Dave Odom's Demon Deacons would be a thorn in the side of UNC for the next few seasons, and they led by five points with 1 minute and

15 seconds to play. Carolina rallied, cutting the lead to three. Odom instructed his team to foul Derrick Phelps with 11 seconds left, and after missing the second shot, Phelps got his own rebound and passed to Dante Calabria, who sent the game into overtime with a jump shot. Despite 31 points from Wake Forest's Randolph Childress, UNC advanced, 86-84. Carolina earned a 12th ACC tournament title for Dean Smith the following day, beating Virginia, 73-66. Freshman Jerry Stackhouse earned the MVP award, while the Tar Heels moved back into the No. 1 ranking for the NCAA tournament. Most experts figured that Carolina had a good chance of returning to the Final Four, but after a 20-point victory over Liberty in the first round, the Tar Heels met a streaky Boston College team. The Eagles played a fantastic game, building a double-digit lead. Carolina made another famous rally, but this time, they came up short. Boston College held on for a 75-72 victory, which ended North Carolina's streak of 13 consecutive Sweet 16s. It was a bitter defeat for the Tar Heels, which ended the careers of Eric Montross, Brian Reece, and Derrick Phelps.

Rasheed Wallace and Jerry Stackhouse returned in 1994–1995 and assumed the brunt of the load offensively. With two players destined for greatness in the NBA in their lineup, the Tar Heels did not miss a beat. The Tar Heels won their first nine games to claim the No. 1 ranking, which included decisions over ranked teams from Cincinnati and Villanova. Carolina was finally beaten in Raleigh by N.C. State but then embarked on another nine-game win streak to improve to 18-1. During that streak, UNC played in a classic at Duke, where they threw away a late lead and were forced into double overtime by a half-court shot from Jeff Capel. The Tar Heels held on against a struggling Blue Devil team for a 102-100 victory. After returning the favor against N.C. State with an 82-63 triumph, Carolina was beaten on the road at No. 8 Maryland, 86-73. Two more conference wins followed, but UNC split its final four regular-season games, dropping decisions at Virginia and at home to Wake Forest, while squeaking out a win at Florida State and outplaying Duke on Senior Day.

UNC entered the ACC tournament confident, and after knocking off Clemson in the opener, prepared for another showdown with Maryland. The Terrapins, led by Joe Smith, had tied Carolina for the ACC regular-season title along with Virginia and Wake Forest, and although the Tar Heels built a seven-point halftime lead, Maryland refused to go away. Smith led the way with 24 points for Maryland, helping the Terrapins force overtime. However, UNC's combination of Wallace and Stackhouse was too much, as Wallace finished with 33 points and Stackhouse finished with 19. Donald Williams added 17, and Carolina moved past Maryland, 97-92. Another chance at an ACC title brought about a rematch with Wake Forest, but the Tar Heels could not stop Randolph Childress. On his way to setting a record with nine made three-pointers, Childress scored 37 points for the game. Jerry Stackhouse scored 24 for UNC, but Wallace sprained his ankle and was held to only nine points. Wake Forest overcame a five-point halftime deficit and took the lead down the stretch. Carolina had a chance to tie in the closing seconds but dropped the game, 82-80.

The Tar Heels were forced out of the No. 1 seed in the East Regional by Wake Forest, and they wound up instead playing out of the Southeast Region. Wallace's absence in the first round gave Murray State the chance to pull off a huge upset, but Carolina advanced, 80-70. Things were much easier in the next round, as the Tar Heels shot well in a 22-point verdict over Iowa State. Following a 10-point win over Allen Iverson and Georgetown in the Sweet 16, Carolina prepared to meet Kentucky for the right to go to the Final Four. The Wildcats were coming off an SEC championship, and many expected them to advance past the Heels. The Carolina players had other ideas, however, and controlled the game from the outset. Forcing UK out of its comfort zone, the Tar Heels got 18 points and 12 rebounds from Jerry Stackhouse, whom *Sports Illustrated* named its national player of the year. A healthy Rasheed Wallace scored 12 points, and his late dunk signaled that the Tar Heels were headed back to the Final Four, 74-61. Arkansas, the defending NCAA champions, met Carolina in the national semifinal in Seattle, and things immediately fell out of favor for the Tar Heels when Stackhouse bruised his thigh 12 seconds into the game. The multi-

talented sophomore was in and out of the lineup all night, and with Wallace held to only 10 points, it wasn't Carolina's night. The Razorbacks moved into the NCAA finals for a second straight year, 75-68.

During the summer of 1995, Rasheed Wallace and Jerry Stackhouse became the first sophomores in North Carolina's basketball history to declare for the NBA Draft. Their departures left some serious holes to fill in the UNC lineup in 1995–1996. Fortunately, Smith had recruited another talented pair of athletes who would, in time, join Stackhouse and Wallace in the professional ranks. Antawn Jamison, a six-foot-nine-inch forward from Charlotte, teamed with Vince Carter, an explosive six-foot-six-inch guard/forward from Daytona, Florida, to give the Tar Heels another solid one-two punch. Jamison would become the first UNC player in history to earn first-team All-ACC honors. Junior Jeff McInnis returned to the lineup and, along with Dante Calabria, helped Carolina remain competitive in the ACC standings.

UNC won 9 of its first 10, the only loss coming by two points to a top-five Villanova team in Maui. The Tar Heels were up and down after their 9-1 start, winning only four of their next seven, including a second defeat to Villanova. The Tar Heels got hot in late January, winning three straight, but promptly lost three straight, coming to N.C. State, Maryland, and Georgia Tech in overtime. UNC regrouped to beat Clemson, Virginia, and VMI but then lost back-to-back games to Florida State and Wake Forest to fall to 19-9. Duke was the resistance as always in the regular-season finale, and this time around, unlike their first game, there would be no need for a big comeback. The Tar Heels won their seventh straight over their biggest rival, 84-78, heading into the ACC tournament. Carolina broke out to a comfortable nine-point halftime lead in their first-round ACC tournament game against Clemson, only to watch the Tigers make an inspired comeback. With four different players in double-figures, Clemson took the lead in the closing seconds. The Tar Heels couldn't counter and dropped a humiliating 75-73 final score. That forced UNC into the No. 6 seed in the East Regional, but the No. 25 Tar Heels put it all together in a 19-point victory over New Orleans in the first round. Carolina met Texas Tech, and explosive forward Darvin Ham, in the second round. Ham shattered a backboard during the first half with the Red Raiders already winning, and the Tar Heels were unable to make a rally. The season ended for Carolina at 21-11 after the 92-73 pasting by Texas Tech.

Jamison and Carter returned to the fold in 1996–1997 and, along with freshman point guard Ed Cota, would go on to an impressive season. In recent years, Dean Smith had been getting closer and closer to Adolph Rupp's NCAA record of 877 victories. Although the record meant nothing to Smith, the national media followed Smith's quest to surpass Rupp all season. Though they fell in their season opener to Arizona, UNC reeled off nine straight victories over non-conference opponents in November and December. However, league play couldn't have possibly started off worse for Carolina, as they dropped their first three ACC contests for the first time in school history. Each of the defeats was by double-digits, and the Tar Heels were simply run off the floor by Wake Forest, 81-57. UNC desperately needed a win when they squared off in Chapel Hill against N.C. State, but it didn't look good. State led by nine points with two minutes left, but Carolina finished the game on an inspiring 12-0 run. Vince Carter saved the day, stealing a pass after Ademola Okulaja's go-ahead basket to preserve a three-point win. After blowing out Georgia Tech, Carolina slipped again, losing at Florida State and Duke in a span of three games. The Tar Heels were only 3-5 over the first half of the ACC schedule, and some foolishly reasoned that the game had passed Dean Smith by.

In one final, vindicating run, Smith proved all the critics wrong by leading his team on a 16-game winning streak. UNC began the run with a 50-point massacre of Middle Tennessee State and followed it up with a pair of lopsided scores over Florida State and Virginia. The Tar Heels coaxed out a one-point win in Raleigh over the Wolfpack and won their last five regular-season games in succession, including four straight over ranked teams. Carolina was

peaking at the right time and proved to be overwhelming in the ACC tournament, where they won three consecutive games by 10 points or more. Led by MVP Shammond Williams, who averaged 20 points over the weekend, the Tar Heels defeated Virginia, Wake Forest, and N.C. State in succession.

Over the course of six weeks, Carolina had gone from an afterthought to the No. 1 seed in the East Region, while Dean Smith was only two wins away from surpassing Adolph Rupp. Smith tied the Kentucky legend with 877 wins as the Tar Heels held off Fairfield in a first-round shootout, 82-74. As several of his former players made their way to Winston-Salem to witness history, Smith tried to deflect the attention of the record away from his team. Although Colorado stayed close throughout most of the game, the Tar Heels pulled away for a 73-56 triumph, which placed Dean Smith at the top of college basketball's coaching victory list. UNC struggled in their Sweet 16 game against California but took control down the stretch for a six-point win. Surprising, Louisville was the resistance in the regional final, and although the Tar Heels nearly squandered a big lead, they won Smith's 879th game, 97-74.

Moving to the Final Four against Arizona, the Tar Heels had their worst shooting night of the season, making only 31 percent of their attempts. Although Carter scored 21 points to lead Carolina, Arizona's Miles Simon and Mike Bibby combined for 44 points, as the Wildcats, on their way to the NCAA title, advanced with a 66-58 victory. As it turned out, North Carolina's sensational run to the 1997 Final Four would be the last for Dean Smith. The last 16 seasons had been good to Smith, with five Final Fours and two NCAA championships. After 36 years at the helm of the UNC basketball program, the legendary coach was considering walking away.

Here, Jimmy Black protects the basketball from Indiana's Isaiah Thomas during the 1981 NCAA championship game. The Tar Heels were beaten by the Hoosiers, 63-50, but the team returned to the Final Four in New Orleans the following season and earned Dean Smith his first national title, beating Georgetown, 63-62. Black was an unsung hero during the 1982 Final Four, holding Houston All-American Rob Williams to only two points in the national semifinals and not committing a single turnover in the title game against Georgetown. (*Yackety Yack.*)

James Worthy is seen here driving to the basket. Worthy was named MVP of the ACC tournament, NCAA East Regional, and the Final Four in 1982, as the Tar Heels won the NCAA title. The junior scored 28 points in UNC's 63-62 championship game victory over Georgetown, and he entered the NBA Draft later that year. Nicknamed "Big Game James," Worthy won three NBA titles in the 1980s with the Los Angeles Lakers and was named one of the NBA's 50 Greatest Players in 2002. (*Yackety Yack.*)

Michael Jordan is shown releasing his game-winning jumper in the 1982 NCAA championship game against Georgetown. Largely unknown to the sports world before this moment, Jordan's shot, which came with 17 seconds to play, gave UNC a 63-62 lead. Moments later, the Tar Heels won UNC's first national championship in 25 years and the first under Dean Smith. (*Yackety Yack.*)

Here, James Worthy and Sam Perkins ride triumphantly down Chapel Hill's Franklin Street on top of a bus following North Carolina's 1982 NCAA championship game victory over Georgetown. Worthy would soon leave to embark on a successful professional career, while Perkins played at UNC for two more years, earning All-American honors in the 1982–1983 and 1983–1984 seasons. (*Yackety Yack.*)

Sam Perkins is pictured shooting over a defender in a 1984 game in Chapel Hill. One of the finest to ever play at North Carolina, Perkins is UNC's all-time leading rebounder and second-leading scorer. A three-time All-American from 1982 to 1984, Perkins was a vital cog in Carolina's run to the 1982 NCAA title. After winning a gold medal in the 1984 Olympics, Perkins played 17 seasons in the professional ranks, where he helped three different teams reach the NBA Finals from 1991 to 2000. (*Yackety Yack.*)

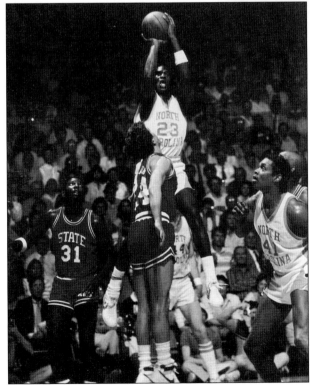

Michael Jordan is shown setting up for a jumper against N.C. State in 1984. Arguably the greatest player in the history of basketball, Jordan hit the game-winning shot as a freshman in UNC's victory over Georgetown in the 1982 NCAA championship game. Jordan was named National Player of the Year in 1983–1984, as he led the Tar Heels to a final record of 28-3. Jordan went on to win six NBA championships with the Chicago Bulls from 1991 to 1998, and he was named the Greatest Athlete of the 20th Century by ESPN in 1999. (*Yackety Yack.*)

Brad Daugherty is seen here battling for possession of the ball in a 1985 game against Clemson. Daugherty averaged 20.2 points a game as a senior in 1985-1986, helping the Tar Heels stay at No. 1 in the national polls for several weeks during the regular season. The first pick in the 1986 NBA Draft by the Cleveland Cavaliers, Daugherty went on to become a five-time All-Star in the professional ranks. Daugherty currently works as a college basketball analyst for ESPN.. (*Yackety Yack.*)

The Dean E. Smith Student Activities Center, more commonly known as the "Dean Dome," was completed in 1986, built entirely from private funds on UNC's south campus. One of the most name-recognized facilities in collegiate athletics, the Smith Center sells out its capacity for virtually every home game and, between the Tar Heels and their opponents, has showcased some of the best amateur basketball talent in the world over the last two decades. (*Yackety Yack.*)

Here, Kenny Smith defends in the backcourt. One of the fastest players in school history, Smith was a four-year starter for the Tar Heels. In his senior year of 1986–1987, Smith led UNC with 16.9 points and 6.1 assists a game, earning All-Conference honors and leading the team to a perfect 14-0 run through the ACC regular-season schedule. Smith went on to win a pair of NBA championships with the Houston Rockets in 1994 and 1995, and he is currently an NBA analyst for Turner Sports. (*Yackety Yack.*)

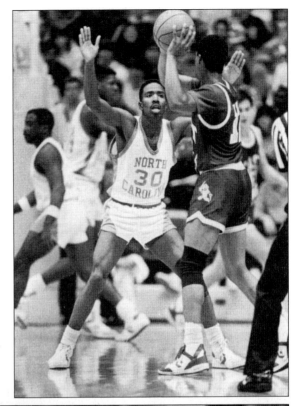

Joe Wolf is pictured looking for position against Clemson's Horace Grant during a 1987 game in Chapel Hill. Wolf earned first-team All-ACC honors in 1986–1987, helping the Tar Heels earn an ACC regular-season championship and a berth in the NCAA tournament's Elite Eight. Wolf went on to enjoy a long career in the NBA, where he played 12 seasons for seven different teams. (*Yackety Yack.*)

J. R. Reid is shown here looking to push the ball upcourt during a 1987 game in the Smith Center. Reid made the cover of *Sports Illustrated* during his freshman season, a year in which he earned ACC Rookie of the Year honors. A two-time consensus All-American at North Carolina, Reid averaged 16.2 points a game from 1986–1987 to 1988–1989, and he was the first-ever draft selection of the NBA's expansion Charlotte Hornets in 1989. (*Yackety Yack.*)

Jeff Lebo is seen here laying in two points. A fan favorite, Lebo played for the Tar Heels from 1985 to 1989, helping Carolina earn two regular-season ACC titles and an ACC tournament title during his career. A tremendous outside shooter, Lebo still ranks among the school's career leaders in three-point field goals and three-point field-goal percentage. Like many Tar Heels who came before him, Lebo went into coaching after his playing career ended and, in 2004, was named the head coach at Auburn University. (*Yackety Yack.*)

Here, Scott Williams looks to pass in a 1988 game against Temple. A steady contributor at North Carolina, Williams played on ACC regular-season championship teams in 1987 and 1988 and an ACC tournament champion team in 1989. In his junior season, Williams averaged 11.4 points a game, helping the Tar Heels set a school record with 3,331 total points. Williams has played for seven different teams in a 15-season NBA career, earning championships with the Chicago Bulls in 1991, 1992, and 1993. (*Yackety Yack*.)

Following their 96-74 victory over Duke in the championship game of the 1991 ACC tournament, the Tar Heels assembled for a team photograph. Carolina went on to earn a berth in the Final Four that spring and finished with an overall record of 29-6. Several players on the team went on to have careers in the NBA, including Rick Fox, Pete Chilcutt, Hubert Davis, George Lynch, and Eric Montross. (*Yackety Yack*.)

Rick Fox is shown cutting down a piece of net following North Carolina's 75-72 victory over Temple in the East Regional final of the 1991 NCAA tournament. It was North Carolina's first Final Four appearance since winning the 1982 NCAA title and was the first of five during the decade of the 1990s. Fox enjoyed a long and successful professional career, earning NBA championships with the Los Angeles Lakers in 2000, 2001, and 2002. (*Yackety Yack.*)

George Lynch is seen completing a slam dunk in Carolina's 82-77 victory over Florida State on January 17, 1993. Lynch's steal and score gave UNC the lead, 78-77, with under two minutes remaining in the game, much to the appreciation of the Smith Center faithful. In one of the greatest comebacks in the history of college basketball, Carolina overcame a 19-point deficit with nine minutes remaining by scoring 28 of the game's final 32 points. (*Yackety Yack.*)

Here, Eric Montross rises over a pair of defenders to score. A consistent performer, Montross was a two-time All-ACC selection at North Carolina and a second-team All-American in 1993–1994. Montross saved some of his best performances for big games, such as his 17 points as a freshman in the 1991 NCAA tournament against Eastern Michigan and his 16 points in Carolina's 1993 NCAA championship game victory over Michigan. (*Yackety Yack.*)

Derrick Phelps is shown consulting with Dean Smith on the sidelines during North Carolina's 1993 national semifinal game against Kansas in the Louisiana Superdome. One of the best defensive guards to ever play at UNC, Phelps set school records for career steals (247) and steals in a single game (9) in a career spanning from 1990 to 1994. A gritty competitor, Phelps played through a back injury to help lead the Tar Heels to the 1993 NCAA championship. (*Yackety Yack.*)

111

Donald Williams is pictured sinking a critical free throw in the final seconds of North Carolina's 77–71 victory over Michigan in the 1993 NCAA final. Williams's 25 points, which included five three-pointers, earned him Final Four Most Outstanding Player honors. Moments earlier, Michigan's Chris Webber (in background) had drawn a technical foul by calling a time-out when his team did not have one, which gave UNC an opportunity to salt away Dean Smith's second national championship from the free-throw line. (*Yackety Yack.*)

Dean Smith is seen here handing down one of the nets shortly after North Carolina's victory over Michigan in the 1993 NCAA final. The victory earned Smith his second national championship, solidifying his place among the legends of college basketball. Smith is one of only two coaches in ACC history, the other being Duke's Mike Krzyzewski, to earn more than one NCAA title. Ironically, both of Smith's NCAA championships were won in the Louisiana Superdome. (*Yackety Yack.*)

Here, Rasheed Wallace emphatically throws down a dunk in North Carolina's 74-61 victory over Kentucky in the Southeast Regional final of the 1995 NCAA tournament. Wallace, who was named a second-team All-American in 1994–1995, left UNC after two seasons as the ACC's all-time leader in career field-goal percentage (63.5 percent). A standout in the professional ranks, Wallace won an NCAA championship with the Detroit Pistons in 2004, coached by another former Tar Heel, Larry Brown. (*Yackety Yack.*)

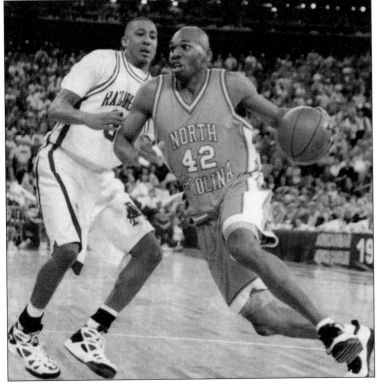

Jerry Stackhouse is shown penetrating against an Arkansas defender during the 1995 Final Four. One of the most dynamic players to ever play at North Carolina, Stackhouse became only the fourth freshman to be named MVP of the ACC tournament, which he did in 1994. Named the National Player of the Year by *Sports Illustrated* in 1995, Stackhouse went on to a successful career in the NBA, where he was named an all-star in both the 1999–2000 and 2000–2001 seasons. (*Yackety Yack.*)

Jeff McInnis is seen here driving to the basket. Part of a standout 1994 freshman class that included Jerry Stackhouse and Rasheed Wallace, McInnis helped the Tar Heels win the ACC tournament in 1994 and earn a berth in the Final Four in 1995. McInnis tied a school record with eight three-pointers in a February 14, 1996, game against Clemson and became only the sixth player in UNC history to amass 1,000 career points and 400 career steals. McInnis currently plays in the NBA with the Cleveland Cavaliers. (*Yackety Yack.*)

Dean Smith is pictured working the sidelines in 1996 in the arena that bears his name. A year later, Smith retired from UNC as the winningest coach in the history of college basketball, having triumphed in 879 games. In 36 seasons, Smith posted a .776 winning percentage, as the Tar Heels won 13 ACC championships, earned 11 Final Four berths, and won two NCAA championships. More importantly to Smith, over 96 percent of his players went on to earn their college degrees. (*Yackety Yack.*)

SIX

Changes and Homecomings
1997–1998 to 2004–2005

In the months following North Carolina's run to the 1997 Final Four, Dean Smith played quite a bit of golf. Smith had always told his coaching staff that when he didn't get tired of golf by the early summer and ready for the new basketball season, he would step away, and by the early fall, he was still out on the links. By early October, Smith was telling friends how tired he was, and when Michael Jordan visited Chapel Hill to play a round of golf with his former coach, Smith told him, confidentially, that he was about to step down. On October 9, 1997, in a Chapel Hill press conference, Smith made the official announcement. The news was met with surprise and disbelief, creating media frenzy in the state of North Carolina. Bill Guthridge was offered the position to replace Smith, and although he was reluctant at first, the longtime assistant was eventually persuaded to accept the job. Although Guthridge had less than two weeks before the start of fall practice when he accepted the job, Smith had left him a wealth of talented players to work with, including returning juniors Vince Carter and Antawn Jamison.

The Tar Heels opened the season ranked No. 4 and immediately showed why they were touted as one of the nation's top teams. After blowouts over Middle Tennessee State, Richmond, and California, Carolina traveled to Anchorage for the Great Alaska Shootout. It was no contest, as the Tar Heels wiped out No. 7 UCLA, 109-68, and followed it up with a 30-point annihilation of Seton Hall. Purdue was the resistance in the final, and Carolina hung on for a 73-69 win. The Tar Heels continued their dominant play in early December, knocking off Louisville and then Tennessee-Chattanooga and Virginia Tech in succession in Charlotte. Moving up to the No. 2 spot, Carolina engaged the methodical approach of Princeton. Although they didn't score their typical amount, UNC won the game, 50-42. The Tar Heels moved to No. 1 before beating up on Hampton, and they opened ACC play with an eight-point victory over Florida State in Tallahassee. Heading back towards home, the Tar Heels struggled in a game at Georgia. Trailing late in the second half, the Tar Heels rallied to send the game into overtime, where they pulled out an 82-80 victory. Carolina blew out Bethune-Cookman by 51 and finished out its four-game road run with a win at No. 21 Clemson.

Home victories over Georgia Tech and Virginia had the Tar Heels sitting at 17-0, but a difficult game was waiting at Maryland. Although North Carolina had won 33 of their last 34 games, the Terrapins had their number, shutting down Jamison and sending the game into overtime. UNC could not get on track in the extra session and dropped from the top ranking with an 89-83 defeat. Carolina only dropped one spot, and they regrouped by going on another winning streak. Behind Jamison, Carter, and Cota, the Tar Heels won five in a row, four of which were over ACC opponents. Sitting at 22-1, Carolina waited for the invasion of the top-ranked Blue Devils. Duke had no answer for Jamison, who scored 35 points in leading the Tar Heels to an impressive 97-73 victory. It took two overtimes to defeat Georgia Tech, but Carolina moved into the top ranking after the 107-100 win. After burying Virginia and Maryland, the Tar Heels had a truly bad night against N.C. State. The Wolfpack came into Chapel Hill and shocked Guthridge's team, 86-72. After dispatching of Wake Forest, Carolina blew a second-half lead against Duke and dropped a heartbreaking 77-75 decision.

Carolina embarrassed N.C. State, 73-46, in a rematch in the first round of the ACC tournament, and they played Maryland in the semifinals. Behind Shammond Williams's 25 points, the Tar Heels moved into the finals, where they outplayed Duke. Antawn Jamison earned MVP honors with 22 points, while Carolina shot 54 percent in an 83-68 final. UNC moved back into the No. 1 position in time for the NCAA tournament, but after blowing out Navy in the first round, UNC-Charlotte took the Tar Heels into overtime. It wasn't easy, but Carolina took control in overtime and won going away, 93-83. The Tar Heels had the luxury of playing the East Regional in Greensboro, and although they kept it close for most of the game, a young Michigan State team was taken down by Carolina in the Sweet 16, 73-58. Connecticut was the opponent in the regional final, and the Tar Heels put it all together in a 74-65 triumph. In impressive fashion, Bill Guthridge had led North Carolina to 34 wins in his first season as head coach, setting a new NCAA record. Along the way, he would earn National Coach of the Year honors.

Carolina headed to the Final Four as the favorite in their national semifinal game against Utah. Most people were expecting a matchup between the Tar Heels and Kentucky in the NCAA final, but the Utes did not oblige. As the Tar Heels came out flat, Utah was on its way to building a 13-point halftime lead. With Jamison held to only 14 points for the game, Vince Carter stepped up and led the Heels with 21. Unfortunately, he could not pull the Tar Heels into the lead, as the team connected on a dreadful 39.1 percent from the field. With Andre Miller earning a double-double with 16 points and 14 rebounds, Utah handed UNC a bitter 95-59 defeat. The loss was a tough one for Carolina fans to swallow, for much like that loss to Indiana back in the 1984 NCAA tournament, everyone knew that the team's stars were not returning the following year.

The early departures of Vince Carter and Antawn Jamison in the summer of 1998 surprised few in Chapel Hill, although the fact that they were subsequently traded for each other in that year's NBA Draft added an interesting twist. The 1998-1999 Tar Heels would be returning starters Ademola Okulaja and Ed Cota, but most of the team's scoring punch from the previous year was departed. Sophomore Brendan Haywood moved into the starting lineup and became a productive player for the Tar Heels over the next three seasons. Guthridge's team started off hot, playing arguably their best ball of the season in the first month. After a 23-point home opener win over Appalachian State, Carolina won a pair of games over Florida International and Georgia. UNC moved into the top five after a pair of wins over ranked teams in Purdue and Stanford, which earned Carolina the preseason NIT title. A victory over Middle Tennessee sent Carolina into Charlotte with a 7-0 record, but Guthridge's team barely squeaked out a 63-61 over Old Dominion in the opener. The next night, UNC fell to the College of Charleston by a late field goal.

The loss to Charleston did not diminish team spirit, as the Tar Heels promptly reeled off a four-game winning streak. Following an 82-68 triumph over Dartmouth, however, Carolina

was beaten in Atlanta by Georgia Tech in their first conference game. After a week off, the Tar Heels were beaten again by a tough California team, 78-71. Carolina continued to play up and down, for after beating Clemson and Florida State, UNC was outplayed by Maryland in the Smith Center. A trio of wins over ACC opponents followed, but Duke handled the Tar Heels in Durham, 89-77. The Tar Heels got revenge over Georgia Tech but lost two of their next three contests. UNC reached the 20-win mark with a triumph over N.C. State, and after a one-point win at Virginia on a buzzer-beater by Okulaja, the Tar Heels needed overtime to knock off Wake Forest.

Duke was on its way to the NCAA title game in 1999 and had a vastly superior team to Carolina this season, which was evident in the Blue Devils' 81-61 blowout in Chapel Hill. The Tar Heels entered the ACC tournament having lost four of their last nine games, but the team dominated Georgia Tech in the opening round by 29 points. Maryland was ranked in the top five and had beaten UNC twice during the regular season, but the Tar Heels, behind 23 points from substitute Max Owens, completed a memorable 86-79 upset. Carolina had another crack at Duke, but the Blue Devils were too powerful, claiming a 96-73 final. UNC traveled to the West Regional of the NCAA tournament with a No. 3 seed and met No. 14 seed Weber State in Seattle. In a nightmare for the Tar Heels and their fans, Weber State kept the lead throughout most of the game. Behind 36 points from Harold Arceneaux, the Wildcats pulled off a shocking 76-74 upset.

The first-round NCAA tournament loss to Weber State left a bad taste in the mouth of the returning players in 1999–2000, and opening the season in Hawaii's Maui Invitational, the Tar Heels earned a three-game sweep. Freshman Joesph Forte hit a three-pointer in his first attempt from the field as a collegian and went on to lead Carolina past USC, 82-65. Another pair of wins followed against Georgetown and Purdue, which moved UNC to No. 2 in preparation for a home game against Michigan State. The Spartans, on their way to the national championship, outplayed Carolina on its home floor. The 86-76 defeat brought UNC back down to Earth, although they went to Charlotte and swept a pair of games in the Food Lion MVP Classic. Following a win over Buffalo, the Tar Heels met the nation's No. 1 team, Cincinnati, in Chicago's United Center. The Bearcats featured Kenyon Martin and overwhelmed UNC for a 77-68 win. The Heels rebounded for wins over Tennessee Tech and Miami, but the team struggled in a game against Indiana, dropping an 83-72 final. The tough times continued at unranked Louisville, where the Cardinals dominated the struggling North Carolinians, 97-70.

The Tar Heels sat at a disappointing 8-4, but things were about to get tougher. Although UNC got back in the win column with decisions over Howard, Clemson, and N.C. State, the team then went on a four-game losing skid, the first for North Carolina basketball in eight seasons. The last of the defeats, coming to Florida State in Chapel Hill, was a particularly demoralizing loss, one that took the Tar Heels out of the national rankings. Carolina was in desperate need of a win over Maryland when the Chapel Hill area was covered by a winter blizzard. The scene in the Smith Center was quite different for this contest, as students consumed the lower level of the arena due to the fact that the normal patrons could not get to the game. The atmosphere helped inspire the Tar Heels to a thrilling 75-63 victory, which got the team back on track. A win over Georgia Tech followed, and although UNC lost in overtime to Duke, the team won four of its next five.

Maryland got revenge in College Park, and after an overtime victory in the final home game against Georgia Tech, the Tar Heels were beaten by Duke. With 18 regular season victories, Carolina entered the postseason at risk of snapping the school's two-decade streak of 20-victory seasons. Things fell apart in the first round of the ACC tournament against Wake Forest, as the Deacons held Carolina to 37 percent shooting. It was an early exit, as the Tar Heels were bounced, 58-52. UNC got invited to the NCAA tournament with an 18-13 overall record, and after an impressive 14-point victory over Missouri in the first round of the South Regional, the Heels prepared to play top-seeded Stanford. Carolina played

its most complete defensive game of the entire season, holding the Cardinal to 34 percent shooting. The Tar Heels made enough shots to pull out an inspiring 60-53 victory, which moved them into the regional semifinal against Tennessee. The Volunteers got Brendan Haywood in foul trouble, and led by seven points down the stretch, before UNC made a comeback. Behind Joesph Forte's 22 points, the Tar Heels moved past Tennessee, 64-59, and then knocked off Tulsa to move to the Final Four. Forte was again the hero for Carolina, scoring 28 points to go along with 8 rebounds.

North Carolina was back in the Final Four for the 15th time but quickly fell behind in their national semifinal showdown with Florida. Although the Tar Heels rallied in the second half and briefly took the lead, the Gators took control down the stretch and ended Carolina's spirited postseason rally, 71-59. UNC fans could not help but be happy with the team's impressive finish, while Bill Guthridge also sang his team's praises.

"I couldn't have been happier nor prouder than I was for that group of players to make it to Indianapolis," said Guthridge. "This was a determined group of players. They overcome a lot of adversity to get to the Final Four."

The University of North Carolina was in a state of transition in the spring and early summer of 2000, as the school was in the midst of a search for its new chancellor. Unexpectedly, the school didn't even realize that it was about to be on the lookout for a new leader of its basketball program as well. Within minutes after television trucks were seen on campus around the Bell Tower and the Smith Center on the afternoon of June 30, 2000, word spread quickly around Chapel Hill that Bill Guthridge was resigning as head coach. In an abrupt, surprising move, Guthridge had decided to step down after what turned out to be a draining season for the 62-year-old longtime assistant. The up-and-down Tar Heels of 1999–2000 struggled to meet the school's lofty regular-season standards, but their impressive run to the Final Four erased any doubt about Guthridge's head coaching skills. "Coach Gut," as he is called by many of those who know him, won more games in his first two seasons (58) than any head coach in the history of the NCAA. In a truly impressive career in college basketball, Guthridge participated in 14 Final Fours as a player, an assistant, and as a head coach.

It was taken for granted around Chapel Hill that Kansas head coach Roy Williams would answer the call to return home and become the heir apparent to his mentor, Dean Smith. Williams turned down a full scholarship to Georgia Tech in 1968 to fulfill his dream of playing basketball at North Carolina, and although he wasn't good enough to make the varsity, his love and knowledge of basketball made an impression on Smith. While attending Carolina, Williams often sat in the upper reaches of Carmichael Auditorium during UNC practices, paying close attention to the action below. Williams coached high school for a number of years but returned to Chapel Hill as an assistant coach in 1978. He stayed until 1988, when he was offered the head-coaching job at Kansas. Williams embarked on a highly successful run at Kansas, earning seven regular-season conference titles over an eight-season period from 1991 to 1998.

Although Williams did answer a call from UNC athletic director Dick Baddour in the days following Guthridge's resignation, his immediate response was something few were expecting in North Carolina. Williams was legitimately torn, as 12 years in Lawrence had grown him loyal to his Kansas players and the program he had built there. Williams struggled with the decision, traveling back and forth between Kansas and North Carolina over a period of several days. Although he reportedly had told Dean Smith that he would take the job at UNC on one of his trips to Chapel Hill, he never signed a contract. Upon returning to Lawrence, Williams announced in front of a large crowd at KU's Memorial Stadium that he would be staying at Kansas. It was a truly stunning blow, one that the UNC athletic administration did not seem prepared for.

In the days immediately following Williams's decision, both Larry Brown and George Karl were also taken out of the running. Brown elected to stay with the Philadelphia 76ers, while Karl was not given permission by his then-NBA team, the Milwaukee Bucks, to

pursue the position at North Carolina. Baddour then went after Matt Doherty, who had just finished his first season as head coach at Notre Dame. Doherty had worked for years on Roy Williams's bench at Kansas, and although he clearly wasn't the school's first choice, Doherty had a dedication and passion that won him the job.

Doherty made a lasting impression on the UNC faithful in his first game, when he tossed out t-shirts to the crowd and subsequently earned a technical foul in the early minutes of UNC's game to Winthrop. The Tar Heels prevailed, 66-61, and won the next night as well over Tulsa. Following a third win, Carolina lost to a pair of solid teams from Michigan State and Kentucky. However, the loss to Kentucky would be Carolina's last for more than two months. Behind the play of Joesph Forte, who went on to share the ACC's Player of the Year Award with Duke's Shane Battier, the Tar Heels won 18 consecutive games to surprisingly assume the No. 1 ranking in the national polls. The victories included six over ranked opponents and a two-point win in Durham over a Blue Devil team that was on its way to the NCAA title.

The Tar Heels appeared to be on the right path, but the team suddenly got derailed at Clemson, where they gave up a season-high 99 points in an 18-point loss. Carolina was up and down from that point, splitting their final four regular-season contests. UNC had a chance to earn the ACC regular-season title all to itself, but Duke came to town and spoiled the party, 95-81. The Tar Heels entered Atlanta's ACC tournament ready to compete, and they outplayed Clemson and Georgia Tech to reach the final. However, UNC ran into a Blue Devil team that was playing its best basketball of the year. Carolina never could get it going and wound up getting blown out by its biggest rival, 79-53. The Tar Heels moved into the NCAA tournament hopeful to make a run, but after dominating Princeton in the opening round, the team ran into a scrappy Penn State squad. The Nittany Lions pulled away down the stretch and ended Carolina's season, 82-74. Doherty cried after the Penn State loss, but the rookie coach led the Tar Heels to a 26-7 record, helping him earn National Coach of the Year laurels.

North Carolina basketball had known little more than tremendous success over the last 35 years, but during the winter of 2001-2002, the Tar Heels learned plenty of lessons in humility. With Joesph Forte and Brendan Haywood gone to the NBA, and fellow 2000-2001 contributors Julius Peppers and Ronald Curry focusing on making a career in professional football, the cupboard of talent that the Tar Heels always seemed to reach for was suddenly bare. Matt Doherty did the best he could with limited resources, but as early as UNC's first two games, when they were beaten at home by Hampton and Davidson, it was evident that it was going to be a long winter in Chapel Hill. The Tar Heels were outplayed in another home game against Indiana but got their first victory over ACC rival Georgia Tech. Kentucky blew out Carolina next, and the team nearly lost to lowly Binghamton, squeaking out a one-point win at home. After another loss to the College of Charleston, the Tar Heels had their only winning streak of the season, beating St. Joseph's, North Carolina A&T, and Texas A&M.

Following the win over Texas A&M, the Tar Heels endured the worst stretch of losing in the 90-year history of the UNC basketball program, dropping 11 of their next 12 games. Carolina was beaten by at least 10 points in each game of a six-game losing streak, and then after beating Clemson, they lost their next five games by an average of 18 points. With a 6-16 record, it would have been easy for Tar Heel fans to lose interest, but instead, they came out and helped lead UNC to a thrilling home win over Florida State. Carolina lost its next two games but pulled it together to continue the school's long home winning streak over Clemson. Over the years, Clemson has never won a basketball game in Chapel Hill, and the 2002 Tar Heels maintained the streak with a 96-78 victory. Carolina's final two games were against Duke, and after getting overwhelmed by 25 points in Cameron Indoor Stadium, the Tar Heels tried to slow it down in the opening round of the ACC tournament. Although it was close for a while, UNC bowed out, 60-48, to end the season with a miserable 8-20 record.

The 2001–2002 season was a nightmare for UNC basketball, but help was on the way the following year. Doherty and his staff lured an outstanding trio of high school players: Raymond Felton of Latta, South Carolina; Rashad McCants of Asheville, North Carolina; and Sean May of Bloomington, Indiana. The group would make a fast and immediate impression in the Tar Heel lineup, leading the team to wins over Penn State, Rutgers, and Old Dominion to start the 2002–2003 season. At 3-0, Carolina moved into the semifinals of the preseason NIT in Madison Square Garden, where they met Roy Williams and Kansas. The Tar Heels completely dominated KU, taking a substantial lead in the second half. UNC went on to an 11-point victory over the Jayhawks and moved into the national rankings after a 17-point blowout of Stanford in the preseason NIT championship game.

There was plenty of optimism in Chapel Hill, but the Tar Heels were picked apart in their next two games, coming against ranked teams in Illinois and Kentucky. Two more wins followed over Vermont and Florida State, but on a return trip to Madison Square Garden, the Tar Heels were upset by Iona, 65-56. Even worse than the loss was the fact that Sean May broke his foot during the game, effectively ending his season. With a lack of depth in the low post, May's injury in December quickly changed the Tar Heels from a viable contender for the ACC championship to a second-division squad that barely won more games than they lost. Following May's departure from the lineup, Carolina lost two of its next four games, including an overtime setback at Miami.

The Tar Heels rallied for close home wins over Clemson and top-ranked Connecticut but then went on a five-game losing skid. UNC was suddenly sitting at 11-9, and although they narrowly avoided another loss to Florida State and then beat Virginia soundly, they lost a 10th game at Clemson. Carolina split their final six games, beating North Carolina A&T, Georgia Tech, and Duke, while losing to Maryland, N.C. State, and Wake Forest. Over the final month of the regular season, rumors swirled around Chapel Hill and the rest of ACC country about possible turmoil within the UNC system. Although the school put on a good face, it was apparent that third-year coach Matt Doherty was struggling to relate to his players. Combined with the team's lack of success by North Carolina standards, it was a tough time around the Tar Heel program. The team went to the ACC tournament in Greensboro and momentarily quieted their doubters, pulling off a surprising 84-72 victory over the defending NCAA champions from Maryland. That meant a third game with Duke, and the Blue Devils got revenge for their recent loss to Carolina with a 75-63 verdict. With an overall record of 16-14, the Tar Heels once again missed the NCAA tournament, although they were invited to the NIT for the first time in nearly 30 years. The first two rounds were a breeze, as Carolina coasted past DePaul and Wyoming, but in the quarterfinals, the Tar Heels were beaten in the final minutes by Georgetown, 79-74, which ended Carolina's season at 19-16.

In the days immediately following the end of the season, UNC athletic director Dick Baddour held closed-door meetings with every member of the basketball team in order to determine what could be done to get things back on track. Although it was never confirmed, as many as six Tar Heel players were reported to be considering transferring if Doherty returned to North Carolina. After a lengthy conversation between Baddour and Doherty, it was agreed that Doherty would resign, which he did on April 1, 2003.

The head-coaching job at UNC was the safest job in the state for nearly 40 years, but upon Matt Doherty's resignation, UNC was faced with the task of hiring the program's third coach in six years. There was little doubt who the UNC administration wanted, as they again went after Kansas head coach Roy Williams. Williams was in the midst of a run to the NCAA championship game in New Orleans with his Jayhawk team, and although he tried to avoid the situation, there was rampant media speculation on the direction Williams was leaning. After another grueling period of a few days weighing his options, Williams addressed his Kansas players on the morning of April 14 to tell them he was leaving. The former Jayhawk coach left Lawrence on the verge of tears and caught a plane to Chapel

Hill shortly thereafter. That same day, Williams was named the 18th coach in the history of North Carolina basketball.

"I was a Tar Heel born. When I die, I'll be a Tar Heel dead. But in the middle, I have been Tar Heel and Jayhawk bred, and I am so, so happy and proud of that," Williams said at the press conference held in the Smith Center to announce his hiring.

The 2003–2004 Tar Heels got off to a fast start, winning their first six games. UNC next played a classic with Wake Forest in Chapel Hill, which went into triple overtime. The Demon Deacons prevailed in a draining 119-114 final, which started a difficult stretch for Carolina. Over their next eight games, the Tar Heels were beaten three times, including setbacks to Kentucky and Maryland. The third loss, an overtime defeat to Florida State in which UNC led by more than 20 points in the first half, put the team's record at 11-4. The team regrouped for wins over Virginia and N.C. State, but then they fell flat on their faces at Clemson, where the Tigers took an 81-72 verdict.

Although Raymond Felton led the ACC in assists and Rashad McCants became only the seventh UNC player in history to average 20 points a game, the Tar Heels struggled away from Chapel Hill. Carolina won only 4 of 11 games on the road, although the Tar Heels did get some big wins in February at Wake Forest and at N.C. State that helped the team become worthy of entrance into the NCAA tournament for the first time in three seasons. Unfortunately, the Tar Heels were swept by Duke, including a loss in overtime in the Smith Center, and were beaten late in the season by Georgia Tech and Virginia to finish the regular season with an 18-10 record. UNC entered the ACC tournament for a difficult game with Georgia Tech, and the Yellow Jackets wound up prevailing, 83-82, on a late basket by Jarrett Jack. Nonetheless, the Tar Heels returned to the Big Dance, where the team collectively shaved its head before their first-round game in Denver against Air Force. It was a difficult encounter, but the Tar Heels prevailed, 63-52, to move into the second round. Texas was a deeper team than UNC, and although they made it interesting at the end, Carolina dropped a frustrating 78-75 decision to finish the year 19-11.

There were big hopes in Chapel Hill prior to the start of the 2004–2005 season. The Tar Heels were returning their roster from the previous season virtually intact and were adding McDonalds All-American Marvin Williams, a six-foot-nine-inch forward with agility and strong finishing moves. Raymond Felton was suspended for the season opener for playing in an unsanctioned summer-league game, and his absence was felt in Carolina's contest against Santa Clara, a 77-66 loss. The UNC coaches and players headed to Hawaii for the Maui Invitational the next morning, and upon arriving at the hotel, the team immediately went to practice, where they had two excellent workouts before dispatching of Brigham Young University, Tennessee, and Iowa, all by at least 13 points, in the Lahaina Civic Center.

"After Sunday's practice in Maui, Roy Williams told his wife that he couldn't be prouder of the way the team responded," said Woody Durham. "Over the season, the Tar Heels proved to be as tough mentally as any North Carolina team I can remember."

The Tar Heels continued to roll upon hitting the mainland, winning their next 11 games, including a decisive win over Kentucky and a 34-point blowout of Maryland in Chapel Hill. Carolina finally met its match when it went to Wake Forest, where a strong Demon Deacon team prevailed, 95-82. UNC immediately began another streak, beating five ACC opponents, three by more than 20 points. At 19-2, the second-ranked Heels traveled to Durham to play an overachieving Duke team. Mike Krzyzewski slowed down the fast-paced Carolina attack, and although UNC had the ball in the final seconds with a chance to win, the Blue Devils held on for a 71-70 triumph. The Tar Heels went on another winning streak, beating Connecticut in Hartford and conference rivals Virginia, Clemson, and N.C. State. The Maryland game in College Park was close down the stretch, but Carolina held on for a two-point win. After dispatching Florida State, the Tar Heels welcomed Duke for a return engagement in the Smith Center. The Blue Devils looked to be in control, leading by nine points in the final three minutes, before the Tar Heels went on a decisive 11-0 run. A late

score by the freshman Marvin Williams gave Carolina a 75-73 victory and the school's first ACC regular-season title since 1993.

Although they were hailed as arguably the single most talented team in the country, the Tar Heels were missing Rashad McCants, who was battling an illness, in their first-round ACC tournament game against Clemson. The Tigers led for most of the game, but Carolina gained command and won, 88-81. The next day against Georgia Tech, the Tar Heels could not find an answer for Will Bynum. The Yellow Jacket scored a career-high 35 points, as Tech took a three-point victory. Despite the loss, Carolina had proven its worth during the regular season and earned a No. 1 seed in the NCAA tournament.

UNC cruised past Oakland in the opener by 28 points and subsequently blew out Iowa State in the second round, 92-65. Advancing to Syracuse to play Villanova in the Sweet 16, Carolina narrowly avoided a heartbreaking defeat. The Wildcats, playing without one of their best players in Curtis Sumpter, broke out to an early double-digit lead and held the advantage well into the second half. The Tar Heels took control late in the second half, but Raymond Felton fouled out, setting the stage for a dramatic finish. A controversial traveling call went in UNC's favor in the final minute, and Carolina moved on, 67-66. Wisconsin was the foe in the regional final, and the Tar Heels came out running. UNC led throughout the early going, only to watch the Badgers go on a 13-0 run over the last minutes of the first half and early minutes of the second half to take the lead. However, behind Sean May's 13-of-19 shooting for 29 points, along with 21 from Rashad McCants, Carolina moved past Wisconsin and into the Final Four, 88-82.

Despite their impressive credentials, there were still those in the media that questioned Carolina's heart as they prepared to meet Michigan State in the national semifinal in St. Louis's Edward Jones Dome. The Tar Heels answered every question on the floor, as Jawad Williams emerged after a quiet tournament to score 20 points. Sean May added 22 points, with 18 coming in the second half, as Carolina overcame a five-point halftime deficit. For the eighth time in school history, the Tar Heels would play for the NCAA title, following an 87-71 win over the Spartans.

"At the end of the game, I went over and told [Jawad Williams], 'You're the reason we won this game. You have heart, and you wouldn't let us fail.' " said Sean May.

It was fitting that No. 2 North Carolina met No. 1 Illinois in the national championship game, as the teams had been widely regarded all season as the best two teams in the country. The Tar Heels raced out to a 13-point halftime lead, only to watch the Illini, who set an NCAA final record with 40 three-pointer attempts, claw their way back. Illinois tied the game late in the second half and had five different chances to either tie or take the lead down the stretch. The Illini could not convert, and behind 26 points and 10 rebounds from Final Four MVP Sean May, the Tar Heels prevailed, 75-70. As the UNC band triumphantly played "Carolina Victory," the North Carolina players, coaches, and fans celebrated a vindicating NCAA championship, while Roy Williams earned his first national title with the win. For the UNC seniors, who had played on the worst team in school history in 2001–2002, the 2005 championship was the culmination of a three-year quest to bring respectability back to Tar Heel basketball.

The success of Roy Williams's second UNC team marks the turn of a new page in the history of North Carolina basketball. The Tar Heels are back among the nation's elite college basketball programs and figure to be there for quite some time. For the winners of UNC's fifth recognized national championship, they are now placed into a special category among the storied players of North Carolina's past. Like the 1957 NCAA champions, who are still held in high regard nearly half a century after their undefeated season, the 2005 National Champion Tar Heels have staked their own claim in the annals of UNC hardwood history. They will be remembered as the team that brought the glory back to North Carolina basketball.

Vince Carter is seen scoring two points the easy way. One of the most athletic players in school history, Carter averaged 12.3 points a game over his three-year career at North Carolina. Renowned for his high-flying dunks, Carter was named a second-team All-American in 1997–1998, as Carolina reached its second consecutive Final Four. The NBA Rookie of the Year in 1999, Carter won a gold medal in the 2000 Olympics in Sydney, Australia. (*Yackety Yack.*)

Antawn Jamison is pictured working inside for a basket against Maryland. One of the finest to ever don the Tar Heel colors, Jamison was the first player in school history to earn first-team All-ACC honors as a freshman. The Charlotte native was an All-American the following two seasons, as he led Carolina to the 1997 and 1998 Final Fours. The winner of the Naismith and Wooden Awards as National Player of the Year in 1997–1998, Jamison scored 22.2 points a game, the highest average by a UNC player in 18 years. (*Yackety Yack.*)

Here, head coach Bill Guthridge gives instructions to his players during a 1999 game in the Smith Center. Guthridge, who served as an assistant to Dean Smith for 30 years at North Carolina, replaced the legendary coach just prior to the 1997–1998 season. Inheriting a team loaded with talent, Guthridge led the Tar Heels to a 34-4 overall record and the Final Four, earning National Coach of the Year honors along the way. Guthridge led Carolina back to the Final Four in 2000 and later that year joined Smith in retirement. (*Yackety Yack*.)

Ed Cota is shown driving against Duke's Jason Williams during a 2000 game in Chapel Hill. A four-year starter at Carolina, Cota recorded 1,030 assists during his career, the highest total in school history and the third highest in ACC and NCAA history. Cota's unselfish play helped propel the careers of several of his teammates and guided the Tar Heels to Final Fours in 1997, 1998, and 2000. (*Yackety Yack*.)

Matt Doherty replaced Bill Guthridge in the summer of 2000 as head coach at North Carolina and earned National Coach of the Year honors in 2000–2001, as UNC tied for the ACC regular-season title. The following year, however, the Tar Heels suffered through an 8–20 season, the worst in school history. Following a turmoil-filled 2002–2003 season, Doherty resigned from the UNC head-coaching position after only three years. (*Yackety Yack.*)

Here, Brendan Haywood sets up for one of his patented slam dunks. North Carolina's all-time leader in blocked shots, Haywood established new UNC and ACC records by making 63.7 percent of his shots during his career. A second-team All-American in 2000–2001, Haywood recorded the first triple-double in North Carolina history that season, posting 18 points, 14 rebounds, and 10 blocks against Miami. Haywood currently plays in the NBA with the Washington Wizards. (*Yackety Yack.*)

Joesph Forte is seen scoring in transition. The first freshman to lead North Carolina in scoring, Forte was the MVP of the NCAA South Regional in 2000, as he helped the Tar Heels reach the school's 15th Final Four. In 2001, Forte was named first-team All-America and Co-Conference Player of the Year, leading UNC to a share of the ACC regular-season title. (*Yackety Yack.*)

Julius Peppers is pictured stuffing home a slam dunk. Peppers played two seasons of basketball at North Carolina, helping the Tar Heels reach the 2000 Final Four and claim a share of the 2001 ACC regular-season championship. A two-time All-American in football as a defensive end, Peppers was taken by the Carolina Panthers with the second overall pick of the 2002 NFL Draft. Peppers appeared in a Super Bowl with the Panthers in 2004 and played in his first Pro Bowl in 2005. (*Yackety Yack.*)

Raymond Felton is shown dribbling against a Duke defender. Felton was recruited out of Latta, South Carolina, by Matt Doherty and started at point guard for North Carolina from the time he arrived in Chapel Hill. Felton led the ACC in assists during both the 2003–2004 and 2004–2005 seasons, and he was named first-team All-Conference in 2004–2005. Felton was named a third-team All-American as well, as he helped lead the Tar Heels to the NCAA title. (*Yackety Yack.*)

Sean May and Jawad Williams are shown battling under the glass for a loose ball. Williams averaged 13.1 points a game during the 2004–2005 season, and his 20 points against Michigan State in the Final Four helped the Tar Heels advance to the national championship game. May was named first-team All-ACC and second-team All-American in 2004–2005, as he finished third in the conference in scoring (17.5 points per game) and second in rebounding (10.7 rebounds per game). May was also named MVP of the 2005 Final Four after scoring 26 points in Carolina's NCAA final victory over Illinois. (*Yackety Yack.*)

Here, the National Champions of college basketball for 2005, the North Carolina Tar Heels, proudly hoist their trophy. The 2004–2005 Tar Heels went a perfect 15-0 in the Smith Center, finished 14-2 in the ACC regular season, and won 14 of their final 15 games to finish with an overall record of 33-4. The 2005 NCAA championship was the fourth in the history of the University of North Carolina basketball program and the school's fifth recognized national championship. (Jeffrey Camarati.)

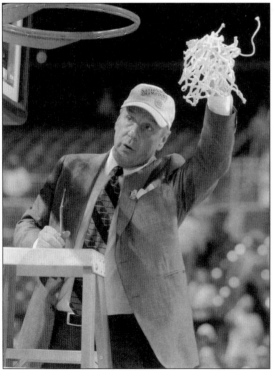

Roy Williams is pictured displaying the net following North Carolina's 75-70 victory over Illinois in the 2005 NCAA title game. Williams spent 15 seasons as head coach of the University of Kansas, where he took four teams to the Final Four. Williams turned down North Carolina's offer to replace Bill Guthridge in the summer of 2000, but three years later, just days after leading the Jayhawks to the 2003 NCAA championship game, the North Carolina native and UNC alumnus decided to come home. North Carolina's NCAA championship in 2005 was Williams's first as a collegiate head coach. (Jeffrey Camarati.)